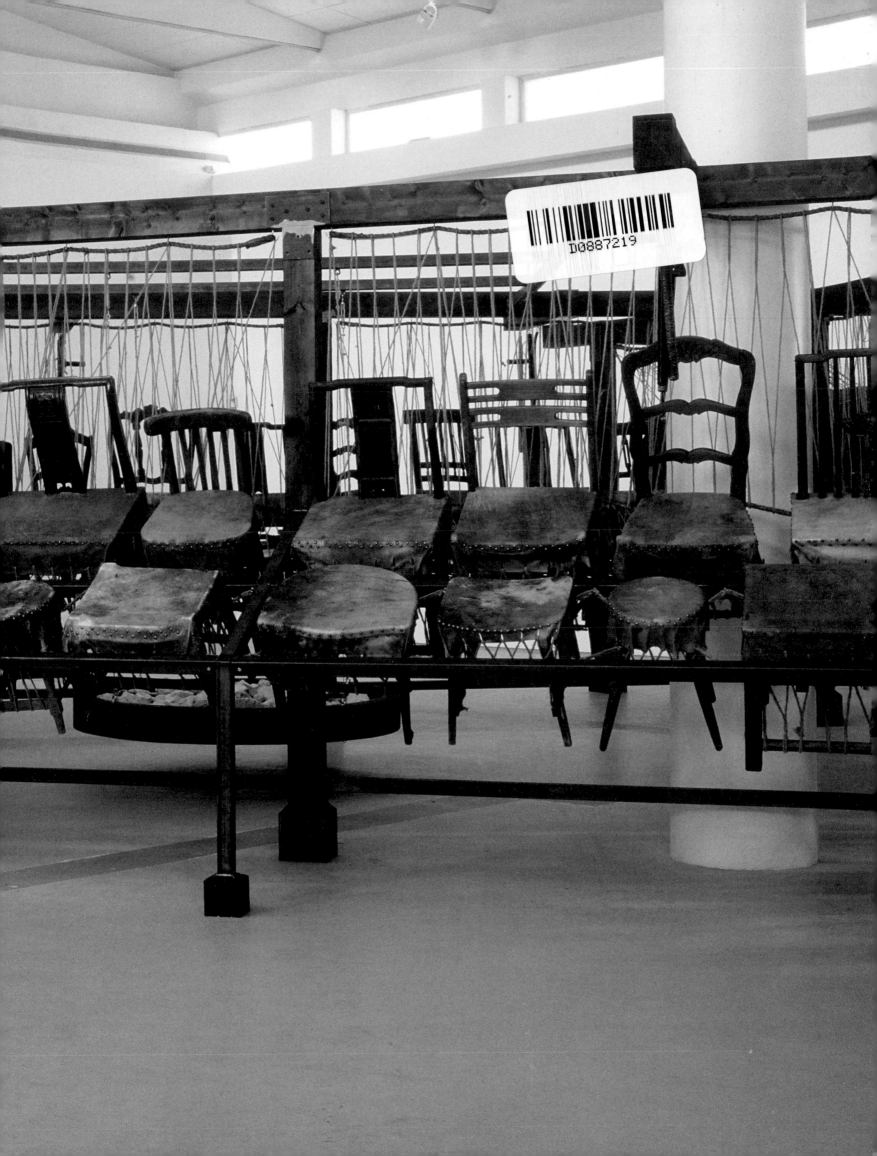

Antoine Guerrero

CHEN ZHEN

P.S.1 Contemporary Art Center

Chen Zhen: A Tribute

P.S.1 Contemporary Art Center, a MoMA affiliate, New York:
February 16, 2003 — May 25, 2003

Exhibition:
Organizer: Antoine Guerrero
Installation Advisor: Xu Min
Registrar / Project Manager: Jeffrey Uslip
Project Manager: Rachael Zur
Exhibition Interns: Selam Menkerios, Matt Ross

Catalogue:
Editors: Jeffrey Uslip, Rachael Zur
Managing Editor: Anthony Huberman
Copy Editor: David Frankel
Texts: Jeffrey Deitch, Hou Hanru, Eleanor Heartney, France Morin, Hans-Ulrich Obrist, Jérôme Sans
Tributes: Eric Angels, Janine Antoni, Sylvie Blocher, Domenico De Clario, Yan Pei-Ming, Cai Guo-Qiang, Sam Samore, Nari Ward
Translations: Martha Kuhlman, Marine Putman
Editorial Interns: Aline Favre, Agathe Lacroix
Design: New Collectivism

This exhibition is made possible by agnès b.; the Cultural Services of the French Embassy; Galleria Continua, San Gimignano (Italy); Annie Wong Art Foundation; and Anthony T. Podestà.

This exhibition is generously supported by Rosa and Gilberto Sandretto.

Cover:
Chen Zhen, *Jue-Chang — Fifty Strokes to Each*, 1998
Wood, iron, chairs, beds, leather, rope, found objects
Collection: Annie Wong Art Foundation, Hong Kong
Photo: Chen Zhen and Xu Min

Inside Cover (alternate view):
Chen Zhen, *Jue-Chang — Fifty Strokes to Each*, 1998
Wood, iron, chairs, beds, leather, rope, found objects
Collection: Annie Wong Art Foundation, Hong Kong

ISBN: 0-9704428-7-4

This catalogue is published to accompany the exhibition organized by P.S.1 Contemporary Art Center, Long Island City, NY

Published by P.S.1 Contemporary Art Center
22—25 Jackson Ave @ 46th Avenue
Long Island City, NY 11101
Tel: 718.784.2084 Fax: 718.482.9454 email: mail@ps1.org
http://www.ps1.org

Printed and bound by Studio Print, Ljubljana, Slovenia

Available through D.A.P / Distributed Art Publishers
155 Sixth Avenue, 2nd Floor, New York, NY 10013
Tel: 212.627.1999 Fax: 212.627.9484
http://www.artbook.com

P.S.1 Contemporary Art Center
a MoMA affiliate
Long Island City, NY, 11101

Table of Contents

Foreword

I am delighted to welcome *Chen Zhen: A Tribute* to P.S.1 Contemporary Art Center, an affiliate of The Museum of Modern Art. It is an honor for us to house the first New York showing of Chen's work since his death in 2000, a result of his life-long struggle with autoimmune hemolytic anemia.

This Shanghai-born artist worked across the divide between East and West, creating works that combine Chinese philosophy (a subject whose discussion was forbidden under Maoist rule) with the forms of Western avant-garde art. In both his life and his work, Chen embraced the topical notion of "cultural homelessness," exploring his ability to cross spiritual and physical boundaries and to react to the unexpected. *Jue Chang — Fifty Strokes to Each*, 1998 — a large interactive installation of chairs, beds, and stools from around the world, all transformed into drums — invites viewers of all cultural backgrounds to "play" the work of art, turning a percussion instrument into a vehicle for global exchange and dialogue. We are eager for visitors from both New York and abroad to share their experiences of aggression and strife through this creative outlet.

Chen came of age in the China of the Cultural Revolution, when political ideals came into conflict with the country's traditional culture. He subsequently moved to the West, spending much of his life based in Paris. This cultural background encouraged him to create an alternative to the ruling ideology of China. His work bridges the divide between Western and Eastern concepts of art, medicine and illness, and cultural identity, addressing the cross-cultural dialogue that defines contemporary human existence.

My gratitude goes to those who made this exhibition possible and I embrace this opportunity to pay tribute to Chen Zhen.

Glenn D. Lowry
Director, The Museum of Modern Art

Foreword

It is with great pleasure that P.S.1 Contemporary Art Center presents the work of Chinese-born artist Chen Zhen, the first survey presented in New York since his premature death in 2000. I have a long history of working with Chen and feel honored to welcome this landmark exhibition to our institution.

We had the distinct privilege of installing *Prayer Wheel* (1997), a work of great vision and dynamic presence, for the reopening of P.S.1 after its 1997 renovation. I worked with Chen again in 1998, when he was included in our exhibition, *Cities on the Move*. Chen's death marked a loss for us all, and I am proud to present this tribute show of hallmark works, including *Jue Chang — Fifty Strokes to Each*, 1998, and the artist's last work, *Zen Garden* (2000), a model for a yet to be conceived municipal garden.

Born in Shanghai, Chen spent most of his life in Paris. His eclectic body of sculptures and installations negotiates a meeting between traditional Chinese culture and Western principles and addresses contemporary social issues such as the

ephemeral nature of the body. A number of Chen's works are informed by his battle with autoimmune hemolytic anemia, the illness that eventually took his life. Much of his work also examines his personal experience of the contradictions of an increasingly global society, exploring such dichotomies as Eastern philosophy and Western practices, the traditional and the contemporary, and the conflicting politics of Communism and Capitalism in Asia. As Chen once stated, "Making art is all about looking at oneself, examining oneself and somehow seeing the world."

This exhibition is produced with admiration and pride. Its organizer, Antoine Guerrero — P.S.1 Director of Operations — was Chen's artistic assistant and close friend for several years in France. Antoine nurtured this project from its inception and worked relentlessly to bring it to fruition, in collaboration with Gilbert Vicario. Xu Min, Chen's widow and artistic partner, and William Norton, P.S.1 Director of Installation, oversaw the often complex installation. I thank P.S.1 Operations Associate Rachael Zur and P.S.1 Project Manager and Registrar Jeffrey Uslip, who together accomplished the challenging tasks of producing the catalogue and coordinating the exhibition.

We all look forward to hearing the drums of *Jue Chang* resonate through our hallways and to pay homage to Chen Zhen and his artistic legacy.

Alanna Heiss

Director, P.S.1

Introduction

A friend once asked me, "How long have you known Chen Zhen?" I answered, "Before Duchamp and Beuys."

Some of our greatest journeys have their Spring in friendship; my journey and friendship with Chen Zhen had a Spring that lasted over ten years and spanned over four continents. He and I met twelve years ago, in 1991. He was my introduction into the art world. Together we had long talks about race, culture, religion, and strategies of being.

I was a nomad, and Chen was a settler. This difference in life-style became the center of many conversations. Chen would often say, "If someone wants to do something significant in life, he has to work hard toward an ambition. Therefore, at a certain time in his life, he has to settle down in one place. He has to work, but also to read, see, understand, exchange, and listen." These were our founding principles and guidelines for how we approached art and life.

First, I assisted Chen on one of his projects, then on another, and then another. I became his assistant, his student, and most important his best friend.

Soon our lives took us in separate directions: he was living in Paris and I was working at P.S.1 in New York. Having been his assistant, I had the opportunity to invite him to participate in several exhibitions. Chen would say "The circle is close, the student becomes the master." In 1996 Chen approached me and asked if I could let him use a space big enough for him to produce an installation for an upcoming New York show. Alanna Heiss and I gladly gave him P.S.1's "archive gallery" and he began to work on his piece for the curator France Morin's project with the Shakers of Sabbathday Lake, Maine. It was a

Acknowledgement: A Fabulous Cultural Short Circuit

joy for me to be reunited with Chen, and to come to work every day and see him produce his latest work. We would talk over morning coffee and I would ask him if everything was okay, or if he needed any help. Every day the answer would be the same: "Everything is fine, no problem." But then, on the last morning of his stay, Chen came into my office completely distressed and said, "Even if your house is on fire, you don't disturb your friend until the fire reaches your eyebrows." Confused, I said "Yes. So?" He answered, "My eyebrows are burning and I need you to help me crate my piece. I leave for Paris in four hours and I don't have enough time to do it myself." Together we worked relentlessly, and Chen's piece was eventually crated and shipped to his next exhibition. At the end of the summer of 2000, Chen told me his back was hurting him badly. By the Fall the pain was so severe that he couldn't leave his bed. He told me over the telephone that he had asked his assistant to build him a bracket to hold his computer above his head, so that he could still work. I remembered his mantra: "Work until our last breath to achieve our aim."

I feel deeply honored to organize this Chen Zhen tribute for P.S.1 Contemporary Art Center and the international art community. I would like to thank Xu Min, the exhibition's installation advisor, for all of her continued support and effort. Without her none of this would have been possible. I view this exhibition as a celebration of a great artist and a truly wonderful friend.

Antoine Guerrero

Director of Operations, P.S.1 Contemporary Art Center

It was hot in Venice as I walked along the avenues of the Arsenale at the Biennale. I felt thirsty and hungry, and I was about to go in search of a bar when I began to hear a strange sound in the air, like the start of an earthquake…

I walked on in the direction of the sound, which soon became a rhythm. It was coming from an enormous hall. I went in and stopped, gasping in amazement. In front of me was a fantastic, enormous installation built out of asian beds and chairs covered by taut animal skins. The sculptures-turned-drums were attached with ropes to wooden structures. The work was surrounded by dozens of visitors releasing their energy by beating away on the drums with provided sticks. People were unconsciously listening to each other, creating an extraordinary shared rhythm. I was completely captivated for I don't know how long. My hunger and thirst vanished, and the only thought in my head was to meet Chen Zhen! It was my lucky day, because I met my friend Rosa who knew Chen Zhen, admired his work and even had his phone number.

When I got back to San Gimignano, I talked things over with my colleagues, Maurizio and Mario, and then called Chen Zhen. I was very nervous. The voice on the other end was calm and courteous. It was him. I told him about my enthusiasm for his work, and after stammering my way through various incomplete sentences, I ended by cheekily informing him of the opening date of his exhibition at the Galleria Continua: Saturday 21 October, 2000.

Highly amused, he tactfully replied that it might not be possible, but in any case he would like to meet me. I leapt at the chance and invited him to come see us in Tuscany. Incredibly, he accepted. Fantastic! I was bowled over — Chen Zhen didn't know anything about us, and anyway why should he be interested in doing a show in San Gimignano? I realize now that it was his innate curiosity that stimulated him.

He arrived with his wife, Xu Min. I've rarely come across a couple so in tune with each other. We talked about all kinds of things — the harmony of the local landscape shaped by man; the Great Wall of China. We compared ham with tofu, and tea with wine, seeing the cultural differences between peoples as a sum of energies, an opportunity for reciprocal enrichment.

He asked many questions about the local culture, the craftspeople, the agriculture, and after I'd responded, he told me about other ways of living and being in some of the places he'd visited — Salvador, Kwangju, Marrakesh, Helsinki, Tel Aviv. The result was a fabulous cultural short circuit, a dish laden with surprises.

We didn't talk about the show that day at all. Chen Zhen only wanted to see the gallery space, which is located in a former cinema theatre, and as he walked around the rooms, he told me he didn't consider big spaces to be any more important than small ones. Every space must have its own individual and magical characteristics, like the vital organs of the human body, each one well-organized and specialized, every component indispensable. It's important to create a visual, spiritual and psychological path where even weakness and a lack of space can represent the distinctive characteristics and wonderful fascination of a particular place. This, he said, holds true for people as well.

Chen Zhen and Xu Min left the next day without even a hint that one day it would be possible to organize a project together, but they did invite me to their home in Paris. Our first meeting had been so incredibly enlivening and refreshing that I soon found myself talking to them again, this time in Paris.

When I arrived back home a letter was waiting for me. My heart skipped a beat… it was from Chen Zhen: "I've drawn a plan of the gallery from memory. I'll do some new works, which I've sketched out here, and I'll position them in the various rooms according to the energy of the space and so as to create an organic whole, as if one were on a mysterious journey inside the human body. The title of the show will be *field of synergy*… some works are almost impossible to realize… they are dreams."

The dreams came true, and the show opened on Saturday 21 October 2000.

Lorenzo Fiaschi
Galleria Continua

11

Sculptor as Doctor

Jeffrey Deitch

My first professional involvement with Chen Zhen was to wire him money so that a friend of his could buy used chamber pots from old ladies on the streets of Shanghai. There were plenty of eager sellers; within two weeks Chen's friend had accumulated 150 chamber pots, which we shipped by boat to New York. We had listed them as "sculpture," and astonishingly they came through customs with no questions asked.

The chamber pots were the main components of *Daily Incantations*, the principal work in the exhibition that I produced with Chen Zhen in May 1996. Chen associated two sets of rhythmic incantations with his daily walks to school in Shanghai in the 1960s. One was the sound of children reciting phrases from Chairman Mao's "Little Red Book," and the other was the sound of older women scraping and washing their chamber pots on the street. The wooden chamber pot was a symbol of the old Shanghai where, until recently, the majority of the population lived without indoor plumbing. It was a shameful symbol most people in Shanghai were eager to banish from their memory as the city rushed toward modernization. Chen thought the chamber pots would be the ideal elements from which to construct a sculpture about traditional culture being swallowed up in the debris of modernity.

The chamber pots actually looked like tasteful wooden flower planters. Chen wired each of them with an electronic speaker that played a recording of a woman scraping a pot clean on a Shanghai street. He mounted the pots in rows on a structure reminiscent of an ancient Chinese musical instrument. In the center was a giant circle of electronic refuse, old television tubes, computer insides, wires, etc. that my staff had retrieved for Chen from a Brooklyn junkyard. The sculpture was structured the way a choir assembles itself for a performance, with descending rows extending out in a wing-like formation. The cacophonous din of the women scraping had its desired incantatory effect. Coupled with the sculpture's powerful regal form, the effect was overwhelming. Chen was on his way to inventing a new approach to sculpture, which fused music, performance, the transformation of everyday objects, and a humanistic and spiritual vision into sculptural form.

Chen Zhen's sculpture was not just something to look at; it was something to experience. His most ambitious works had a sound, a rhythm, a scent, and invited a physical interaction. Chen's approach to sculpture paralleled his own personality — he was a natural teacher who drew people into his aesthetic and intellectual world. You didn't just meet Chen Zhen; you experienced him. In addition to his body of work, Chen left a network of friends and collaborators who remain activated by his spirit.

Jérôme Sans told me a story about how he had met Chen Zhen: in the late 1980s in Paris, he would often notice a Chinese man shyly standing at the edge of the crowd at Paris gallery openings. After a year or more of seeing this curious person, Jérôme pushed himself to walk over and say hello. This resulted in a dialogue that became Chen's real entry into the art world.

Chen had arrived in Paris in 1986 without fluency in French, without any art world contacts, and without even a real understanding of what international contemporary art was about. He had an instinct as a student of theater design in Shanghai that art was his calling, but in China at that time, it was very difficult to gain any grasp of the international art world. Determined to find his way, Chen understood that he would have to leave China to do so. New York would have been his first choice, but a visa was hard to obtain; travel to Paris was possible, and that is where he went, leaving his wife and son behind until he could afford to bring them. His first years in Paris must have been an extraordinary challenge as he circled the periphery of the Paris art world by himself, trying to understand the art and the complex social and economic system that spun around it.

By the time I met Chen Zhen, in 1994, he was already a professor at a prestigious Paris art school and was in New York to prepare for his exhibition at the New Museum of Contemporary Art. The curator, France Morin, had introduced him to the artist Nari Ward as someone who could help him to find and burn the bales of rags he wanted

to use in his installation. Nari took Chen up to a vacant lot in Harlem, where they spent two weeks burning rags and developing an ongoing artistic dialogue that would later result in a magical collaborative work. It was Nari who introduced me to Chen. At the time Chen spoke almost no English, so we communicated in French. It was a mark of his determination to enter the center of the international art dialogue that he pushed himself to learn English. By the time he returned to New York to work on an exhibition project with me a year and a half later, he spoke English fluently.

In 1996 France Morin gathered an exceptional group of artists — including, among others, Chen, Nari, Janine Antoni, and Mona Hatoum — to live and work with the eight remaining Shakers in their historic community in Sabbathday Lake, Maine. Chen's great friend and collaborator Tony Guerrero was in charge of keeping the artists happy and well fed. Each artist developed a project addressing an aspect of the Shaker experience; Chen's was a remarkable sculpture that incorporated Shaker baskets into a Buddhist shrine. He also embarked on another special project to make portraits of the last Shakers. After I had spent a day in the Shaker Village and had been introduced to each of the Shakers, Janine Antoni led me into a closed off room where she said I would see something amazing: hanging on the wall were Chen's portrait drawings of the eight Shakers. They were astonishing in their realism and psychological insight. I had no idea that Chen was hiding this kind of talent. Janine wanted me to keep quiet about what I had just seen because the portraits had apparently caused a serious incident with the leader of the Shakers, Sister Frances. This modest woman who probably rarely, if ever, looked in the mirror. Shocked by Chen's insight into her state of mind, which must have been more troubled than she wanted to let on, she did a very un-Shaker-like thing and demanded that the portrait be redone. After much discussion among the artists about truth and representation, Chen drew a new, brightened-up version.

Chen's most famous and most remarkable work is *Jue Chang — Fifty Strokes to Each*, produced in 1998 for the Tel Aviv Museum and shown again at the 1999 Venice Biennial. It is the central work in the 2003 P.S.1 exhibition. One of my strongest and most memorable experiences with a work of art was to follow the drumbeats into the large open room in the Venice Arsenale where Harald Szeemann had installed *Jue Chang*. Thirty people were engaged in an ecstatic dance, drumming their minds out on dozens of suspended beds and chairs, which had been transformed into drums with stretched leather. I have never experienced another work of art that matches the combined physical, musical, and visual intensity of this one, which fuses dance, music, sculpture, and a cathartic, transforming experience into a single work. *Jue Chang* evokes the specter of political repression that threatens to assert itself in both totalitarian and democratic societies, but the piece also presents a platform for personal liberation.

Growing up in China during the Cultural Revolution and coming to the West as an outsider, Chen had to construct his own version of contemporary art rather than absorbing the conventional version of recent art history. As a result, his approach to art drew more from life experience than from an evolution of formal and intellectual strategies. His orientation was much more art about life than art about art. His background in the theater also led him toward a sculpture that would be a platform for interaction and performance as much as a structure to look at.

Toward the end of his life, Chen's preoccupation with his own health problems, along with his family's background in medicine, led him to investigate art as an alternative path toward healing. He resolved to teach himself traditional Chinese medicine through the practice of art. The centrality of the body in the structure and experience of his work was pushed to the next dimension. The title of one of his last exhibitions, "Between Therapy and Meditation," is a description of his artistic approach at this point. Chen came from a distinguished family of doctors, and had made a tremendous sacrifice in stepping away from the family tradition to find his way as an artist. Ironically, his art brought him back to medicine: he had become the sculptor as doctor.

Chen Zhen's Last Work, "When the Cities Dialogue with the Interior Landscape of the Body:" A Tribute to Chen Zhen

Hou Hanru

Prelude

Walking on the streets of Shanghai, Chen Zhen's native city, is a moving experience. It is November 22, 2002, the opening day of the fourth Shanghai Biennial. Chen Zhen had an intimate relationship with this institution, just as I do: he was one of the most eminent participants in the first Shanghai Biennial, a breakthrough historical event, while I was a curator for the third edition, the first international biennial of contemporary art in China. Looking through my notebook, I have found the following text, which seems a relevant tribute to my dear friend whom we all miss so much. Chen Zhen's last work was initially inspired by his return to this formidably mutating and modernizing city, to which he returned for the first time after years of exile on the occasion of that first Shanghai Biennial of 1996. He returned to the city later for other projects, which, happily, I helped him to realize.

This fourth edition of the Shanghai Biennial included a significant contribution from the curatorial team at P.S.1 — to which, incidentally, Chen Zhen in turn made a significant contribution when the institution was remaking its identity. Should we trust destiny?

Shanghai, November 22, 2002

Chen Zhen's art bears witness to the experience of migrating from East to West and of facing new political, social, religious, and cultural contexts. His work is a form of cultural resistance, revealing a double awareness: on the one hand the "integration" demanded by the new social context, on the other the actual differences of culture and identity that all immigrants manifest. Negotiating this conflict and paradox by articulating his own existence as a "spiritual runaway," Chen Zhen navigates between different geographies and cultures, seeking to develop a new language, a new way of living, in the age of globalization.

Chen Zhen died of cancer on December 13, 2000, in Paris, after struggling strongly and bravely against the disease. Right up until the end, he was hoping to carry out wonderful, ambitious projects in the future to add to his already significant contribution to international art. As a tribute to Chen Zhen, certainly one of the most significant artists on today's global art scene, I'd like to recall his last work and share my deep appreciation of it.

Chen Zhen worked into the last days of his life. His final installation was completed just a few days before he died, at the ARC, Musée d'Art Moderne de la Ville de Paris, in the exhibition *Paris pour escale* (Paris as stopover), which opened on December 6, 2000.[1] According to Chen Zhen, the project was "an attempt to make four elements meet together simultaneously so the work becomes a kind of 'stopover' (*escale*)."[2] The work, *When the Cities Dialogue with the Interior Landscape of the Body*, puts together his experiences of three cities, in different parts of the world, where he enjoyed intense and productive moments pondering questions of urbanism, social justice, and cultural resistance in the process of globalization. The installation consists of slide projections and CD-*roms* documenting Chen Zhen's memories of and projects in those cities — Shanghai (his hometown), Johannesburg, and Salvador, Brazil. The images of the three cities combine to create another form of urban space. The cities are further brought into dialogue with one of Chen Zhen's most recent works, *The Interior Landscape of the Body*. This work is based on the idea in Chinese medical theory and practice that human organs are an "organic totality," like the "inseparable landscape" of the universe. Made of candles in five colors — yellow, black, purple, white, and red — the piece is beautifully fragile and fluctuates between spaces, "demonstrating a synergy between the vulnerability of our bodies and the sensibility of our spirit." This dialogue among urban realities, and between them and the life of the body, provokes "a tension, a liaison, or a distance in our vision of the world."

1. *Paris pour escale*, at the Musée d'Art Moderne de la Ville de Paris from December 6, 2000, to February 18, 2001, was curated by Hou Hanru, Evelyne Jouanno, and Laurence Bossé.
2. All quotations on this work are from Chen Zhen's description of the project in the exhibition catalogue for *Paris pour escale* (Paris: Paris musées, 2000).

An Interview with Chen Zhen

Eleanor Heartney

I first met Chen Zhen in the summer of 1992, at an art exhibition in which he participated in the Hague. I was immediately struck by the wit, humor, and compassion in his work, which, as I got to know him over the years, clearly also summed up his personality. I have rarely if ever met an artist who cared so deeply about his work while displaying so little of the egotism that is often a byproduct of the profession. More than anything else, he was motivated by generosity, and from one perspective his work is an extended essay on the possibilities of societal and personal connection. He taught me, among other things, to appreciate the way an apparently off-hand anecdote or folk saying can build a bridge between cultures. The following, previously unpublished interview was conducted in May of 1997. It touches on some of the issues that dominated our conversations.

Eleanor Heartney: *You have shown in France, Germany, the Netherlands, Japan, Shanghai, China, and the United States. What does it mean to be an international artist today?*

Chen Zhen: I am usually invited to international shows for two reasons: I am invited to be in shows of Chinese art as a Chinese contemporary artist, or I am invited to be in a group show as an Asian artist. It is very fashionable now, in big shows, to have four or five Asian artists. Sometimes they choose me and sometimes someone else.

And then there is a third reason: sometimes people are really interested in my work, so they invite Chen Zhen. This is the best situation, of course.

EH: *This global art world is a fairly new phenomenon. What do you think created it? And do you think it signals a real internationalism?*

CZ: The biennials and big museum shows are almost the same everywhere. We meet the same artists, the same curators, and the same critics.

As for why this has become a world phenomenon: the idea of multiculturalism came from the United States. Decentralization begins in the center. Now shows are being organized throughout Asia: Korea, Japan, Singapore. This reflects not only multiculturalism but also the economic, political, and social changes after the Cold War. There is a Chinese saying: for fifty years the wind is from the east, then for fifty years the wind is from the west. This means: no one can dominate the world permanently. The Chinese people feel that it is our century now. Economic changes create changes in deep consciousness — changes at the level of ideology, politics, and nationalism — and there is money now in Asia, while the Western world *needs* money. There is a new order.

EH: *But if things are shifting east, it is clear that current definitions of art, artistic success, and the art system still come from the West.*

CZ: Totally. There are two main kinds of people in Asia. One kind is completely Westernized, and only looks to the West for what is good; the other, inspired by the postcolonialist context, is against the West, although such people have only a rough idea of what they are against. But even if you are contrary you are depending on Western opinion. It is by working in the empty space between these that you can find a new way to create something. I travel a lot, I see these different opinions, but I feel that for me as an artist it is most important to enrich myself individually. I don't want to be limited to Western or Chinese culture.

EH: *Westerners have the same problem: they either fear Asia or idealize it as a pure culture untainted by the West or by materialism.*

CZ: Of course, this is what Pontus Hultén, in conversation with me, called the eternal misunderstanding between East and West. Shanghai is full of skyscrapers. It is totally covered with concrete and cars. But Chinese people still have their own, very Chinese way of thinking. It is only an illusion that if we transport Western ideas there the world will be totally Westernized. Forget it. Misunderstanding immediately follows when we try to understand the other. It is a permanent situation.

EH: *Do you find that true when it comes to responses to your work?*

CZ: My work often receives totally different reactions from Asian and from Western artists. Take for instance *Daily Incantations*, an instal-

lation I did last year for Jeffrey Deitch in New York. I used chamber pots from Shanghai to create a set of Chinese bells. Chamber pots are disappearing from Shanghai; they symbolize the old city, the old culture, underdevelopment, and so on. When I use them I don't consider them art objects, they are just everyday objects that speak about the modernization of Shanghai. In New York I transformed these everyday objects into bells, which in China were royal instruments. Chinese viewers said, This is horrible, these are ugly, smelly objects, it is terrible to show them in a gallery. Westerners said, These are beautiful old Chinese objects, they are so nice. Then when they realized what they were seeing was chamber pots, it became another thing.

EH: *You constantly try to play between those misunderstandings.*

CZ: I'm not playing with misunderstanding, I'm trying to create it. That's my way of thinking: I want to make things more complicated.

EH: *In the West it's probably fairly easy to create those misunderstandings. But what happens when you go back to China?*

CZ: Last year, at the Shanghai Biennial, I was invited to show my work in China for the first time in nine years. But my work was censored. I had just done a round-table piece in Geneva. This gave me the idea of doing a game table, as a way to question the way money has become a new religion in China, as it is in the rest of the world. My project was to create a new game, based on thirty-six Chinese military strategies, on a huge table. A hundred thousand real Chinese coins were to be spread over the table. There were also to be thirty-six holes in the table, with chamber pots under them. It was a way to say that money is not clean, at least for the intellectual class.

Chinese political people immediately saw what this meant. They wanted me to change this material, because they knew that it could easily provoke social misunderstandings. I discovered that my usual way of making a piece didn't work in Shanghai. But it was still a good experience, because now I understand better. It won't keep me from returning to China for further experiments. After ten years I want to rejoin my own country, and the cultural change in progress there.

EH: *Westerners tend to see Asia as a monolith and all Asians as similar. How should we think about Asia?*

CZ: In my opinion, the best way for the West to see Asia is to study the individual. Each one is totally different from any other. I myself, for instance, belong to the generation that lived through the ten years of the Cultural Revolution. Then I spent ten years in China after the Cultural Revolution, during the period of Chinese reform, and now I have spent ten years in the West. This experience is totally different from that of a Chinese of the same age who stayed, or of artists who spent that time in New York. But we do have certain things in common. For instance, people ask if I am a conceptual artist. What does that mean? I don't think it means anything. What they see as conceptual I see as metaphorical. While the conceptual is linked to a logical, rational way of thinking, the metaphorical is free and flexible. It is a way to talk about deep philosophical ideas. Chinese people are always telling stories with bigger meanings behind them. There is a famous saying: Make noise in the east and attack in the west. This is the Chinese way. Where the noise is, that's not it. It's a paradoxical way of thinking.

EH: *How does that differ from Western ways of thinking?*

CZ: What a New Yorker means by "metaphorical" is probably quite different. I refer to an indirect, Chinese way of metaphor. It is not symbolic. It is about motion or mutation, a kind of insinuation. If something is acid you cross it with something sweet. This is a very Chinese way of contradiction, like yin and yang. The most exciting moment in my work is when there is suddenly a meeting between two things that were inactive before. It is about contrast, contradiction, and confrontation.

EH: *Is this part of your approach individual or cultural?*

CZ: It comes not only from my way of working but from my position as an Asian in the Western world. It relates to questions linked to my own identity. I try to create misunderstanding by creating many tracks in my work. It is my personal strategy for my own existence as well as for my work.

In China There Is a Proverb That Says ...

France Morin

In a photograph of his bedroom in Salvador, Brazil, the student Fabio Bastos has installed two small paintings on his bed. One of the paintings depicts a little boat on the ocean, with a small moon and a comet in the sky. Fabio, who was working with Chen Zhen on the "Quiet in the Land" project in Brazil,[1] could not have known the wonderful Chinese saying that Chen told me during the same period, and that begins my essay in the book on the project: "Like a little boat heading into the immensity of the ocean, it is not where we are going or how we will get there that is important, but that we have embarked on the journey."

Chen's own journey was cut short in 2000, by cancer, when he was forty-five. It was a journey of commitment to life, art, and making the world a better place. Chen had a major impact on my life, and on my relationship to art and to the world. I met him in the early '90s in Paris, and until his death nearly ten years later we were in touch at least every week. Our journeys in both art and life were profoundly entangled. In art, we worked together on major projects, such as the two-person exhibition I organized with Chen and Huang Yong-Ping at the New Museum of Contemporary Art, New York, in 1994.

Chen loved New York. He wanted to move here, and he was hoping his son, Chen Bo, would study in the United States. In 1996 he and I, along with several other artists, spent a month living in Sabbathday Lake, Maine, the world's single surviving Shaker community, for the project "The Quiet in the Land: Everyday Life, Contemporary Art and the Shakers." In 1999 we spent time together again — over six weeks in Salvador, Brazil, for the project "The Quiet in the Land: Everyday Life, Contemporary Art, and Projeto Axé." Chen's wife, Xu Min, and son came to Salvador for a few weeks to work with him. More recently he and I had started working on a new "The Quiet in the Land" project, in Asia, where Chen was finally to embark on his project of becoming a Chinese doctor.

In life we shared Chen's many periods of sickness, my own sickness in 1999, and the deaths of our dear friends Penny and David McCall, on April 18, 1999, and of our friend the Thai artist Montien Boonma, who died in his forties, also of cancer, only a few months before Chen. We also shared the complexities of everyday life, including at some points the balancing of the pressure of our work and our lives with the fragility of our health.

Chen understood the desire to operate in what the Japanese call *ma*, the space between, a zone of seeming emptiness between categories that, seen differently, reveals itself as an interval of fullness and harmony. By creating situations in which artists and communities could work together to perceive both the differences that separated them and the similarities that connected them, we would strive to activate this "space between"as a zone of potential in which we could renegotiate the relationship between contemporary art and life. Fundamental to this process, Chen knew, was our belief in the essentially spiritual nature of artmaking — in a conception of art as rooted in the cultivation of the creative spirit that lies within everyone, a powerful agent of both personal and social transformation.

In 1994, at the New Museum of Contemporary Art, New York, Chen produced the site-specific installation *Field of Waste*. After several trips to the city he had become intrigued by its illusion of being a racial and ethnic melting pot at the same time that it was a world center of power and wealth. Using his own observations and history as raw material, Chen explored converging issues — labor and immigration, racial and cultural disparities, ideological tensions, assimilation, and political inequities. For him, the United States and China represented a radical opposition in terms of culture, tradition, political economy, and technological development. He saw the juxtaposition of these two extremes in *Field of Waste*, through the metaphor of a patchwork fabric, as representative of the new world order. The work combined two processes to produce a field of symbiotic and coexisting identities: the recurrent destructions in Chinese history (symbolized by burning), with the consequent renewal through revolution, and the means by which hundreds of thousands of Chinese immigrants have managed to survive abroad: the manufacture of clothing. During his month in New York, Chen worked with

the artist Nari Ward to collect two tons of newspapers and five cubic meters of clothing. He burned the newspapers in an empty field in Harlem, but stopped short of making them disintegrate or fall apart; this charred paper then became part of his installation at the New Museum. *Field of Waste* suggests a constant, cyclical production and destruction of both materials and human life — a spiritual reality. The work enshrines an ancient, holistic world view in which matter, spirit, "nature," humankind, and manufactured objects exist in a continuum. In Taoist thought, in fact, burning and the ashes it creates are symbolic not of death, as they are in the West, but of purification and transformation. Chen's poetic work enacts a "field" of symbiotic identities, evoking such transformation and renewal through the primordial elements of fire, water, air, and earth.

"The Quiet in the Land: Everyday Life, Contemporary Art, and the Shakers" questioned the assumption that art and life are mutually exclusive. In doing so it examined changing notions of gender, work, spirituality, and art. Many of the works in the exhibition invoked the complex metaphor of the space between; for Chen, *Opening of Closed Center*, the piece he made for the show, is a visual manifestation of that space, a dialogue between his own culture and that of the Shakers. In a space bounded by a series of wooden window frames taken from a Chinese monastery hangs an enclosed, circular rocking chair — a space within a space. Although the wooden structure and caning of the chair recall Shaker design, in serving as a protected place it also recalls the Zen Buddhist idea of sitting as an eternal meditation. Seen only through the screen of the Chinese windows, the chair is physically inaccessible to the viewer. At an opening in the structure of windows is a suspended altar, made of Chinese furniture, on which rest objects of daily life, such as the pots used for carrying water and rice. These common objects are unusual as spiritual offerings, and although they are Chinese in origin, in this context they may reflect the Shakers' reverence for the sacred origins of everyday activities, origins from which creativity flows. Chen conceived the intersecting spaces between cultures as spaces of growth.

When Chen and I were together in Salvador, Brazil, in 1999, we were working with the former street-children of Projeto Axé (the Centre for the Defense and Protection of Children and Adolescents), a nongovernmental agency founded in 1990 to address the devastating situation of the city's street children. It presently serves about 1,000 children and teenagers, ranging in age from five to eighteen, mostly black and poor, who live with the burden of centuries of racism, economic injustice, and physical, psychological, and social violence. Chen saw the "Quiet in the Land" projects not as a series but as a way of living, and one that provoked probing questions for artists: Why have I decided to be an artist? What do I think is the artist's social responsibility? Do I believe that art can change people's lives? These questions ultimately lead to an even deeper question, as Chen said a few months after leaving Salvador: "This type of project poses a very serious question: Art must not only be made by the hands, the eyes, and the intelligence but mostly by the heart." The statement points to a conviction that permeated our projects: artmaking is essentially a spiritual activity through which human beings can examine the experience, quality, and meaning of their lives.

In the many periods of doubt that Chen and I shared, we often reminded each other of hexagram five of the I Ching, "Waiting (Nourishment)": It is only when we have the courage to face things exactly as they are, without any sort of self-deception or illusion, that a light will develop out of events, by which the path to success may be recognized. This recognition must be followed by resolute and persevering action. For only the man who goes to meet his fate resolutely is equipped to deal with it adequately. Then he will be able to cross the great water — that is to say, he will be capable of making the necessary decision and of surmounting the danger. Chen said of his work for Projeto Axé, "In Salvador we liberated our own energies and gave them to the children, and they liberated theirs and gave them to us. These energies merged to create a new field of energy, a new space of possibility." The field of energy, the space of possibility, that Chen alluded to here emerged in part because each project we worked on was designed to undo the categories that structure

and in many cases limit how we perceive and experience art, life, and the gap between them. When Xu Min and Chen Bo worked with Chen in Brazil, they worked not as assistants but as participants — a profound experience. He had chosen to collaborate with a group of teenagers from Stampaxé, a unit of Projeto Axé that focused on printing and printmaking. Chen's group researched the history of housing in Salvador. They discussed what their city, neighborhood, streets, and homes meant to them, and imagined what the home of their dreams would look like. After these discussions Chen helped the group make drawings of these homes. They used the drawings to build models out of candles, in colors corresponding to each Candomblé *orixa* (deity). Chen hoped to help these former street-children imagine brighter futures for themselves — to give them the knowledge that they had choices. As he said, "Of course their problems are not solved. They still live with a lot of uncertainty. But they also asked me if I thought that one day they would be able to live abroad, to make their own choices, like I had done, when I left China." He continued,

My stay in Salvador was one of the most inspiring and fruitful experiences I have had in more than ten years. It's a very rare opportunity to work not only within a particular context but also with the people in the place. We confronted our own capacity and understanding within a very intensive social reality and historical complexity, in which the vocation and the function of art were challenged and examined. The question of the frontier between art and life, artist and nonartist, was "ridiculously" ignored by the crucial and moving fascination of life itself. We felt a deep imperative to meet the inside of people, where hearts, not languages, communicate. As an artist born in China, this was my first deep contact with Latin American culture. I urgently believe that in the future, cultural hybridity will not be between white and nonwhite cultures but among the "colors."

In the project description for *Becoming a Chinese Doctor*, which Chen and I were working on at the time of his death for a third "Quiet in the Land" project, Chen wrote,

I have had the good fortune of belonging to a family of doctors and scientists in the medical field. I was brought up in an atmosphere where human relations, the interest in human beings, friendship, and the close relationship between science and society are based on life. I have also been "blessed" with a serious illness for twenty years. Ongoing crisis, pain, physical and psychological, have been my lot all my life. They have also molded my will and my mind to become a vital energy that feeds my life as well as my passion for art. I have also been an artist since the age of eighteen.

Family, illness and work have been woven into the very fiber of my personality and the way I work. They have helped create a way of life in which I have the privilege to grow and make art. These three components are part of my daily life. They influence each other and criss-cross, creating an environment that allows me to think and make art. . . . For many years, my personal illness has influenced my professional life. My daily battle against illness has given me such energy that the whole experience has been transformed into a positive creative force. Treatment, cure, therapy, purification, and meditation: these daily preoccupations have become the universe in which art and life feed on each other.

I spoke to Chen for the last time on November 22, 2000. He died on December 13.

1. "The Quiet in the Land" is a series of projects I initiated in 1995, consisting of long-term collaborations between artists and different communities in various parts of the world. The first project in the series, "The Quiet in the Land: Everyday Life, Contemporary Art, and the Shakers," brought ten artists to live and work with the world's only surviving active Shaker community, in Sabbathday Lake, Maine, over a period of five months in 1996. It was followed by exhibitions at the Institute of Contemporary Art, Portland, Maine, in 1997, and at the Institute of Contemporary Art, Boston, in 1998. This first project became a model for establishing extended, mutually beneficial interactions between artists and communities. The series has also functioned to investigate spirituality in art and the healing potential of the creative process. It is committed to developing new curatorial practices that reaffirm the potential of contemporary artists as catalysts of positive change in an era in which their social role has become increasingly circumscribed. Through the processes of collaboration and creation, these projects open up questions on broad social and cultural categories such as art, craft, politics, religion, and history. They bring about greater understanding of the impact of globalization on people's lives in both developed and developing nations, and work toward envisioning how the creative process can be used to address major social issues such as poverty, displacement, and the loss of traditions. The series allows artists to work in depth and over a period of time, offering them the freedom to take their work into uncharted realms.

Conversation with Chen Zhen

Hans-Ulrich Obrist

Hans-Ulrich Obrist: *We're in an airport and we're talking about travel. Daniel Buren wrote about poststudio practice very early on.*

Chen Zhen: It's fantastic to meet and talk about travel in this space of random crossings. Recently I had an interview with Daniel Buren, and we spoke precisely about the problem of travel — of location, of position, of the reinterpretation of artworks in different contexts. Through their concept of travel, and their engagement with an absolute logic, Buren's generation, and especially Buren himself, understood the necessity of travel, of intervening in different locations every time. Three decades later our own generation has other objectives, and is practically obliged to travel: travel brings together different cultural contexts, and permits us to meet other artists whose languages we don't necessarily know but with whom we are able to communicate through our work, our gestures.

Our generation is in a phase characterized by globalization — an incredible decentralization. Fundamentally it isn't the concept of work that makes us travel, it is this new situation. The artists of Buren's generation, by contrast, were guided by specific concepts.

HUO: *The application of a concept or method in different contexts?*

CZ: Yes, that's it. A concept underlies their work and is the basis of their thought. Buren is more subtle, more open; he's the rare case of the artist in continual dialogue with his "visual tool," stripes. But his practice is always enriched by a level of absolute concept, absolute logic. It seems to me that my generation, on the other hand, works, plays, and discovers new concepts in the course of our travels, and between

our trips. It's not a question of spreading our ideas, it's that we are obliged to confront a new context, and to create a dialogue with the place, wherever we work. These journeys and encounters with new places are destabilizing in comparison to artists' usual method of working. If I create a project tomorrow for the Taipei Biennial, for instance, or for another biennial, I can't easily replicate what I did on an earlier trip. So the trip and the time between trips, the "in-between," becomes a real space in which to connect different concepts. For our generation, movement and travel aren't simply phenomena of distribution, of presenting the same concepts in different places; they imply permanent and perpetual change.

HUO: *And how do you view the notion of destabilization? It's an interesting notion — that there are these intersections and influences situated around the notion of travel that in a certain way destabilize art practice and take it elsewhere. On the other hand, one could say that an artist who comes to a city is a "destabilizer" of that city.*

CZ: First of all, the question of self-awareness is important. To *be* destabilized one must be *aware* of being destabilized — one must be prepared to be destabilized, it's a kind of position. Later the destabilizing experience — that is to say, one's travels, one's encounters — becomes a new dimension of artistic inspiration and creation.

From the early twentieth century until a peak in the 1960s and '70s, artistic creation always concerned the artist's intellect. That is to say, the individual artist was the catalyst of the idea. Now we are in a system, a complex global network, in which the individual artist is no longer sufficient for creative thinking and innovation. I am interested in becoming destabilized

because I want to be able to gather, to accumulate, all of my experiences of different places. Three years ago I began to develop the theme of what I call "transexperience," or "beyond experience," which consists of a double intersection. The first is the intersection between my experiences of old things and my experiences of new ones; the second is the intersection between my own experiences in connection and the experiences of others, of everyone else — for instance, with people of the West. Even though I've been living in France for the past fifteen years, every time I meet a new person I face new questions. Nothing is self-contained, nothing is fixed. What's interesting is being in motion. In China we say, When the trees move, they die; when men move, they live.

HUO: *How would you define the relation between a certain slowness and acceleration? Is it a kind of negotiation?*

CZ: Three words are important: slowness, deceleration, and acceleration. After the idea of transexperience I wondered how to react when an artist from the margins moves progressively closer to the center. That is my own case: I moved from a marginal position at the beginning of my stay in France to a position, after fifteen years, closer to the Western center. Now I am thinking through the problem of remarginalization. When you are traveling you are constantly in a position of remarginalization, because you are leaving behind the center of your life, your work, your usual connections; you become a stranger — marginalized. We are all marginalized in foreign countries because we are émigrés. Positions and encounters become very interesting in this situation. With respect to slowness and speed, I'm working toward finding a parallel. Recently I've developed a concept based on three R's: Residence, Resonance, and Resistance.

Residence: when you travel, it doesn't matter whether you stay for a day, several days, or a month, it is important to want to live mentally with the other, to let yourself be immersed in the local context. You have to try to understand the culture of the place where you are. It's a question of conscience, of position, in relation to travel. Resonance: resonance is about being in synchronicity with the culture in which you live. Resistance: you must resist Western culture. But when, like me, you have lived in a Western context for so many years, how can you continue to resist the monopoly of Western influence? I have a new strategy: I plan to spend long periods of time in India, Argentina, Brazil, and so on. This destabilizing project will permit me to distance myself from the influence of Western culture. It's a cultural dilution.

My generation of Chinese artists is doubly influenced: first by traditional Chinese culture — Confucianism, etc. — and second by Western culture. This is obvious, but it's actually *so* obvious that I'd like to invoke what Michel Foucault calls "the rupture of the obvious" in order to do things differently.[1] Over the past ten years I've learned a great deal from my travels — I've learned a little of different languages, and I buy as many books as possible. In China we say that you climb up the mountain to see the totality of the situation, and you climb down the mountain to see the totality of the mountain. In other words, we try to see things from a larger, more general perspective without being distracted by their details, and we also try to see the same things from other points of view, from multiple perspectives.

HUO: *Throughout the 1990s, many artists believed in the idea of infiltrating existing exhibition structures. Ten years later I wonder whether this is still the case, or whether the emphasis has*

shifted to inventing new structures altogether.

CZ: People sometimes argue that this phenomenon of extensive travel on the part of artists — biennials all over the world, shows with an international cast — is an institutional one. I prefer to think of it as multiculturalism becoming a style, a system, a machine, in which everyone has the same formula, the same method, for creating shows. But there is already a new structure here, a new system, and it begins with travel: how can these artists' travels be transformed into a new way of living? Our generation has a new life-style; how can that become a new form of questioning, a space for reflection? The structure of the "in-between," with its networks and infrastructures, is already here; how can it be used to question the methods of artmaking and curating? During a discussion between myself and Jean-Hubert Martin, by Catherine Francblin, I said that while we talk about multiculturalism we also talk too much about exhibitions. These become a strategy for demonstrating the importance of discovering new terms, new ideas, new modes of exhibition, but the artist is held hostage: he is invited to come, obligated to be satisfied with doing his work, but the central issue — creation itself — disappears. We have to revive the power of creation. The terms "residence," "resonance," and "resistance" address the artist and the artistic process.

HUO: *How do you view the question of exhibition in light of the explosion in the number of exhibitions? This necessarily leads to new situations.*

CZ: Too much energy has been devoted to the question of exhibition, and too many discussions — because exhibiting is envisioned as a system. As soon as something becomes a system, a formula, it's time to find something else. The show you organized with Hou Hanru, "Cities on the Move,"

was destabilizing, and I loved it, because it was transgressive in comparison to those shows that work within the art milieu. Exhibiting should not be a fixed structure, a frame; that's a constraint for the artist. On the other hand, exhibitions let us pose new questions. And the fact that they travel to different places leads to completely different situations.

HUO: *In fact the structure of that show evolved — it was an artwork in permanent evolution, a complex dynamic system.*

CZ: Synergy is the most interesting and important part of our understanding of artistic creation. It is located at the level of the encounter, the communication, the dialogue, between people and work. Synergy is a medical term, invoking the inherent energies that link and interconnect with each other within the organs of the body. This notion of a network of energies that only function together is becoming increasingly interesting.

HUO: *Your project of becoming a doctor — a view of your career as an endless journey, with exhibitions as one stage in it, it would illuminate this medical metaphor.*

CZ: I've considered myself a patient for the past twenty years. In China we say that an old patient can become a good doctor without having learned medicine. Given my own illness, I'm well placed to tackle this subject. The project of becoming a doctor returns to the question of knowing how to take advantage of all aspects of life itself, of my experiences. That is to say, I can no longer consciously separate life from art.

Every morning I take my medications, a process of which I am very conscious — which lets me keep a cool head and makes me less proud. Twenty years ago I would never have thought that being ill would be so important for me, in either my practice or my thinking. Now I'm developing this pro-

ject of becoming a doctor because I am a patient. And I ask myself, Why not make the process of healing a creative one? I'm going to take advantage of all these trips to see doctors, nonofficial doctors, sorcerers, etc.; I'm making my treatment part of an artistic process. The project of becoming a doctor would be a synthesis of my journey — my way of making art, and of living.

HUO: *It would be your grand project?*

CZ: It would certainly bring together all of my work.

HUO: *The only question I always come back to in my interviews is the question of unrealized projects. Please talk about your unrealized projects, whether concrete or utopian.*

CZ: My unrealized project is a dream to be realized in the future: it's definitely to be a doctor. I imagine a sign reading "Doctor Chen Zhen" in front of my Paris studio.

HUO: *There has come to be a great deal of discussion of "transculture," but I'd like to ask you also about the question of transdisciplinarity.*

CZ: I think it's an important point, since our lives today are so various, so uncertain. It's not just a question of movement; uncertainty imposes a perpetual questioning on everyone. In my own art, from the beginning of the 1990s to the present, my starting point is the Western world.

HUO: *What was your first show?*

CZ: It was arranged in 1990 by Hangar 028, a sort of organization, in Paris, that wanted to create a connection between artists and business. Unfortunately it has disappeared now, but back then they had rented a space on the rue de la Roquette. Ever since then I've been working with large installations. At the same time, I'm also thinking about urbanism and architecture, all

within the framework of a reflection on the connections between humanity, nature, and consumer society.

I've been talking about medicine; in the work I exhibited recently at the Venice Biennial, an example of synergy took place that I had not foreseen.[2]

HUO: *The public's participation in the work.*

CZ: Yes, that was a big surprise to me: visitors to the piece played an important role in it, to such an extent that I realized it would fail without their participation. Its meaning was revealed through the public. The piece confirmed the idea that transdisciplinarity can become an artwork. In order for the installation to be deployed in space, in order for the object to become an instrument, the public must play a role. Does the spectacle reveal its potential through the participation of the public? Could one create an independent video work by recording the public's interaction with the piece? We need a new series of questions like these to address the problematic of transdisciplinarity.

HUO: *Transdisciplinarity functions in relation not only to the artist but to the public.*

CZ: Exactly, it works in relation to the public's potential to interpret what it sees, what it touches. At an exhibition in Tel Aviv, people broke all the drumsticks, although they were oak — in fact a few of them were police batons! The public interprets in its own way. Interdisciplinarity is not simply different categories together, it's the rediscovery of a synergy that releases a kind of power.

HUO: *What installations are you working on currently, after the Tel Aviv and Venice Biennial shows?*

CZ: It's important to me to mount one or two large installations a year, whether they can travel or not. There's a space in Albi (in south-

ern France) called Cimaises et Portiques, it's not so well-known but it's great because it can be flooded — I plan to do something there. When I visited the space it was underwater — the installation, by Michel François, was floating, pressed up against the door! I loved that violence, the force of nature, and its combination with the idea of the artistic purification. I am going to do a large installation there to be called *Jardin Lavoir,* 2000 (Garden bath house). I'll have eleven beds (the number of human organs) transformed into large metal basins. There will be a washing system with a curtain of water running into each bed. I want to do the piece in this particular space because it has been flooded, even if it has been renovated since then. The project will clean the space as the water emerges from each basin. There will be water everywhere in the space, but of course it will drain out.

The second show will be in Turin, at the Galleria Civica d'Arte Moderna e Contemporanea. It will be called "*Éloge de la magie noire*" (In praise of black magic). I see black magic as nonofficial, nonrational, an underground force, an extraordinary energy, which, however, is always crushed by white magic. In fact it's analogous to the status of the artist. I am questioning the status of art, and the status of the artist as someone unofficial and always somewhat clandestine.

There'll be another show following the same logic in Zagreb. It will be called *Six roots.* Initially it was to be about the six stages of life, and about human behavior in Zagreb, one of the cradles of the conflict in the Balkans. It wasn't to repeat what I've already shown in Tel Aviv.

HUO: *Since I've known you, we've talked a lot about the idea of the book. What is your relation to books? They're like a medium for you, aren't they?*

CZ: Yes, the book is more than a medium: it's a glue, a joint, a vise, a cement. It holds pieces together, retains memory as a kind of architecture — although it's invisible in architecture, it holds everything. It's not just the foundation of a building but all of the building's joints.

HUO: *You play with books in your installations, but do they serve as a medium in any other way? You collect books, don't you? Books by artists?*

CZ: Yes, but not just art books, I also collect books from other disciplines — philosophy, sociology, aesthetics. Over the last ten years I've collected a fair number of books on architecture. Whenever I travel I bring back books on the culture of the country I've visited. They're the glue, or the building blocks, that will let me advance to another stage in my development. It's interesting to add one's drop of water to the ocean of books with another book.

There are two ways of making books: you can show what you've already done, which is a certain kind of catalogue, or you can make the book a space for debate. The messages and cultural references in an artist's work are always somewhat paradoxical and confused, and they're often misunderstood; there is a space that can be a place for debate, for discussion, and that space is the book. We've been talking about different categories and disciplines, but the book is a category and discipline in itself. We should benefit from the particularity of each discipline in creating an artwork in that form.

HUO: *This leads us to another medium you've used — the website.[3] You created a website when you returned to Shanghai, which was part of your work on that city's particular urbanism. I'm very interested in this research, and in your return to Shanghai.*

CZ: I went back there in 1993, for the first time after an eight-year absence.

HUO: *You're from Shanghai originally?*

CZ: Yes, and for me it's an extraordinary place — a huge laboratory, because it's a city of immigrants. Its history isn't that long, six or seven hundred years I think. My parents, for example, are not from Shanghai; nor are the parents of my wife, Xu Min. Everyone in Shanghai is an immigrant from China, and they live as if they were on a separate continent from the rest of China.

HUO: *So it's like a diaspora.*

CZ: Yes. The diaspora is a meeting place, and in this way I think Shanghai resembles other great metropolises like Paris and London. My Shanghai project is long-term — I'd like to go back there regularly to ask new questions and conduct a sort of social survey until the end of my life, in a way that would be similar to my project of becoming a doctor.

HUO: *To do that would be to become an urbanist. We might discuss the multiplication of roles.*

CZ: Yes. People may not have known about this kind of work, this very ambitious long-term project, until now. We could also talk about the two interpretations of slowness: either you slow down the moment or you accumulate many tiny moments about the same subject. Slowing things down is in my opinion a question of intensity, of depth — it's not just stopping everything in order to do one thing. Slowness for me is a profound process of excavating time. The urbanist project comes out of a study I did in Paris, "Paris Rive Gauche," which was well received; it was about the question of how to make architecture today, and the connections between architecture and contemporary art.

Everything moves every week in Shanghai, but the city doesn't know where it's going. There's no long-term urbanist strategy. This is what is extraordinary about Asian capitals — the total chaos. The big question there is how to catch up — but when you want to catch up with something, how do you view the process once you've done it? Perhaps this is the source of their energy. I'm interested in following the changes, the developments, the bustle of a city like Shanghai, through the continuity of a social investigation.

HUO: *Do you go back to Shanghai regularly to get images?*

CZ: This is part of my survey: I take notes, I take photographs of every kind, and now I've discovered a dozen mediums in which to record this social survey — drawings, video, interviews, and so on. If an investigation of Shanghai is to be successful it has to include interdisciplinary. I have friends over there who occupy important social positions now — directors, for example. It's extraordinary to be able to interview them. I'm going to take advantage of every trip to Shanghai to continue the project, but I don't know yet what it will become. The process is important in itself.

HUO: *Isn't that a very Buddhist idea?*

CZ: Buddha said, We do not know if today will be more or less important than tomorrow, but we know that tomorrow is another day. The core of Buddhism is the idea of stage after stage, moment after moment, the accumulation of every step, the accumulation of every energy, daily work.

Transcribed by Alexandre Pollazzon.

1. Foucault's phrase is "*la rupture des évidences.*"
2. Chen Zhen is referring to his viewer-interactive piece *Jue Chang — Fifty Strokes to Each*, 1998. The following description is taken from the Website of the Institute of Contemporary Art, Boston, which exhibited the work in the fall of 2002: *Jue Chang — Fifty Strokes to Each*, 1998 "deals metaphorically with the notion of conflict and misunderstanding among people in a general, global context. This percussionlike 'instrument' consists of more than one hundred chairs and beds that have been stretched with animal skins to produce makeshift drums. Visitors are encouraged to play the instrument using 'drum sticks' made out of police clubs, branches, wooden sticks, stones, and fragments of guns and ammunition." See www.icaboston.org/exhibits/chenzhen.cfm.
3. See http://www.shanghart.com/artists/chenzhen/default.htm.

The Resounding Silence:
Interview of Chen Zhen (2000)
Jérôme Sans

Jérôme Sans: *From the beginning your work has explored tensions between man and nature. At a time when nature in the city has become "conceptual," reduced to a few rare signs, this idea is more relevant than ever.*

Chen Zhen: When we speak of spirituality we tend to think immediately and too much about religion, but both nature and humanity have an undeniable spiritual strength. That strength is not an abstraction; it substantially influences the emotional and immune system of the human body. The German philosopher Meister Eckhart said, "The eternal body of men is imagination." So the "soul," or spiritual strength, of man is also the soul of art.

I have been committed to this sphere for a long time. In an interview with you in 1990 I was already locating the center of my practice in the relationship between humanity, nature, and a consumer society. This remains so ten years later, even as my preoccupations have enlarged. If I was dealing with nature in my work back then, it was to somehow confront it with our artificial, materialistic world. Over time, my personal investment in nature has grown. I consider it a therapeutic power, a balancing power of irrationality, with both critical and spiritual dimensions. I try to transfer its mythic synergy into my own body and soul, to borrow its strength for my work. My constant desire to put nature at the center of my practice allows me to renew this commitment.

In 1995, at the Galerie Ghislaine Hussenot (in Paris), I covered the space and a few objects with dirt to create a place of purification. In 1997, the *Fu Dao/Fu Dao Upside-Down Buddha — Arrival at Good Fortune* project, at the CCA in Kitakyushu, Japan, questioned the relationship between nature, the Buddhist tradition, and the fast-paced proliferation of consumer products in Asia. In 1998, in a study for Paris's Rive Gauche called "S'ancrer dans l'eau, la terre et évoluer dans l'espace-temps" (To anchor oneself in water and earth, and to evolve in space-time), I stressed our situation in the megalopolis, as

well as the relationship between the cycles of production and the cycles of nature. In 1999, my work *Fuir à l'anglaise?* (Sneak away?), in Breda, Holland, was an ironic response to an invitation to make art on a public dump 700 acres large and 160 feet deep. With the *Jardin Lavoir*, (Garden bath house) at the Cimaise et Portique art space in Albi (in 2000), I used water as a "healer" to cleanse not only everyday objects but also the space itself. All of these projects, made at various times and places, are tied to each other by a continuing awareness and spirit. It is what I call a "scattered slowdown," a process that accumulates different experiences of the same topic through time and space. This lets me to keep a number of works in process that I can revive at any moment, like a series of computer files that you can reactivate, update, and download.

JS: *For you the word "between" seems to me a strategy that lets you keep your goals unfixed and leave room for thought.*

CZ: Exactly. It is also a matter of attitude, a way of looking at the world. For me, the world is not an object. The Greeks were the first to seize on the concept of the object — they identified matter as an object. The Chinese way of thinking, by contrast, oscillates "between" objects and elements. As François Jullien has argued, this idea of the "nonobject" and "nonplace" describes the "fleeting, constant changeability of things, the transience and insubstantiality of existing things." For the Taoists, the void is precisely a question of "between." In this vision the world can be considered an "occasion" in space. Why not see art the same way?

JS: *In your* Jardin lavoir *installation, you say, you use water in its "purifying" dimension. Isn't purification a transverse phenomenon to your approach?*

CZ: We live in a world where cleanliness and dirt have lost their true, "original" meaning. The axis of modernity is stark cleanliness, everything always cleaner, so the natural process of accumulating dust is evacuated and erased — as if that were possible when dust is an invisible, inescapable, permanent rain. When I "purify" objects and places with mud, and sometimes, as in Albi, with water, I use elements that contrast with everyday industrial disinfectants; mud, for example, is considered "dirty." But these ele-

ments are natural, and can purify and disinfect our materialistic object culture and our artificial environment.

When I first visited Cimaise et Portique, the space was totally flooded. That was an art piece in itself, an unbelievable performance that gave me the inspiration for *Jardin Lavoir*. This purifying quality plays the role in my work not just of a targeted cure but of a personal daily shower for my body and soul, a kind of meditative refreshment.

JS: *In fact therapy and meditation are always at the center of your work, which functions as a kind of diagnostic system. Beyond your personal experience of fighting illness, isn't this a metaphor for art?*

CZ: Art needs new resistances today. The notion of resistance has always been at the heart of the great evolutions and revolutions of human history, whether they be political, social, scientific, or cultural. It is also an essential part of everyone's path through life. The problem today is that technology and capitalism have developed at such speed, and have become so irresistibly seductive, that we can't keep up. In the end we are little hangers-on to this reality. But resisting my illness every day for the last twenty years has given me energy, which has turned into a resistance that fuels my creativity. Cure, healing, therapy, meditation — these daily parts of my life have become a universe in which art and life fuse.

Thought and spirituality can influence and reinforce the immune system. According to the latest research into the issue of body and spirit, the immune system acts as a "second brain," a network of specialized cells that gives the body a flexible identity. This physical identity, tied to the nervous system, has become the most important factor in human health. Difficult emotions, like stress, can affect our health and body. If our brain can regulate some emotions, what agent will adjust the other ones, and the nervous system in particular? Buddhism gives us an extraordinary opening here, because its objective is to transform perception and experience as well as to synchronize soul and body through "attention meditation." A constant but invisible substance can produce incredible miracles in life, so why not in art? Rather than any religious or nostalgic

ideas, this is the basis for my desire to "exploit" my personal experiences by transposing them into a reflection on art. In this approach, you cannot perceive either history or art history the same way. Art is not limited to being a conceptual issue, it is a life experience. Imagination is not a factory but a kind of laboratory. When one's own body becomes a kind of laboratory, a source of imagination and experiment, the process of life transforms itself into art.

JS: *The incarnation of abstract ideas in physical and visual form is a very delicate matter. If most artists work by visualizing their concepts or conceptualizing their experiences, what is your approach? What is the relationship between what you might call a particular experience and the plastic means you gather in your use of familiar objects and materials?*

CZ: The book *Transexpériences*, published by the Kitakyushu CCA, contains a long conversation I had with an old friend from Shanghai. In that conversation I discussed the concept of "transexperience," which I had developed for the occasion; I wanted to stress the importance of multiple experiences, the idea that art should no longer be dominated by the concept but by the experience of movement in space and time. Over the last three decades artists have often worked from a certain concept, which they distribute and develop wherever they are invited to exhibit. What interests me, though, is that while traveling, while being challenged by different contexts, in these intermediary spaces, I am fed by new concepts and ideas. It is the water strategy: water runs everywhere and nowhere. Lacking its own shape, it is shaped by circumstances; it is supple, flexible, transparent, changing, moving, penetrating, circulating. It is also a glue, the perfect joint for holding together the continents. Experience, or transexperience, is like water, at any moment allowing the creation of new situations, different ways of thinking. It is a free zone that prevents us from falling into rigidity and system. It is a way to refuse to be satisfied, like the waves that wrinkle the ocean's surface without troubling the depths below. The power of water lies in its volume; a man's depth is the richness of his experience. The nub of all this is freedom. I want to keep

concept from overshadowing experience, art, and life. The link between my experience and my work is simply transformation, which has no borders or limits. It can be both conceptual and material. Keeping your mind as free as water lets you turn any material to use. I am not afraid of using common objects; on the contrary, they allow me to send messages capable of reaching a larger number of people.

JS: *Is this the reason why beds and chairs, for both adults and children, often appear in your installations?*

CZ: The beds, like the chairs or any of the other objects that I divert and transform, are things that accompany life. Making an adult's hospital bed into a crib, another bed into a drum, a lotto box, a washtub — all of these transformations are triggered by their different contexts, and play with the context's history. It is the meeting with and experience of a new space that shape my ideas. This is why neither the object nor the way I transform it can become a "style."

JS: *In your installation in Albi, beds became a resting place for the human body and soul while objects turned into interior organs of the body. Meanwhile the center of the space became a real garden, and the water a part of the River Tarn. But even though everything was transformed, everything also kept its original identity, as if the work dealt with mirrors reflecting their relationship with men. Is this the soul that speaks?*

CZ: Yes. It is the process of art itself. The transformation takes place in three successive stages: study problems, formulate questions, and develop your imagination.

JS: *Why do your installations so often take the shape of paths of initiation?*

CZ: Isn't life itself like a chain of paths of initiation? My way of life today, being always between two countries, two invitations to exhibit, two stays somewhere, is a kind of "chain residence." I want to use this way of life as a new structure, an exceptionally flexible and open one. Living by challenging yourself allows you another perspective on life, another approach to art. Little by little, this chain of experiences in different contexts triggers productive short-circuits between places and myself as well as

between my different projects. There is no unique concept linking all of these stories; it is the thread of life that creates a logic.

JS: Six Roots, *created at The Museum of Contemporary Art in Zagreb, suggests the various stages of life: six rooms, six essential stages. Could you clarify this notion, which is borrowed from Buddhism? What do you mean by it?*

CZ: The Buddhists use the idea of "six roots" to describe the basic senses of the body: sight (the eye), hearing (the ear), smell (the nose), taste (the tongue), touch (the body), and knowing (consciousness). These essential human capacities link and reflect our various behaviors and thoughts. They also vary with age and personality. Borrowing this theme allowed me to reflect on the "six stages of life," which involve contradictory human behaviors. In Buddhism, these six evolutionary human functions can bring either the best things or the worst.

JS: *How did you integrate the context, the local, in Zagreb? How did you stand in relation to the specific context of the Balkans?*

CZ: Nothing happens by accident: it was when I visited the MoCA space in Zagreb, with its six rooms linked by doors, that I thought of this code. On the other hand, the space's human dimension made me think of a series of organs — a body in six parts, a life in six stages. When I was actually working on the project, though, I felt the need to find something more refined. *Six Roots* clarified my thinking perfectly: a physical space imposed its physical proportion and number. A historical place (the Balkans) convinced me to pursue particular questions, like the meaning of the body, the behavior of men, and the circle of life.

JS: Jue Chang — Fifty Strokes to Each *was initially created for the Tel Aviv Museum of Art — that is, for a context known for historical conflict. (It was later exhibited at the 48th Venice Biennial, in 1999.) The work doesn't seem to have any immediate links to the context in question, but it ends up making an extraordinarily deep examination of the historical stake in the Middle East. The political and social dimension is rarely explicit in your work — how do you deal with these parameters?*

CZ: Indirect language has a special strength that goes farther into human consciousness than simple

images created for the senses. I prefer the "second layer," the powerfully effective layer behind the visual, to the "power of images" strategy, which was born from the vocabulary of the media (television, advertising) and has become popular in art, as can be seen in many exhibitions. I prefer a way of creating a "visual and conceptual trap" in relation to what we see. In other words, the physical reality of the work in space is not the only thing that matters for the eye and for one's emotional response; we look for something more, something that touches our stomach, our digestion, our nervous system, our soul, something that triggers an "immune vibration."

A Chinese proverb speaks of "the sound away from the string" of a musical instrument. I would add to that, "The shape away from the visual." This is where we find the double transformation I've been talking about: the transformation of the artist in relationship to the creation of the work of art, and the transformation of the spectator in relationship to the perception of the work of art. This "sound away from the string," this "shape away from the visual," allows viewers to make their own transformation, in a sort of prolongation of the creative act. I am particularly interested in this possibility of developing the involvement of the viewer. That is why I like misunderstanding, which is something quite far from the three Western esthetic functions defined by Ananda Coomaraswamy: "denotation," "connotation," and "implication," which respectively correspond to recognition, interpretation, and understanding.

JS: *We've been talking here about two exhibitions, one from the west (Albi) and one from the east (Zagreb). Doesn't this in itself reveal what you call "transexperiences?" In other words, do you always try to link different contexts through experiences?*

CZ: I have always been looking for an irrational conducting thread, without theory, structure, or system, that would allow me to travel the world freely, position myself in these displacements, and identify with the other. The term "transexperience" summarizes my way of living and artmaking fairly accurately. We all have in us this transexperience, this real potential.

JS: *When you speak of the importance of experience as an artistic process, how do you approach*

the various contexts that you traverse, from Japan to Johannesburg, from Tel Aviv to El Salvador, via North America and Europe? You are invited to exhibit worldwide; how do you imagine the continuity of a practice, and the diversity of sources of inspiration, in a world where globalization and decentralization are more and more dominant?

CZ: After ten years of mostly seeing exhibitions in a Western context, and after moving from a marginal position to the "center," I am currently exploring "remarginalization." The idea of "Residence, Resonance, Resistance" (R-R-R), which has grown out of my experiences of the last few years, asserts some positions that I would like to develop. "Reside," anchor yourself in a variety of cultural contexts; "resonate," dialogue with "local" cultures; "resist," dilute the monocultural influence of the West on your mind. Of course these are ways to widen one's field of inspiration, but they mostly reflect a desire to make one's activity more and more dense, an activity based on the human and on experience. It is not a matter of managing or reacting to the travel that arises out of invitations to exhibit. It is more like the will to give priority to the "marginal" invitations, or to make this type of invitation happen throughout the world. I try to slow down the pace of my exhibitions and to take more and more time to accommodate long stays on different continents. I want to continue to learn. Globalization cannot involve an attitude of one-way expansion, it should be a mutual penetration. Otherwise everyone loses.

JS: *Given the fast pace of the shows in which you are invited to participate, how do you imagine getting mental rest and the renewal of your energy?*

CZ: In China twenty years ago, when I was very ill, people used to ask me, "How will you come back on top and show your will?" Your question goes in the opposite direction. I have kept the same mindset, I have not changed. The Chinese remember two ideas in the face of change or movement: "Ten thousand changes do not transform the essence of things," and "Before ten thousand changes, don't change." I may have a special advantage in that my illness wakes me up every morning only to situate me in a resounding silence.

2000

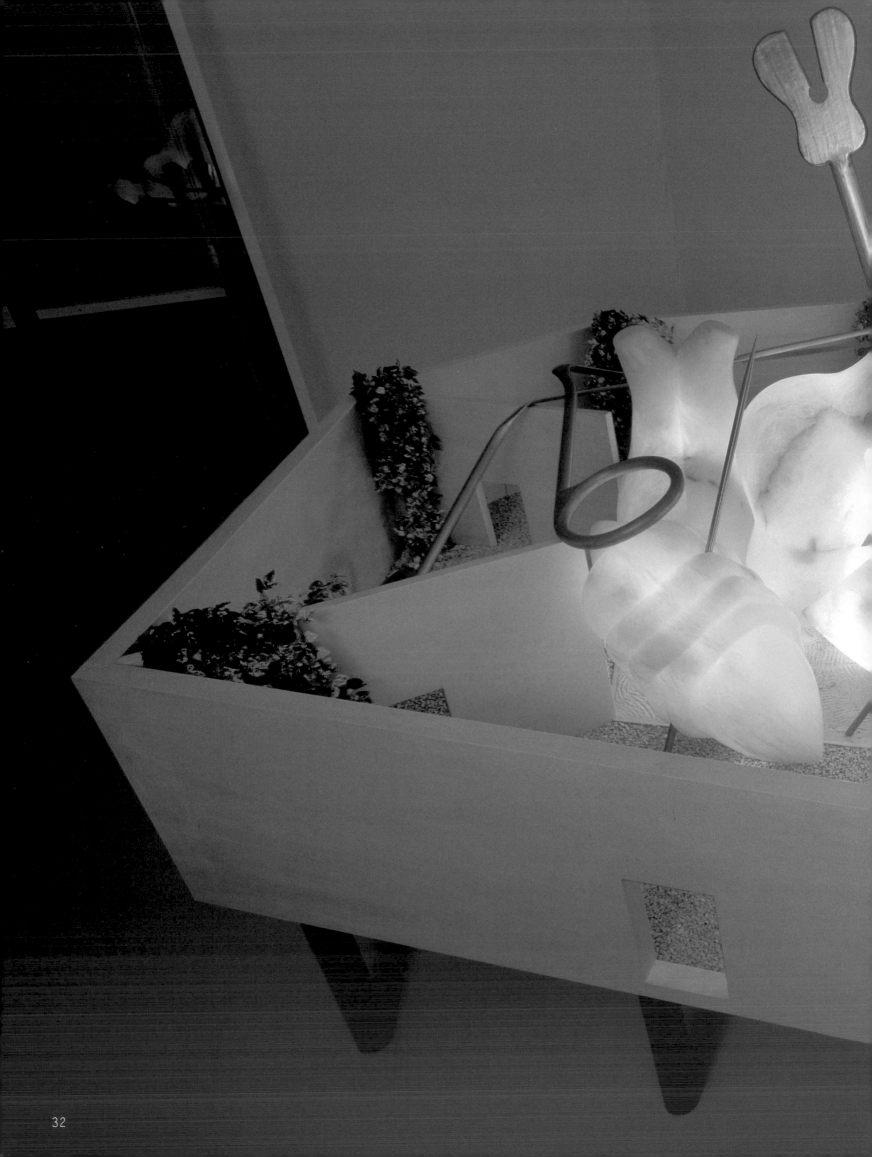

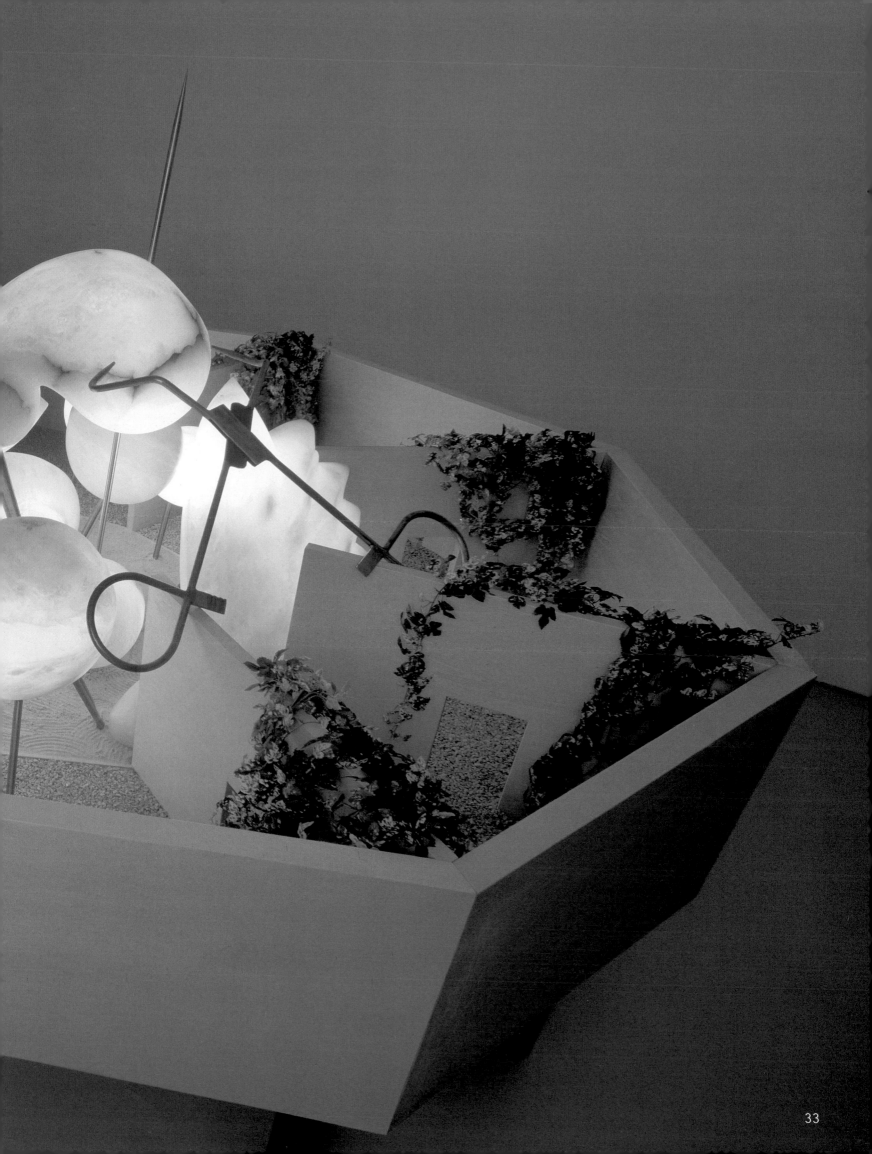

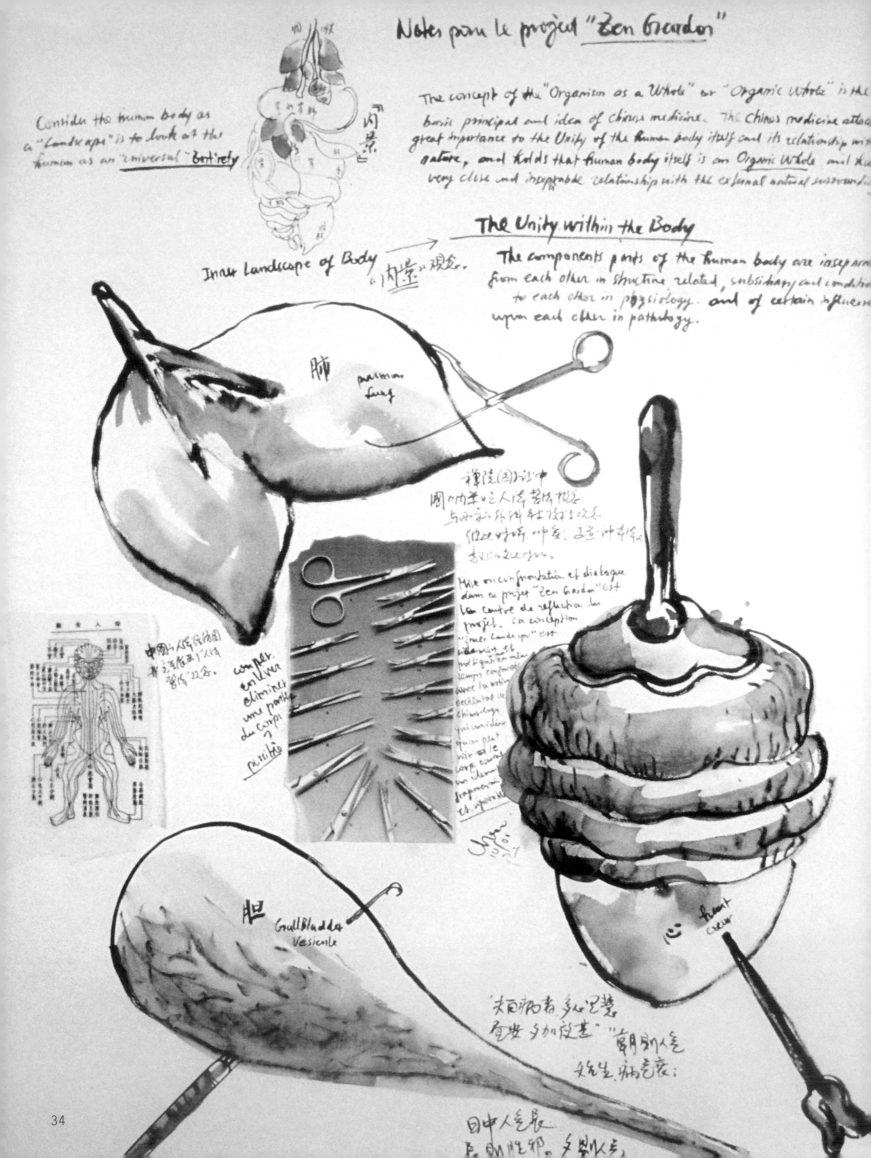

Notes pour le projet "Zen Garden"

Consider the human body as a "Landscape" is to look at the human as an "universal" Entirety

The concept of the "Organism as a Whole" or "Organic Whole" is the basic principal and idea of chinese medicine. The Chinese medicine attach great importance to the Unity of the human body itself and its relationship with nature, and holds that human body itself is an Organic Whole and the very close and inseparable relationship with the external natural surroundi...

Inner landscape of Body → "内景"观念.

The Unity within the Body

The components parts of the human body are inseparable from each other in structure related, subsidiary and condition to each other in physiology. and of certain influence upon each other in pathology.

内景

肺
pulmonary lung

中国的人体经络图和古代西方的"22经.

complet. enliver eliminer une partie du corps y possible

禅境(园)设计中
国的中医学把人体看成统一体
与周边环境相互联系从整体
从观点对待,即景.是一个不可侵
犯的不能分割的.

Mise en confrontation et dialogue dans ce projet "Zen Garden" est le centre de réflexion du projet. La conception "Inner Landscape" est évidement multiquérien en même temps confronter avec la nature occidental en chinalogie qui considère qui un peut avec elle corps comme un élément fragmentaire et séparé.

胆 GullBladder
Vesicule

心 heart
cœur

"关有病者, 多如已楚
急发 多加攻慧" "朝别人全
先生, 病气衰:

日中人气长
長, 即肚卵, 夕则水气,

34

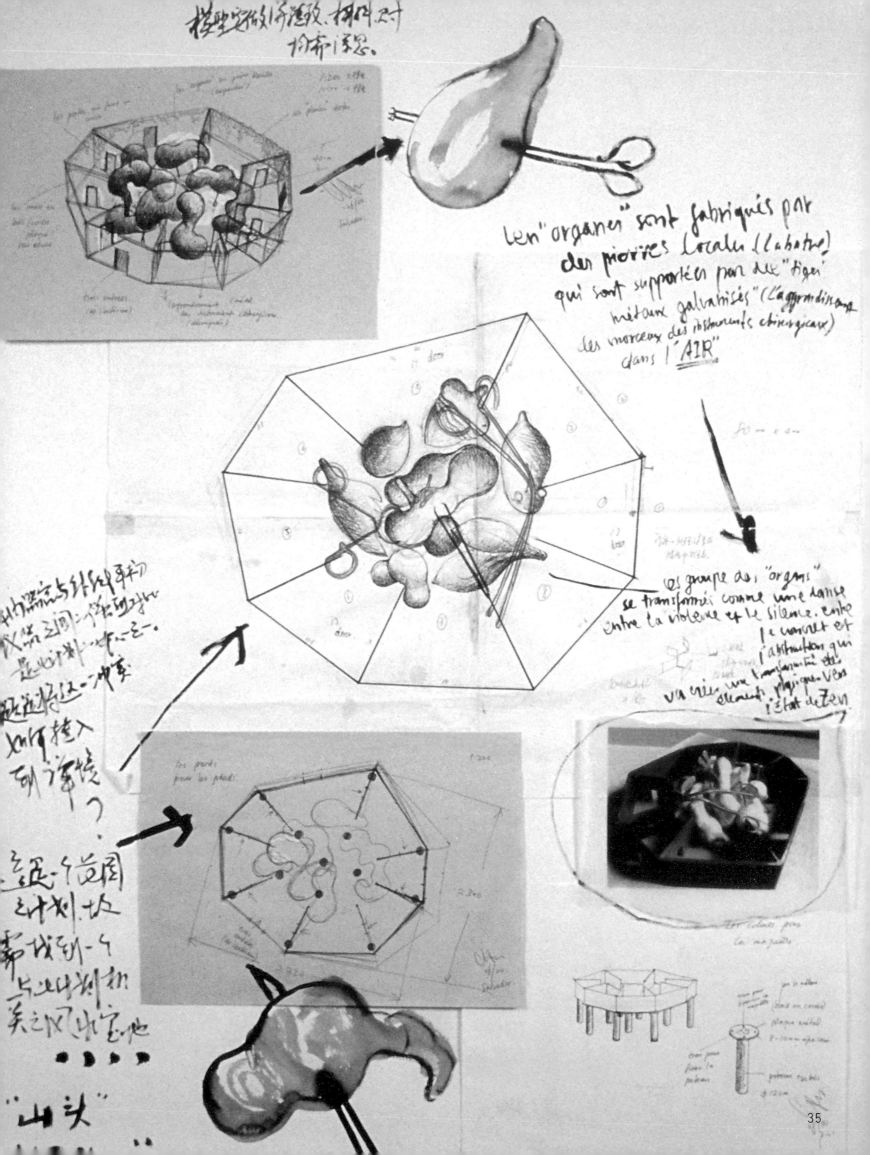

楼型穿孔引布透致、材料对
挎布i祭。

Len "organes" sont fabriqués par
des pierres locales (l'abatre)
qui sont supportées par des "tiges"
métaux galvanisés" (L'aggrandissant
les morceaux des instruments chirurgicaux)
dans l'__AIR__

es groupe des "organs"
se transformés comme une danse
entre la violence et le silence. entre
le concret et
l'abstraction qui
va créer une transformité des
éléments physiques vers
l'état de Zen

材料流与结构事料
收缩空间一坐生间该好
是必须料一沈一些。

这也将这一冲室

X种把入
到了环境
？

延一个范围
之计划、坊
希找到一个
与此计划机
美之风中宜也

● ● ● ●

"山头"

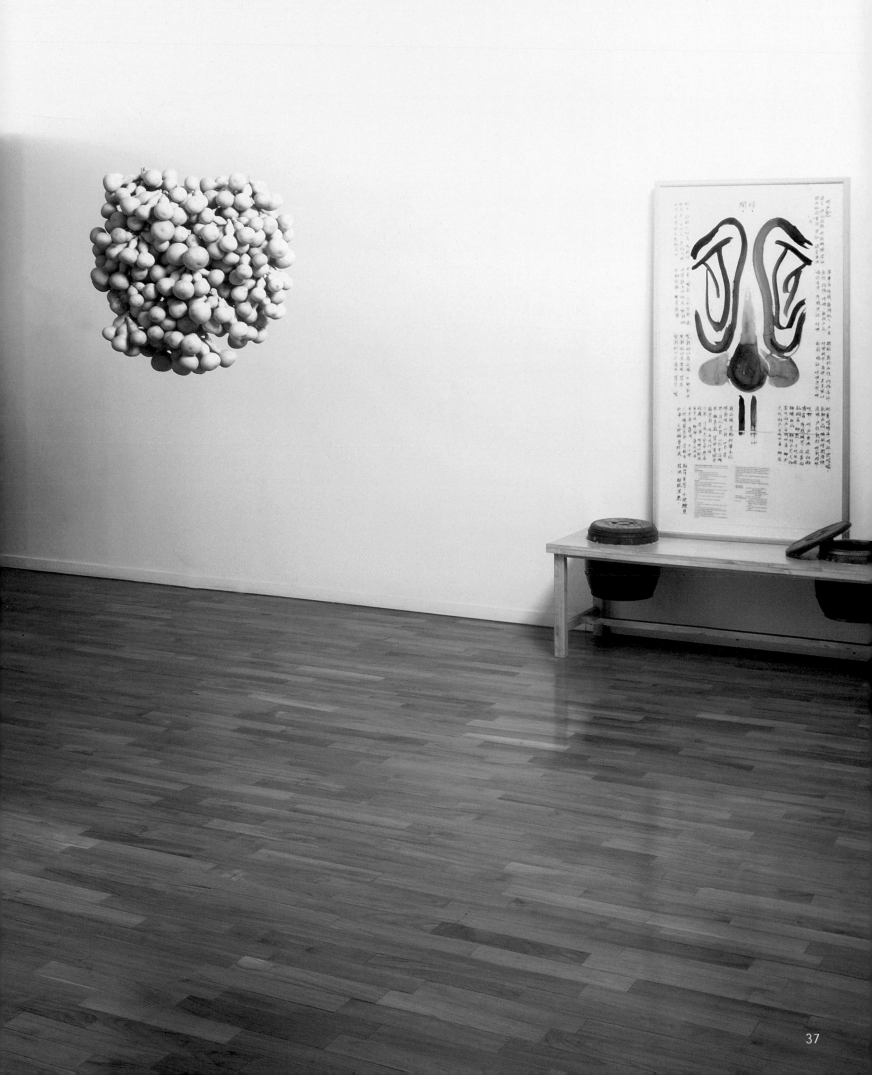

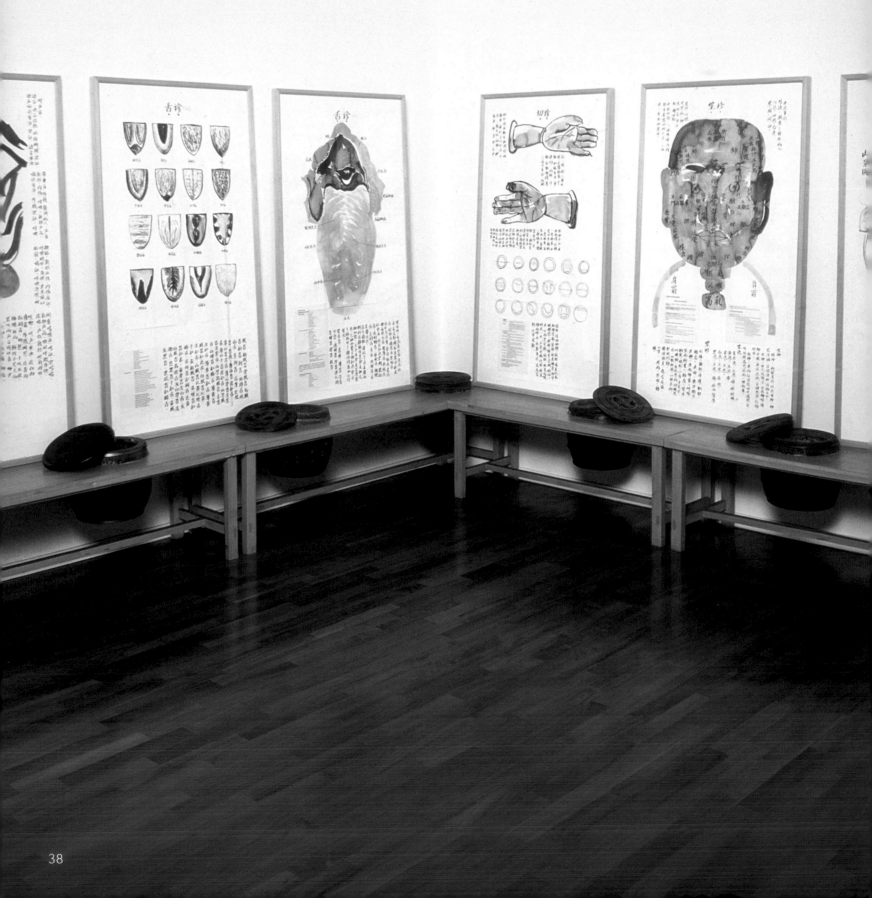

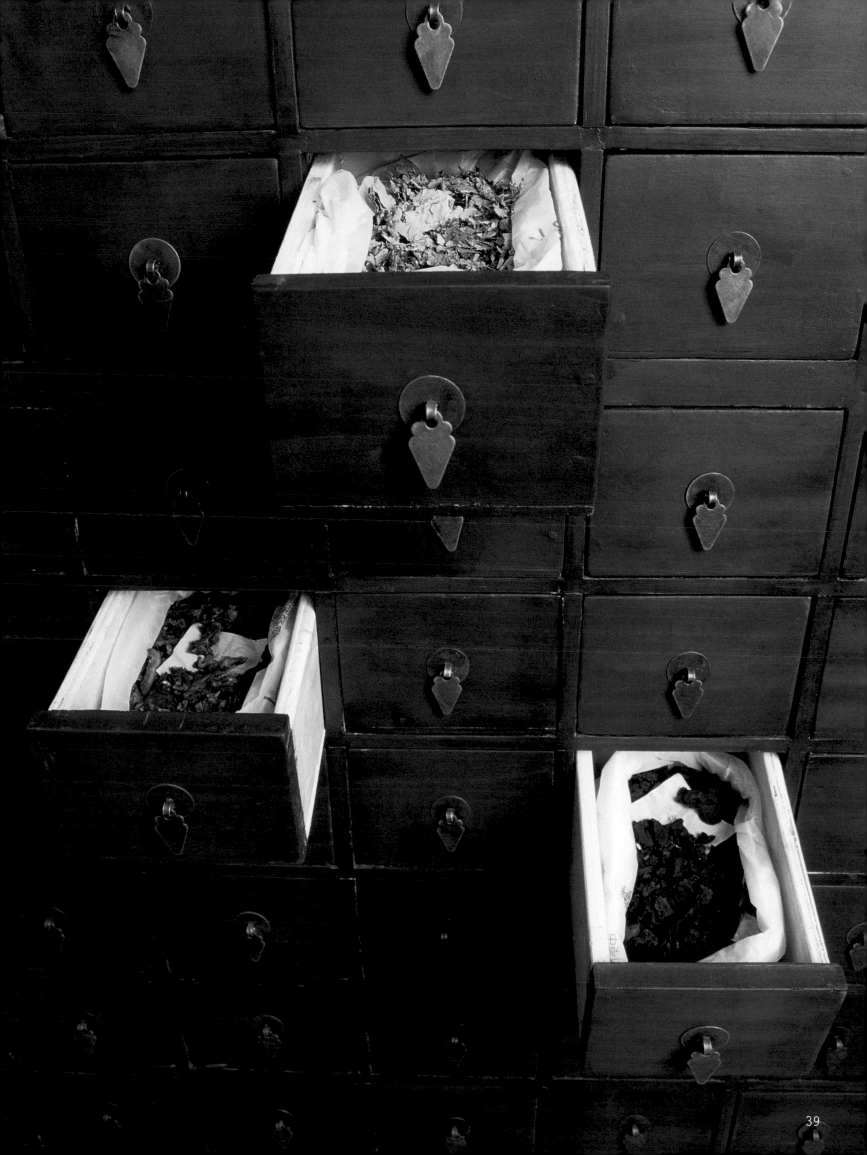

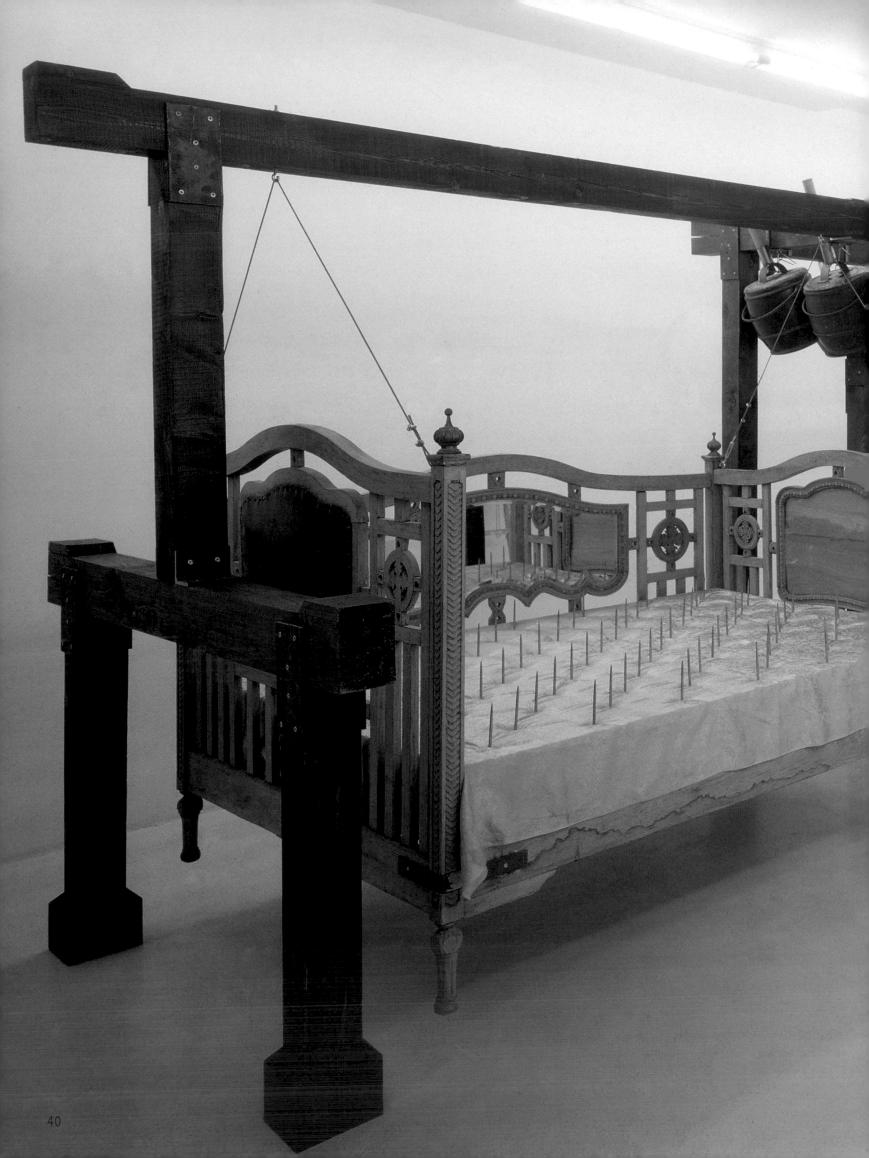

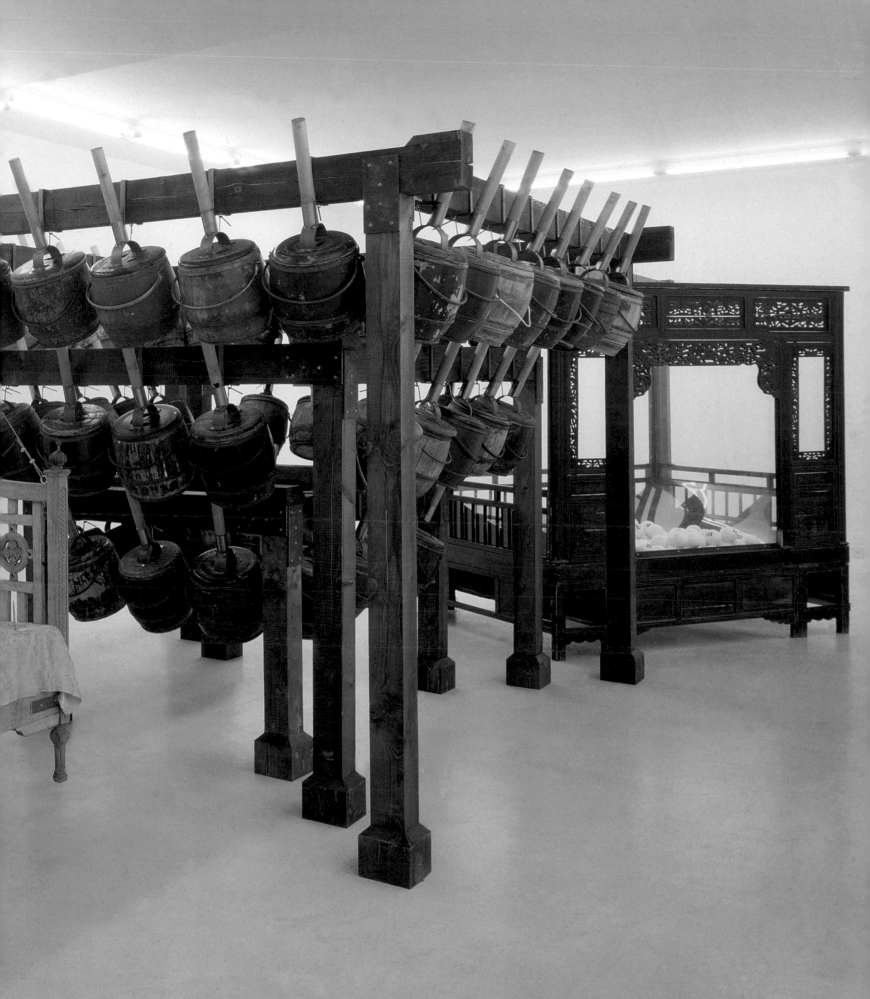

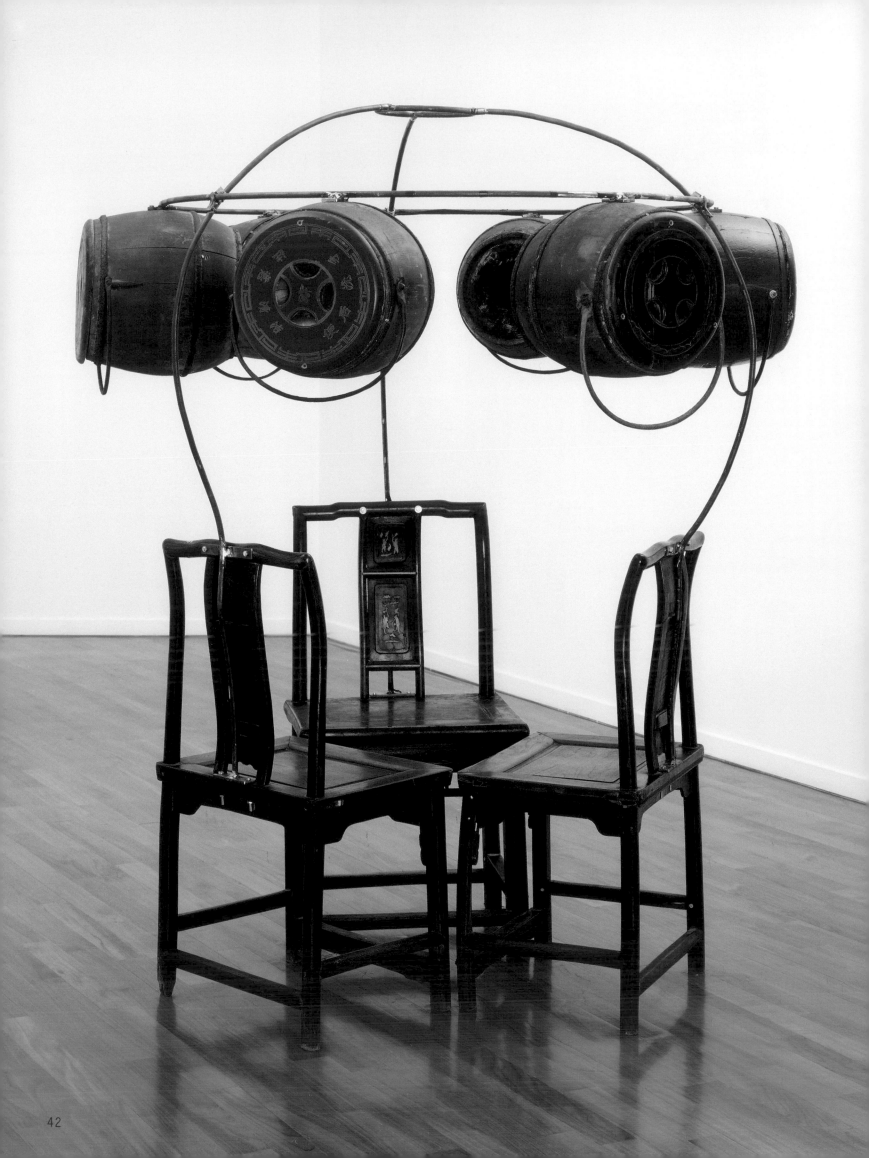

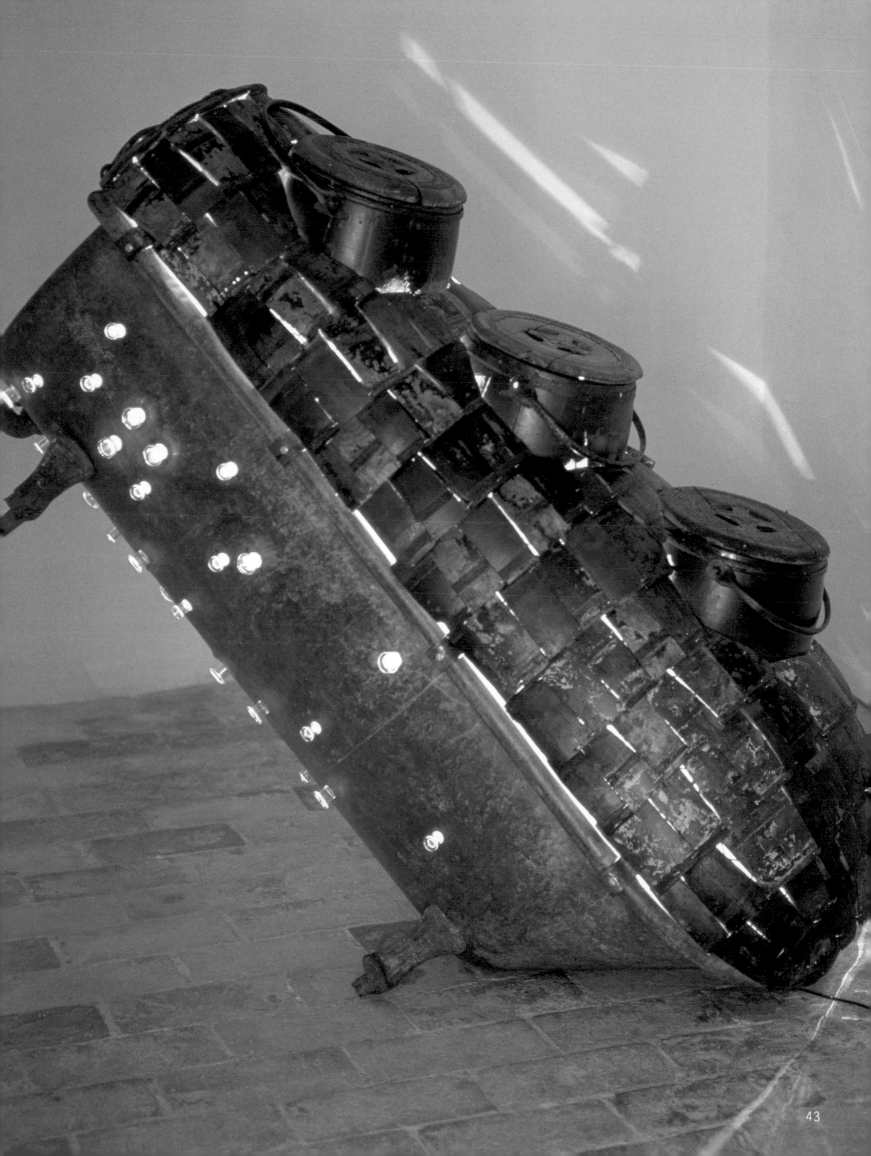

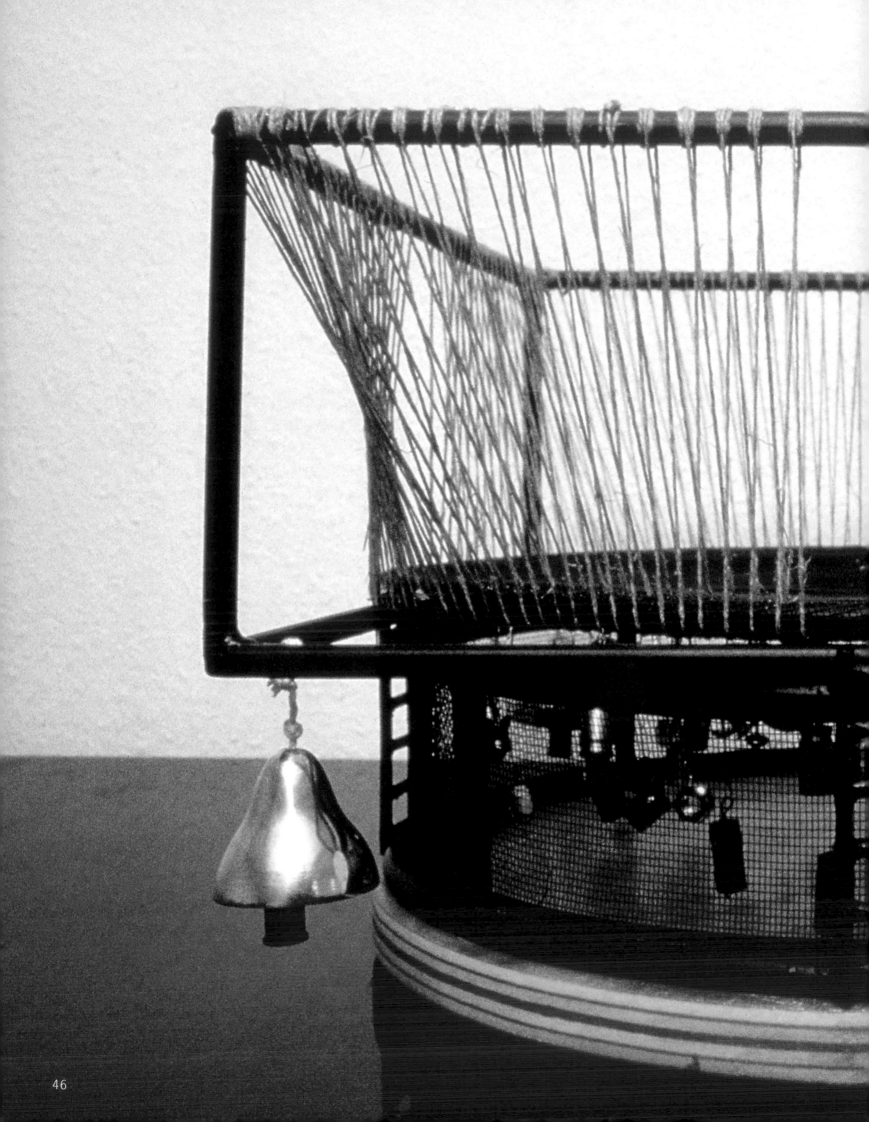

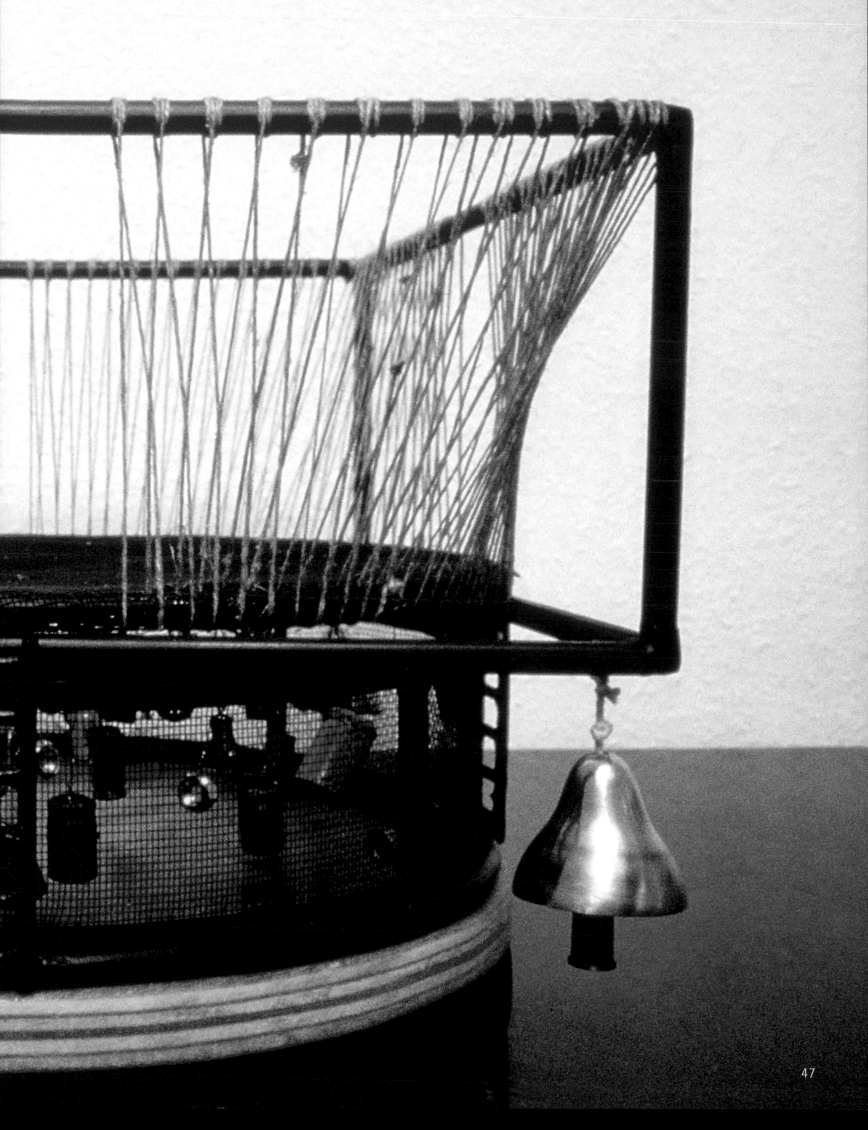

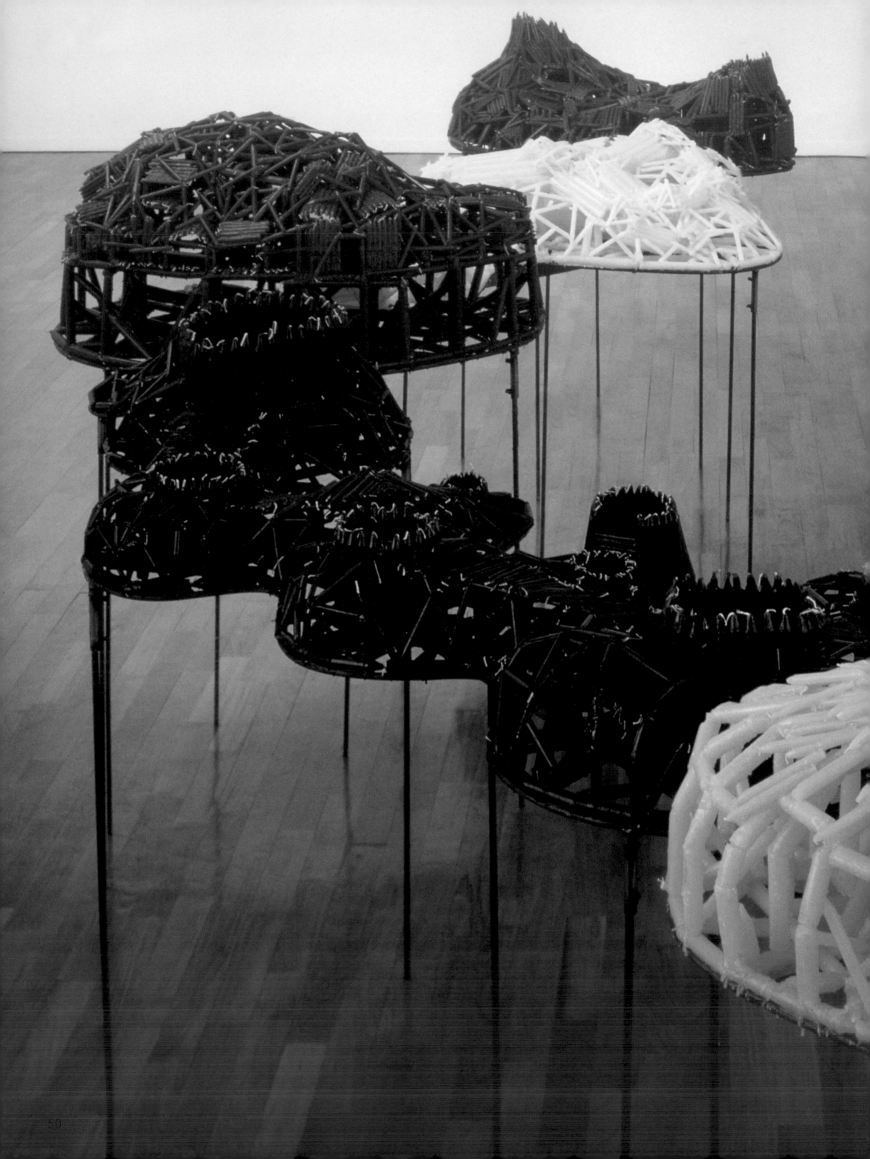

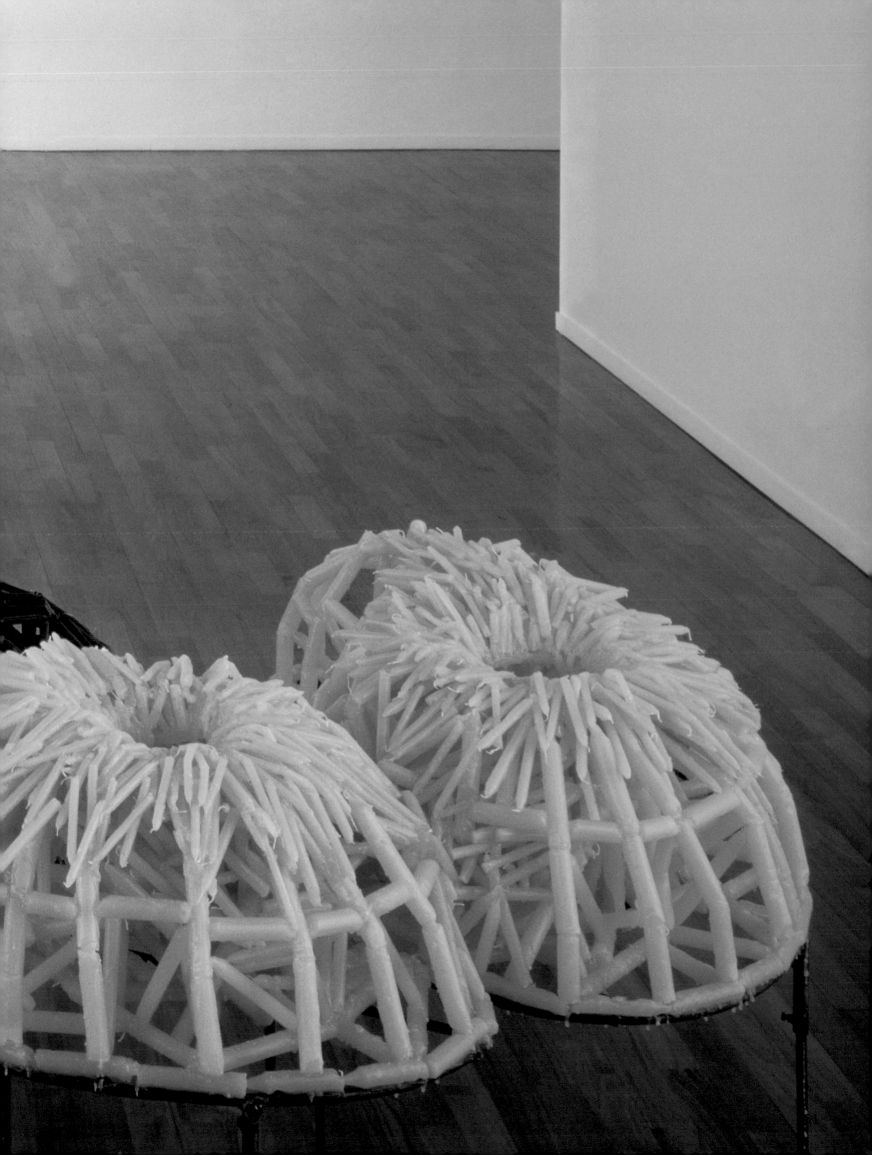

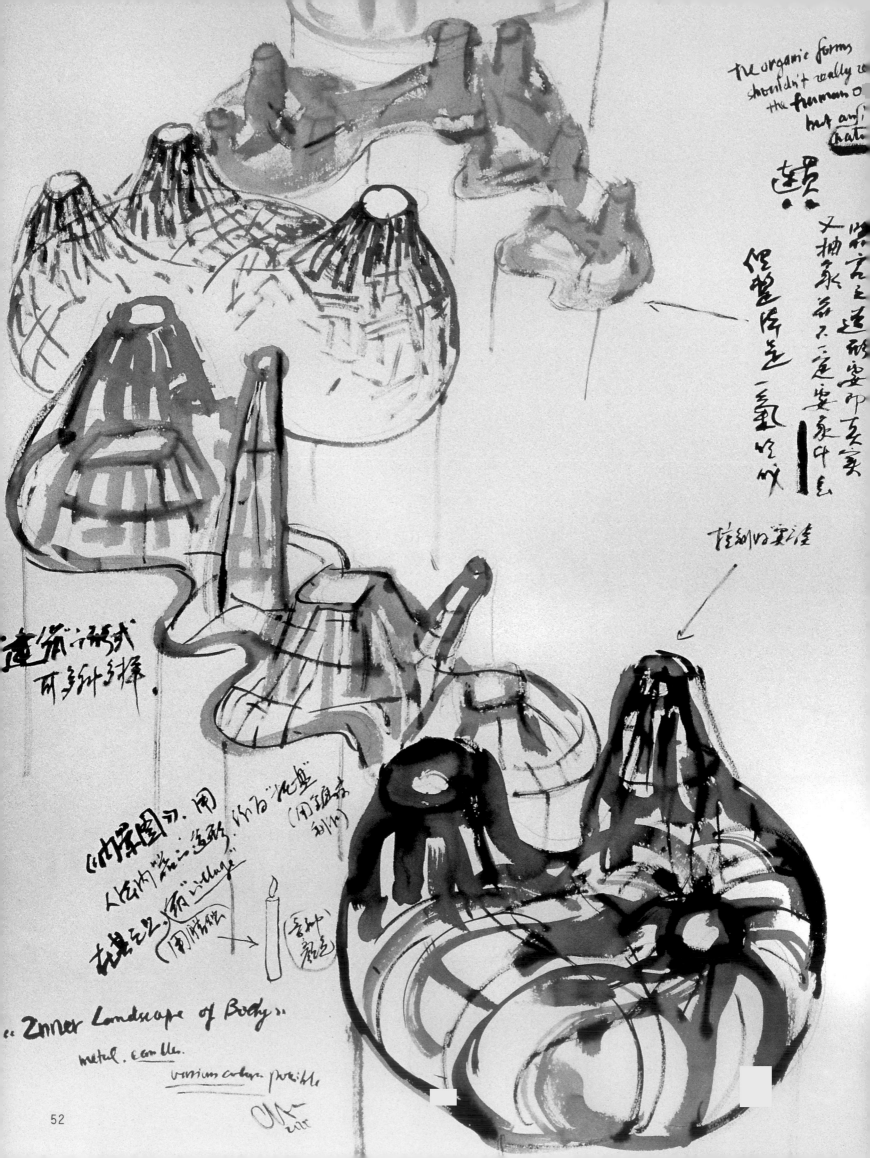

the organic forms
shouldn't really [...]
the [...] O
but [...]
[...]

蓮
藕

紫[...]之造形[...]印[...]
又抽象又不[...]
[...]
但[...]一[...]

[...]实[...]

達[...]的形式
可多[...]

(地[...]图)[...]用
人[...]内[...]的[...]
[...]村 village
[...](用[...])
→

"Inner Landscape of Body"

metal. candles.

various colour possible

52

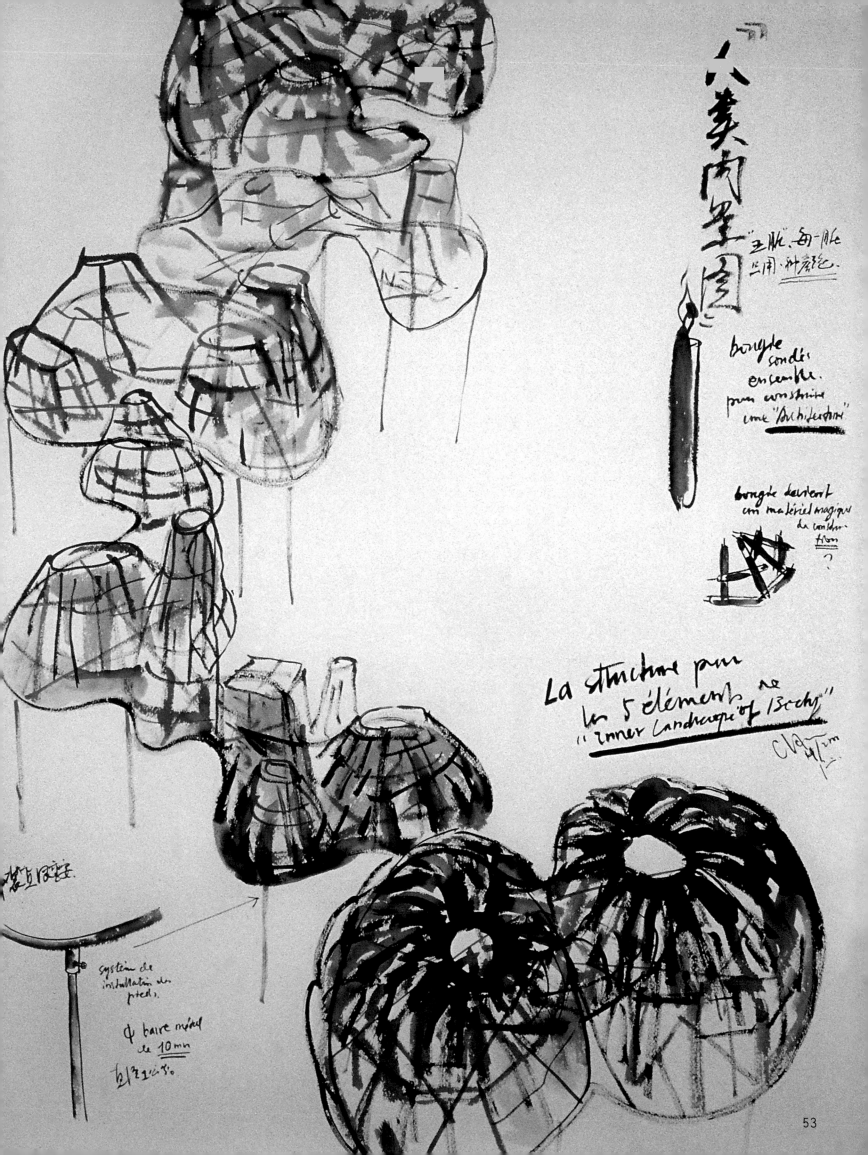

六美肉墨圖

"王肌. 每一肌
"出月. 科崔屹.

bougie
sondés
ensemble
pour construire
une "Architecture"

bougie devient
un matériel magique
de construction ?

La structure pour
les 5 éléments de
"Inner Landscape of Bach"

system de
installation des
pieds.

φ barre métal
de 10 mn

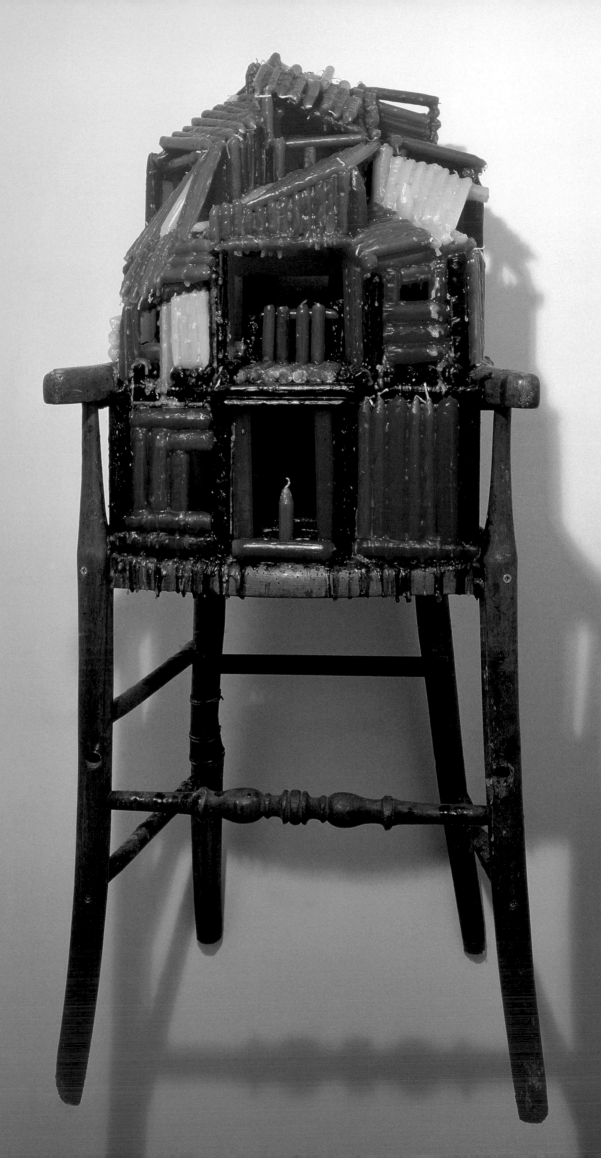

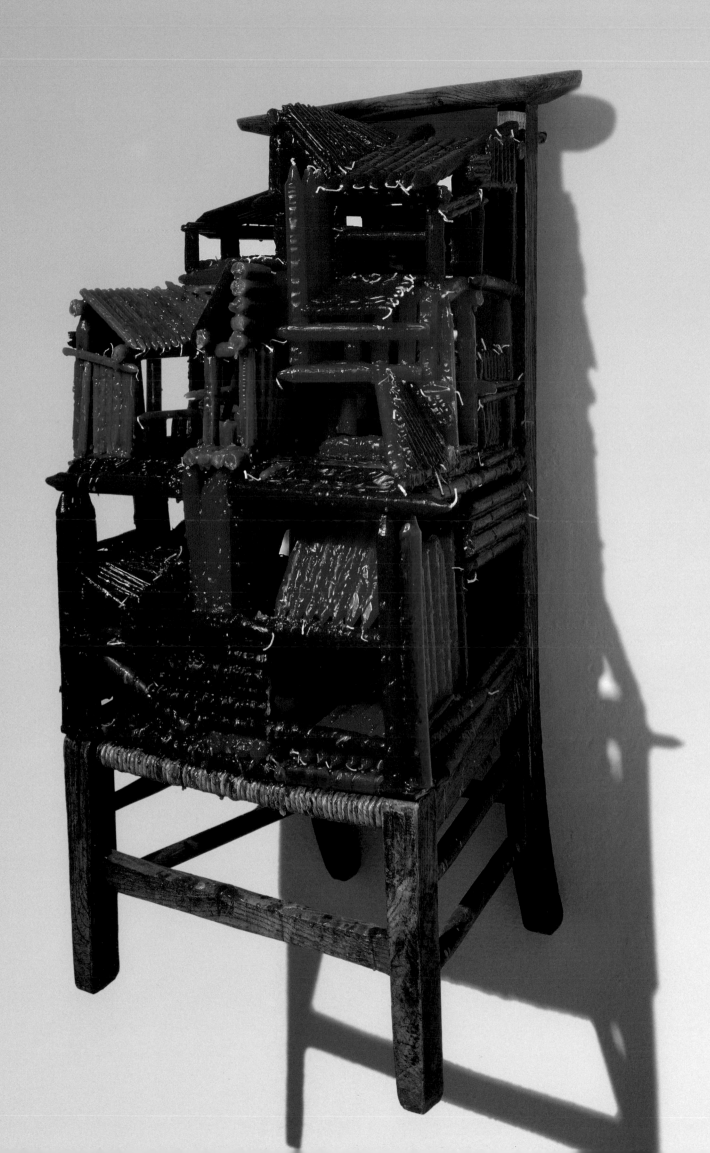

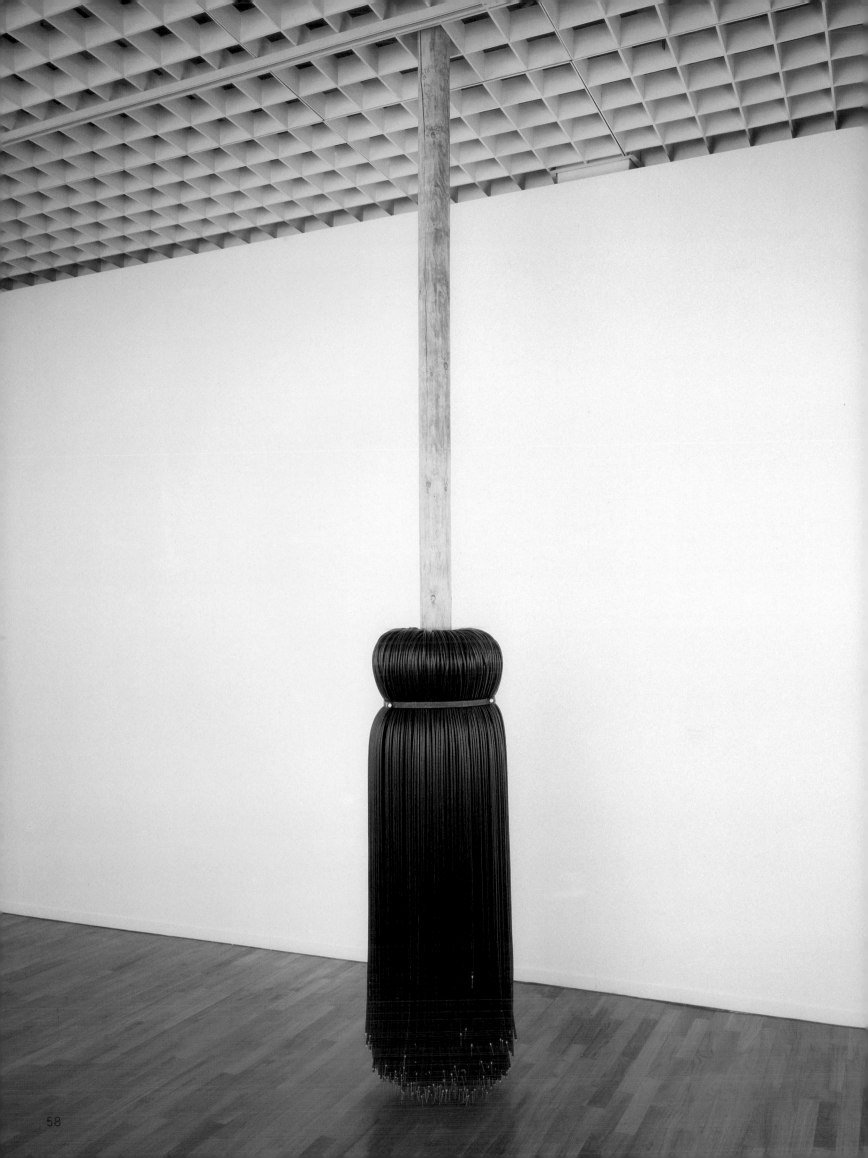

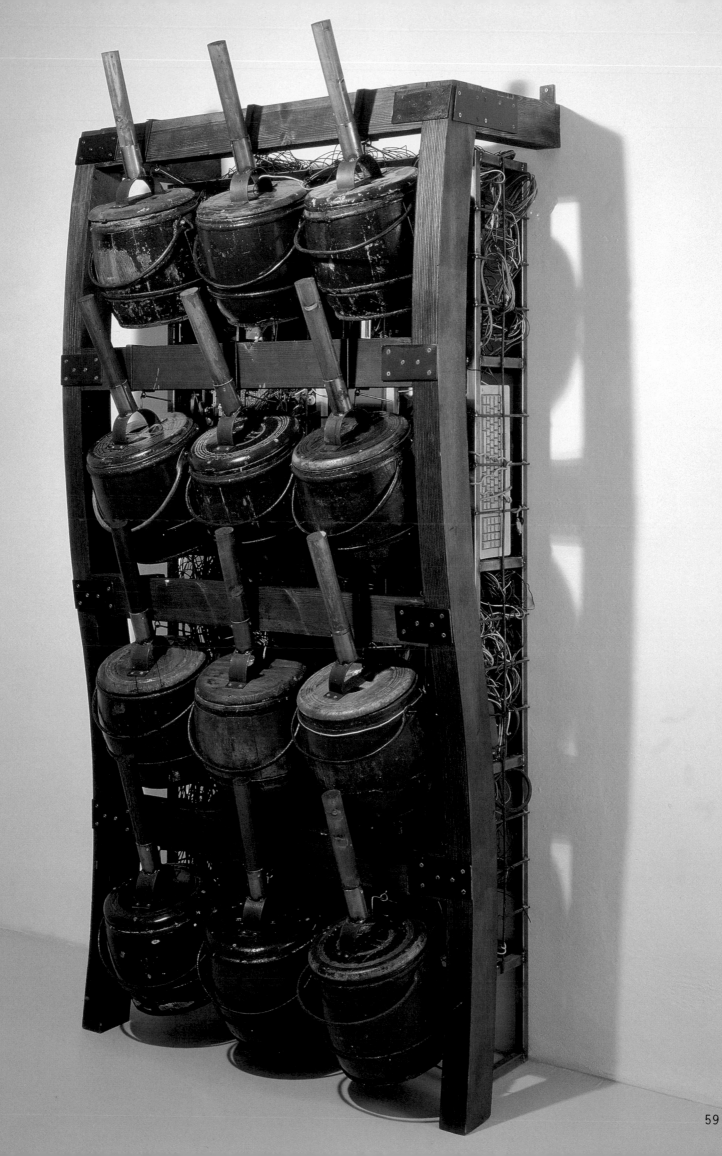

59

analysis of inner
landscapes

medical notes

[signature] 2010.

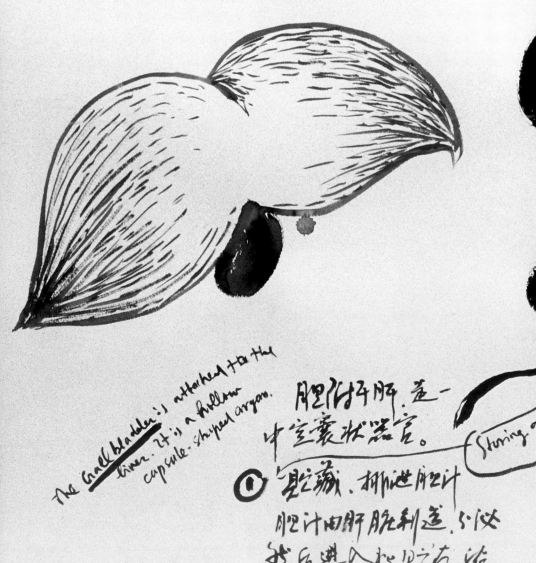

The upper part of
the large intestine
is connected to
the small intestine
and the
lower part of the anus.
Its main physiological function
is to pass and eliminate waste, ie.

大肠上接小肠下接肛
门. 其主要生理功能传送传导
糟粕. "大肠者
传导之官, 变化出焉"

The small bladder is attached to the
liver. It is a hollow
capsule-shaped organ.

Having something to do with or
courage in making decisions.

胆附于肝. 是一
中空囊状器官.

① 贮藏. 排泄胆汁
胆汁由肝脏制造. 分泌
然后进入胆贮存. 浓
缩. 并通过肝的疏
泄作用注入十腾…

Storing and excreting
bile

② 主决断
"胆者. 中正之官. 决断出焉"
中医对胆主. 善恐.
失眠. 多梦等神志
病变. 常从胆论治.

62

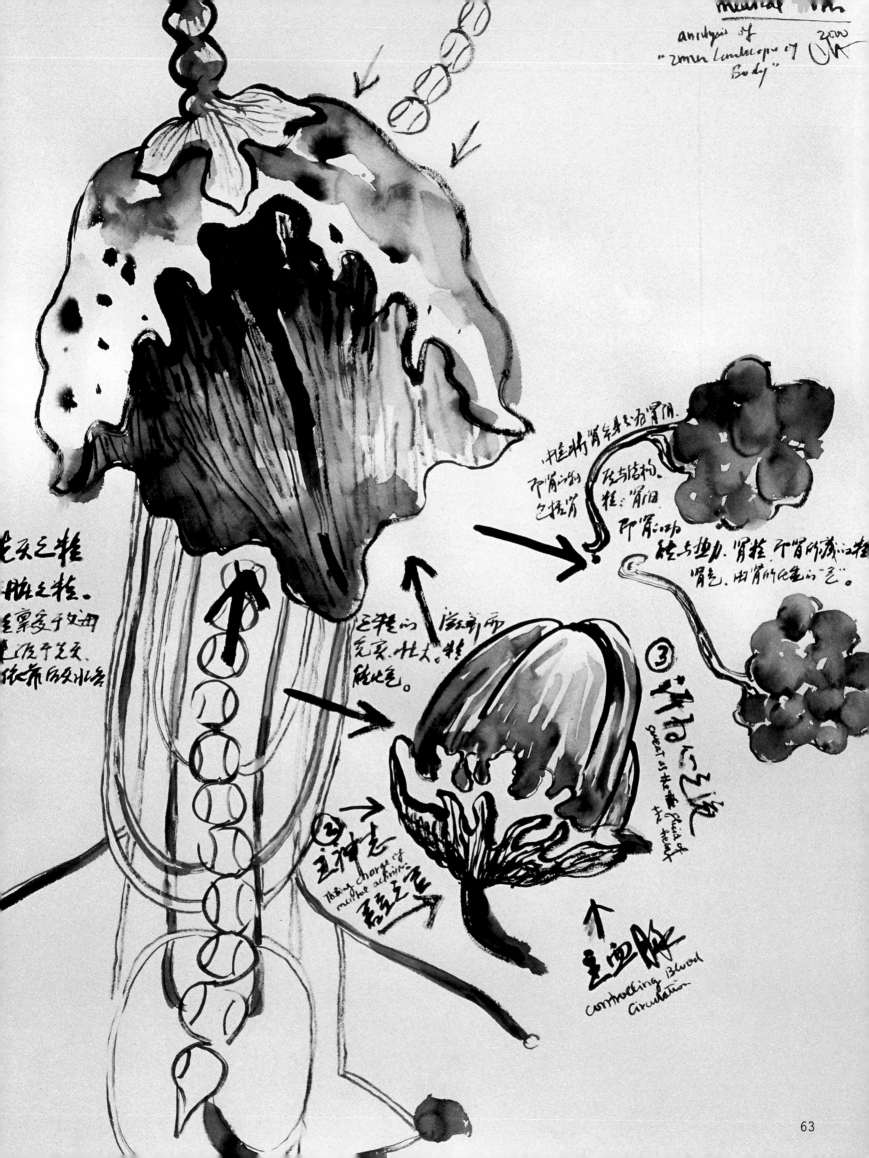

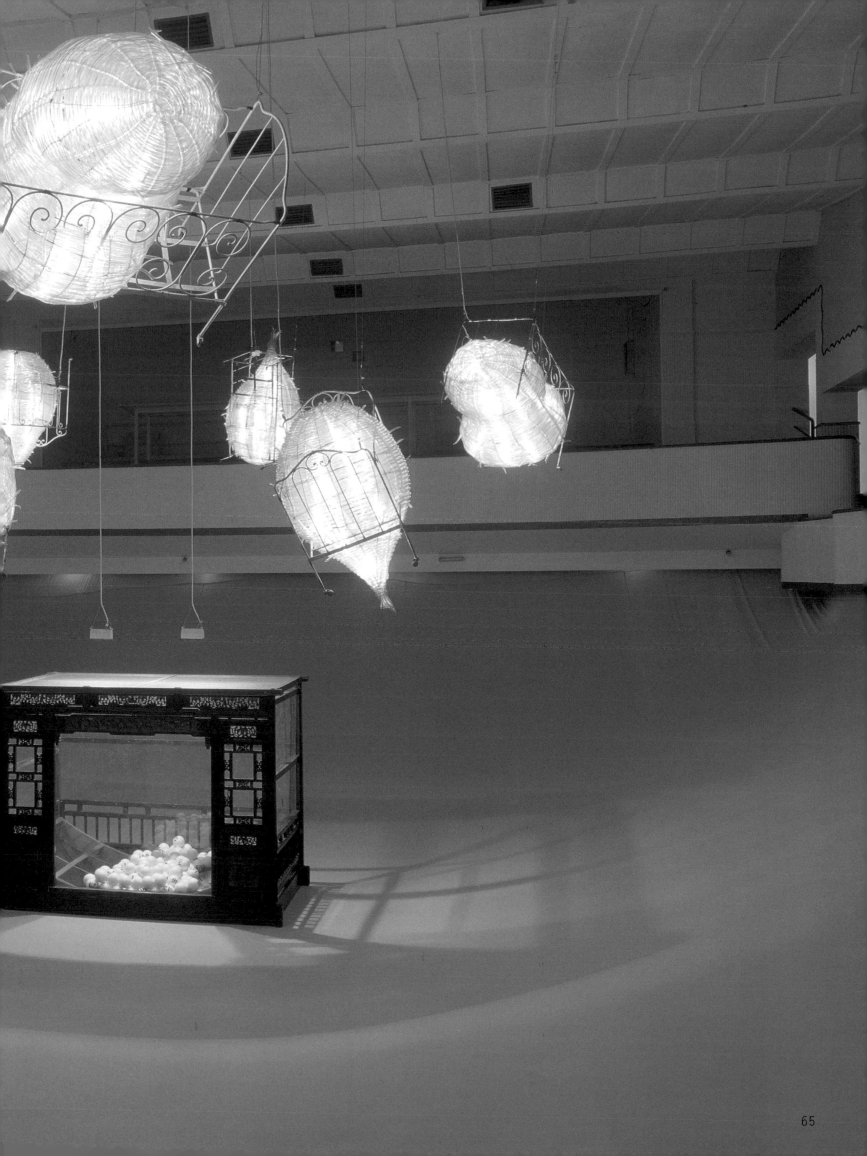

Φ9mm

适用透明塑料管。
tube plastique transparente, q
da

les positions
sont différentes
d'un à l'autre.

7 lits.
发了几件.
七八接用?

66

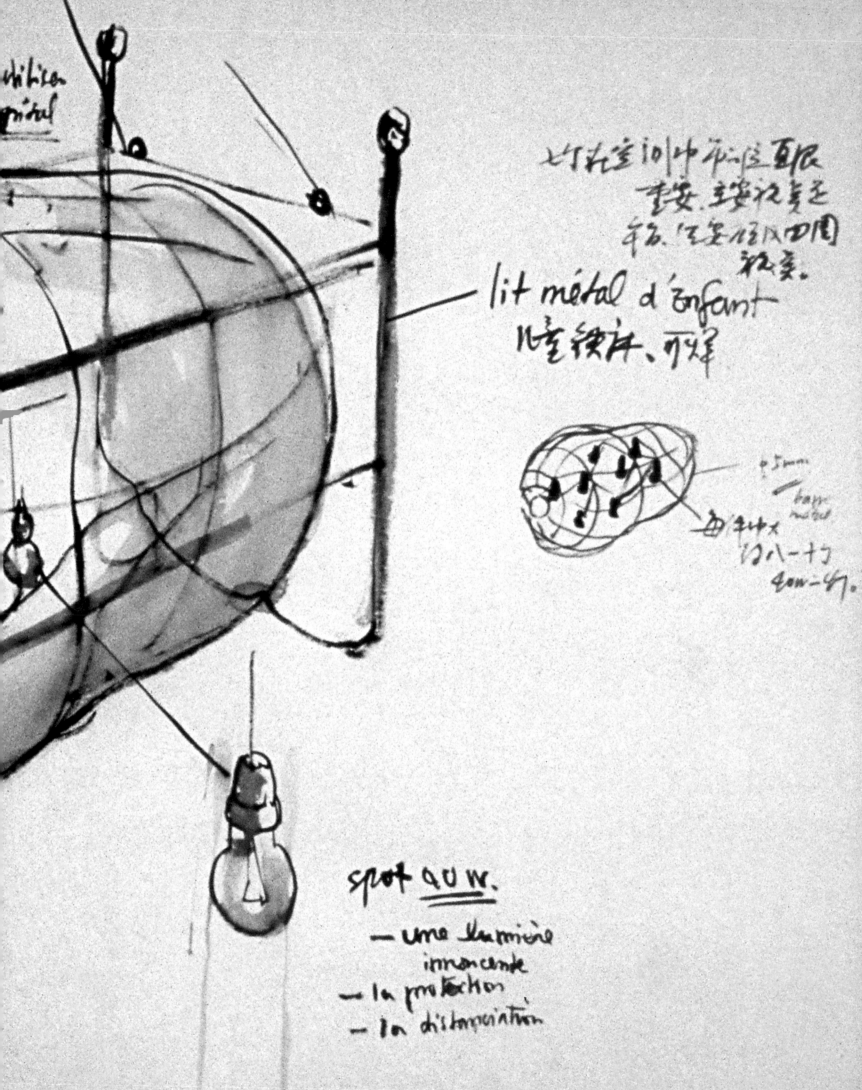

utilisa
pirul

比礼室10中平座取限
要安. 主要礼吉王
平五. 飞室13从四周
祝客.

lit métal d'enfant
陸室線序、可焊

φ3mm
tape
rebut
曲径44×
10八一寸
4m-4寸.

spot 40 w.

— une lumière
innocente
— la protection
— la dissémination

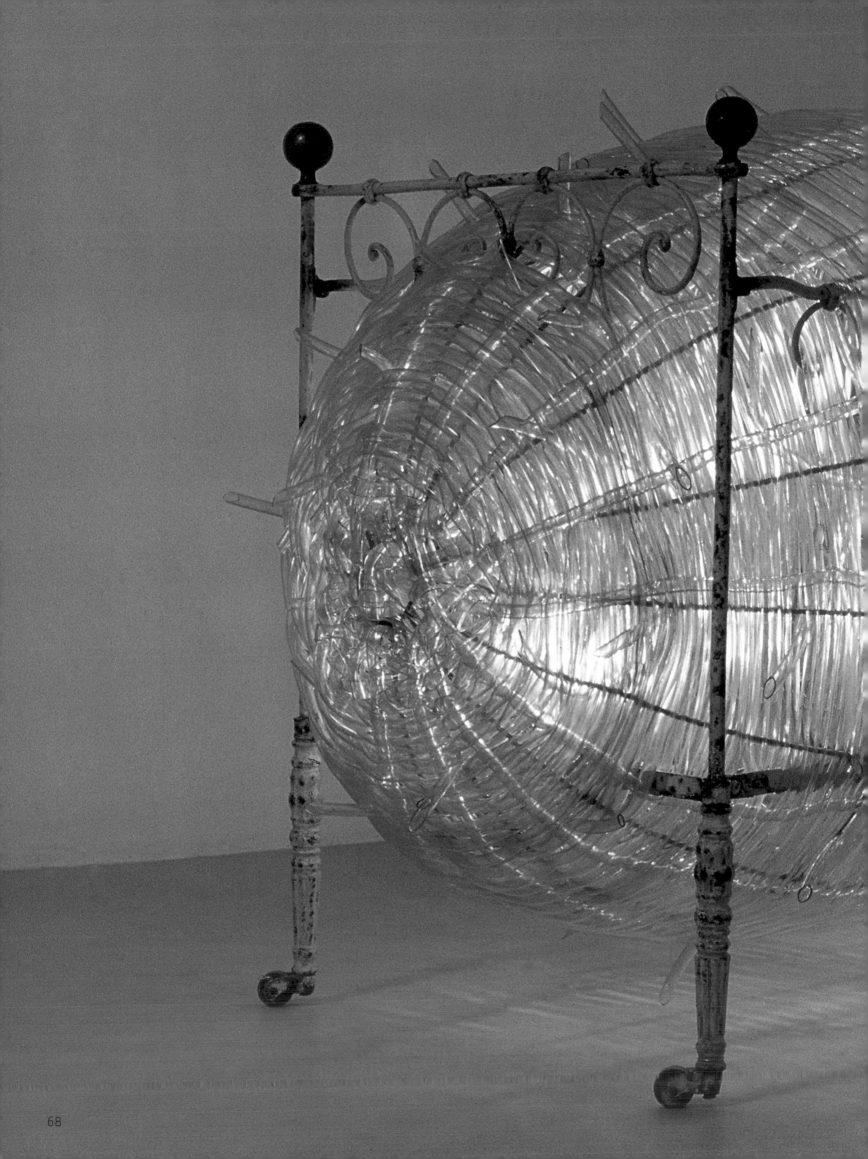

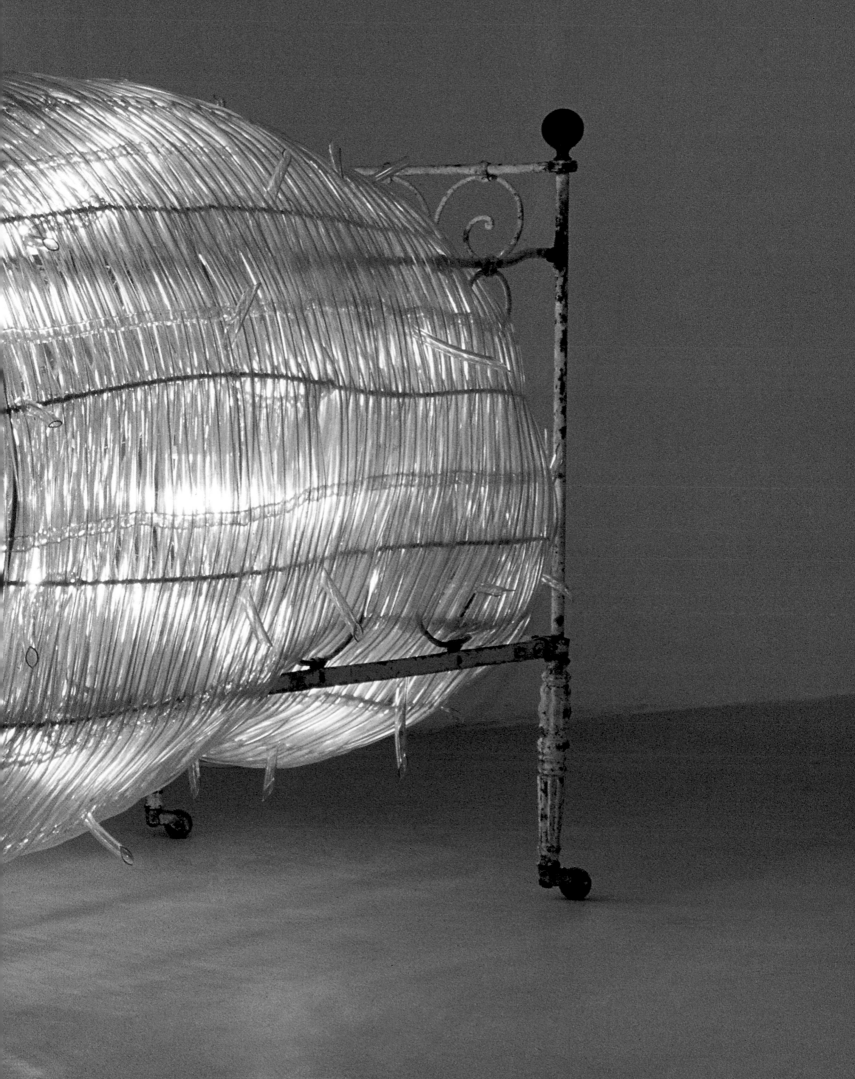

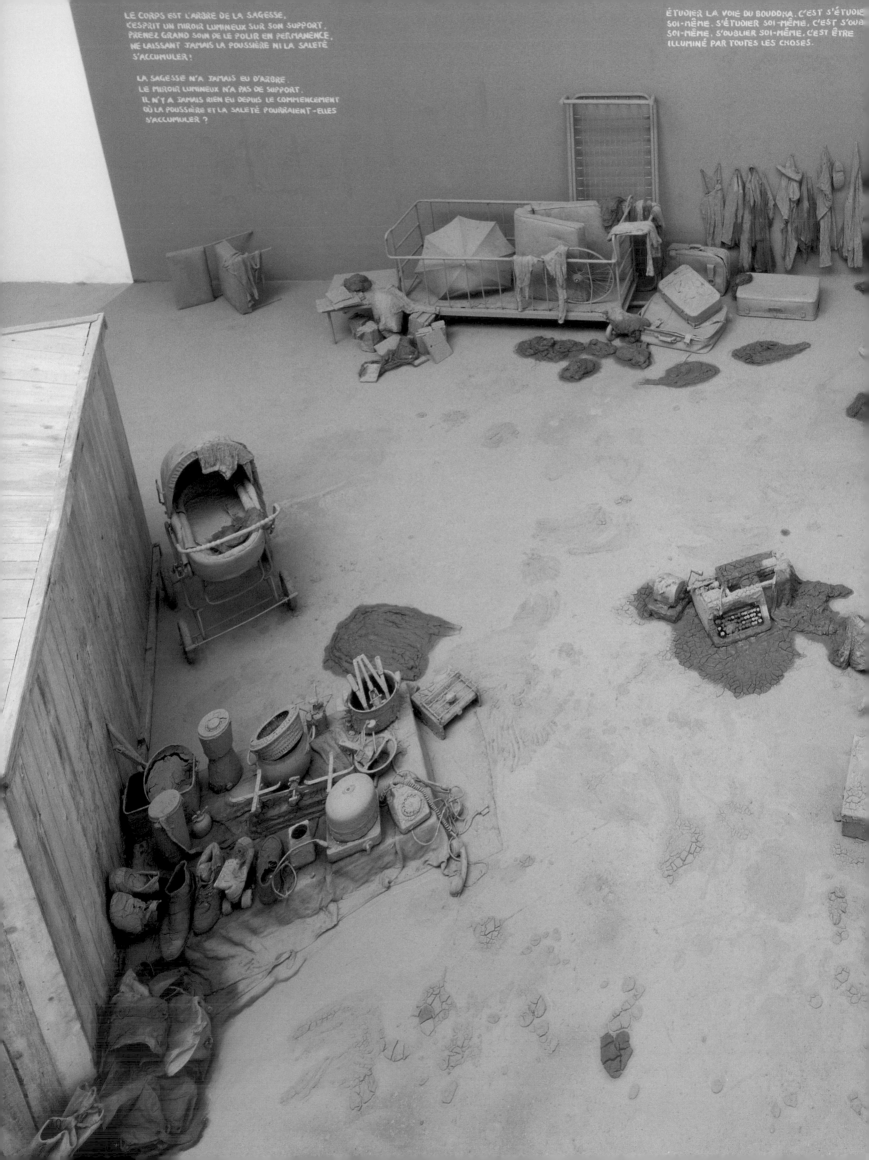

LE CORPS EST L'ARBRE DE LA SAGESSE,
L'ESPRIT UN MIROIR LUMINEUX SUR SON SUPPORT.
PRENEZ GRAND SOIN DE LE POLIR EN PERMANENCE,
NE LAISSANT JAMAIS LA POUSSIÈRE NI LA SALETÉ
S'ACCUMULER!

LA SAGESSE N'A JAMAIS EU D'ARBRE
LE MIROIR LUMINEUX N'A PAS DE SUPPORT.
IL N'Y A JAMAIS RIEN EU DEPUIS LE COMMENCEMENT
OÙ LA POUSSIÈRE ET LA SALETÉ POURRAIENT-ELLES
S'ACCUMULER?

ÉTUDIER LA VOIE DU BOUDDHA, C'EST S'ÉTUDIER
SOI-MÊME. S'ÉTUDIER SOI-MÊME, C'EST S'OUB
SOI-MÊME. S'OUBLIER SOI-MÊME, C'EST ÊTRE
ILLUMINÉ PAR TOUTES LES CHOSES.

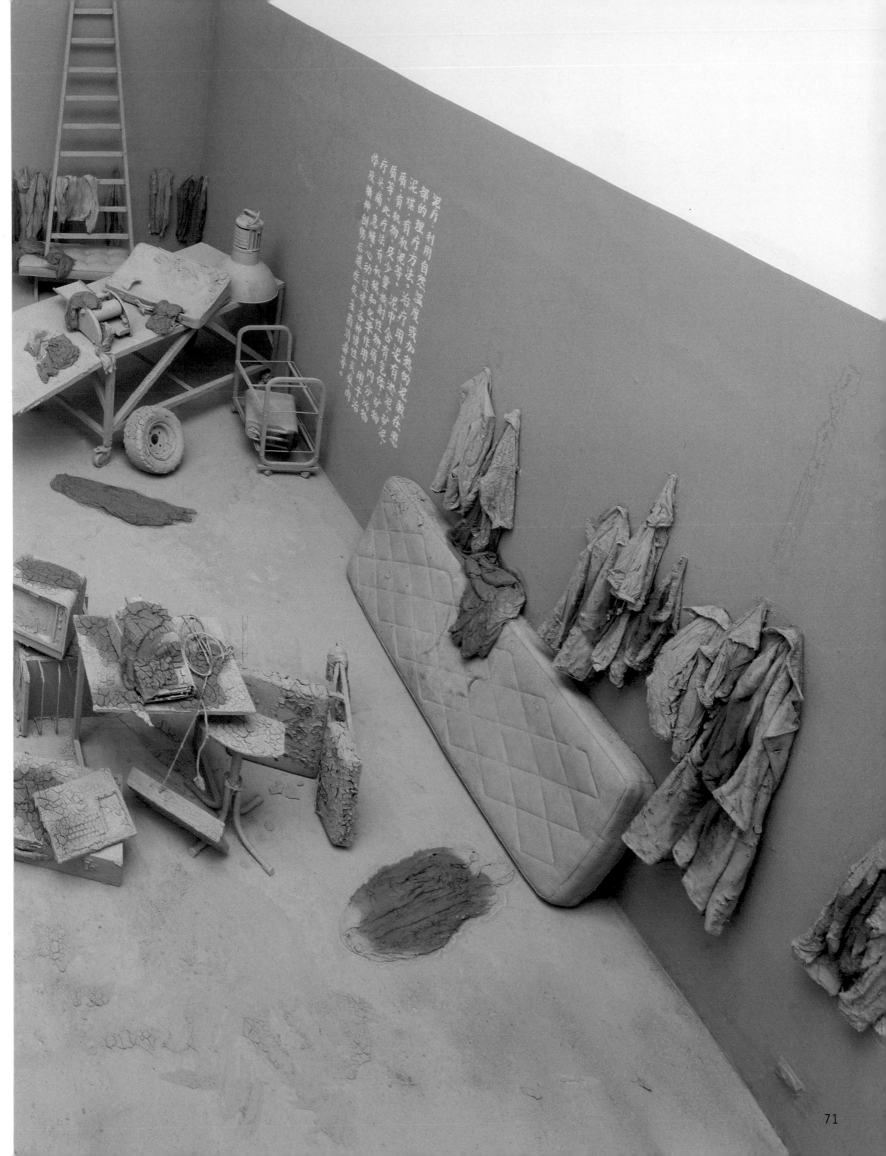

泥疗，利用自然、温度、或加热的泥浆敷在患部的理疗方法，治疗用泥浆等，泥中含有浓泥、矿泉泥浆、有机物泥等，此疗法有机械和温热的作用，以使各种性药及蒸气的物种种刺激作用，内分之物，及来自溶发的体疗头痛急躁等急慢性病，用于治疗等。

71

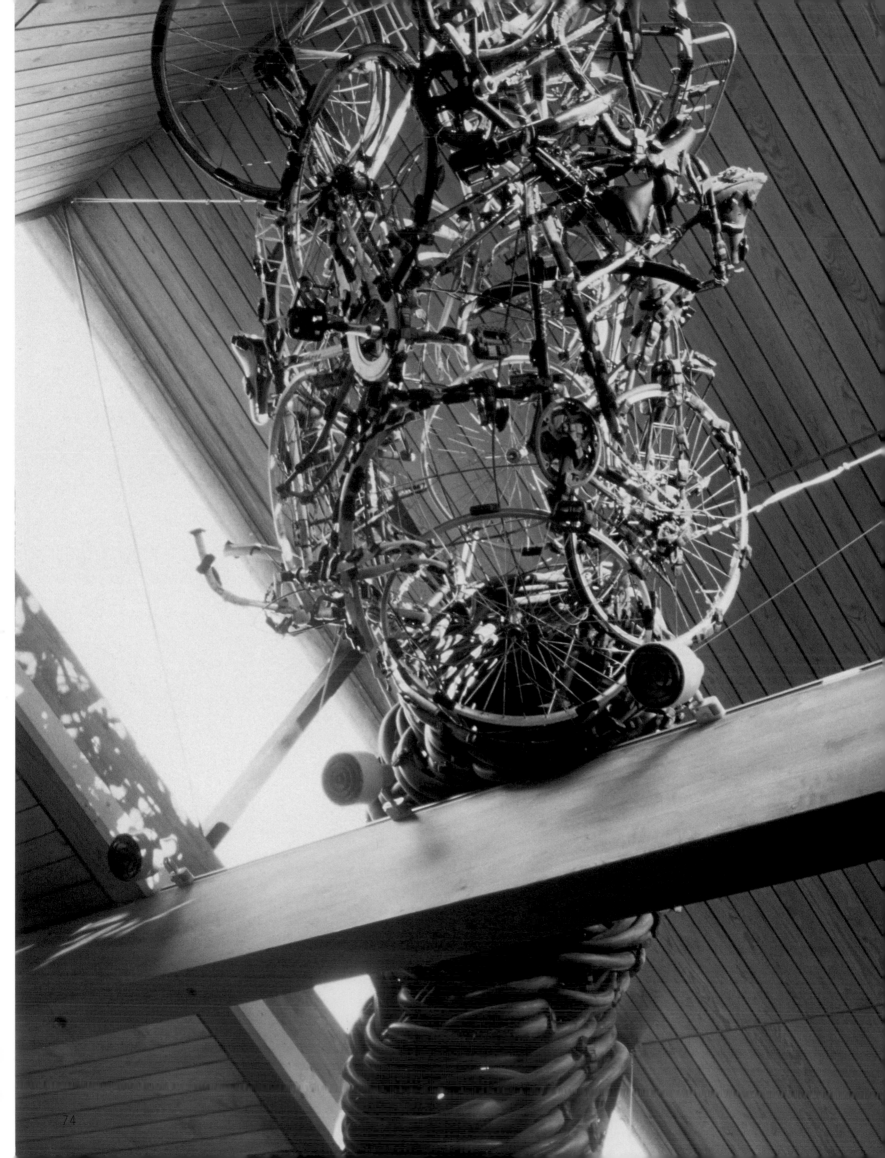

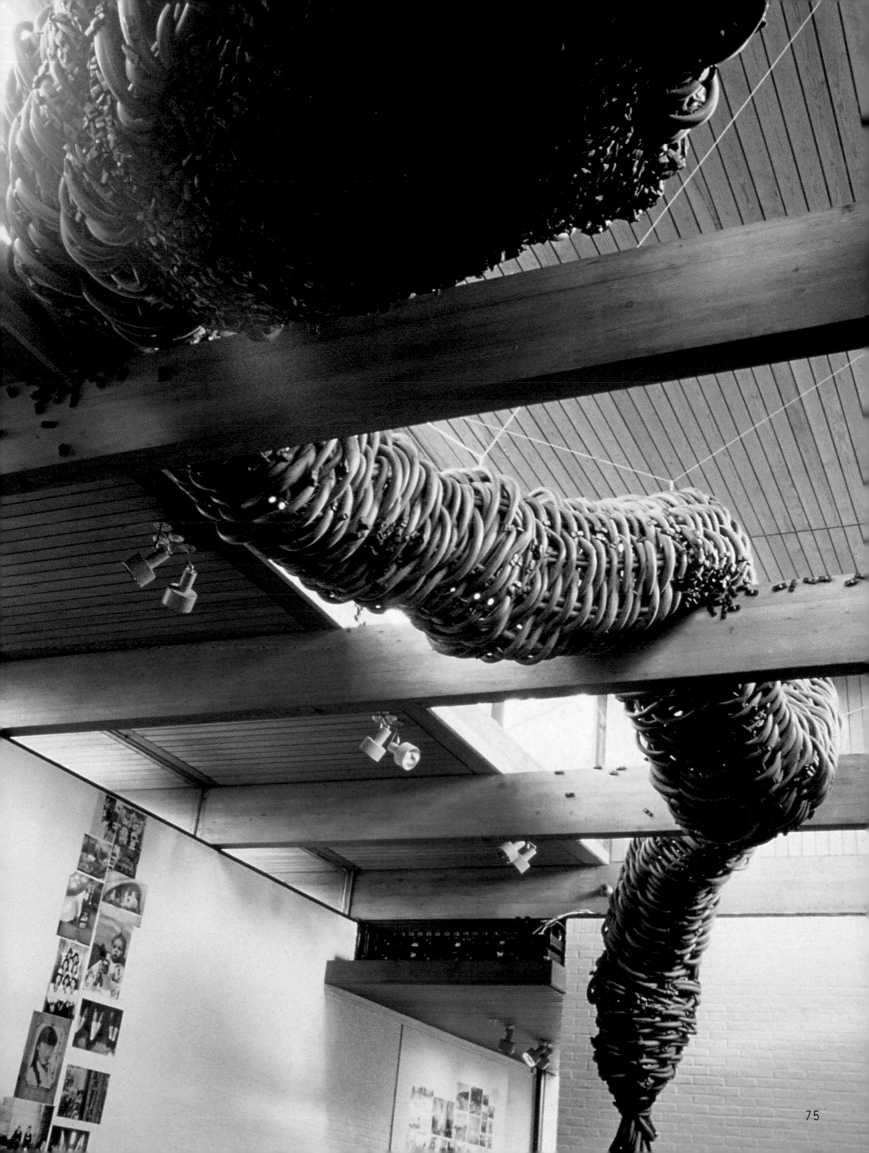

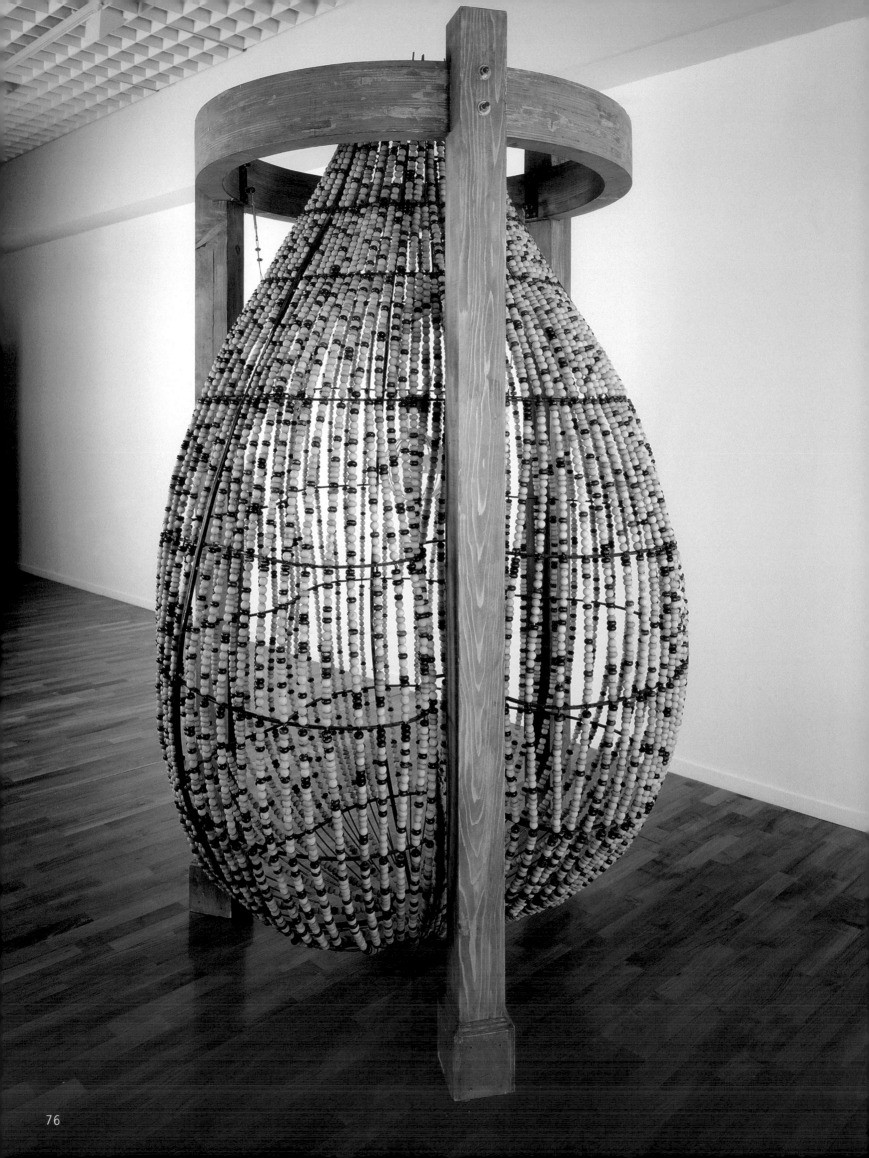

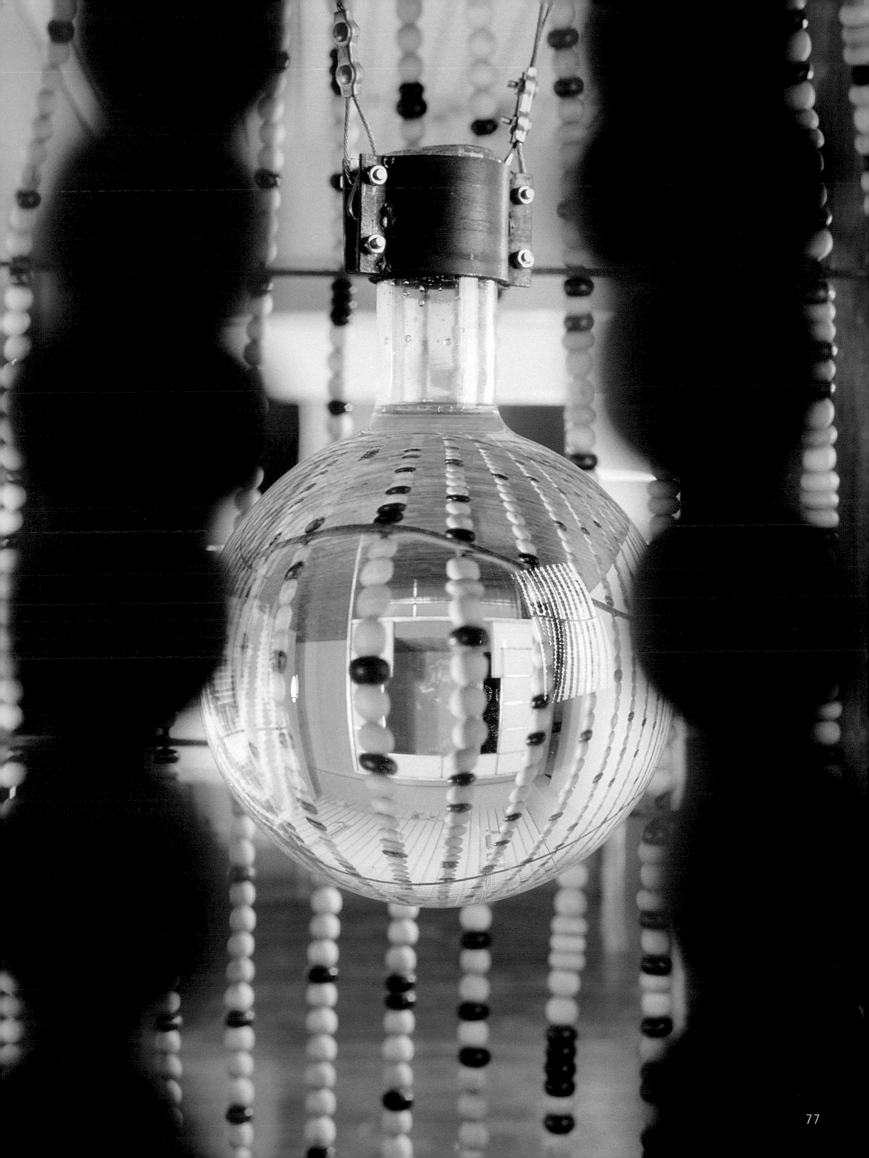

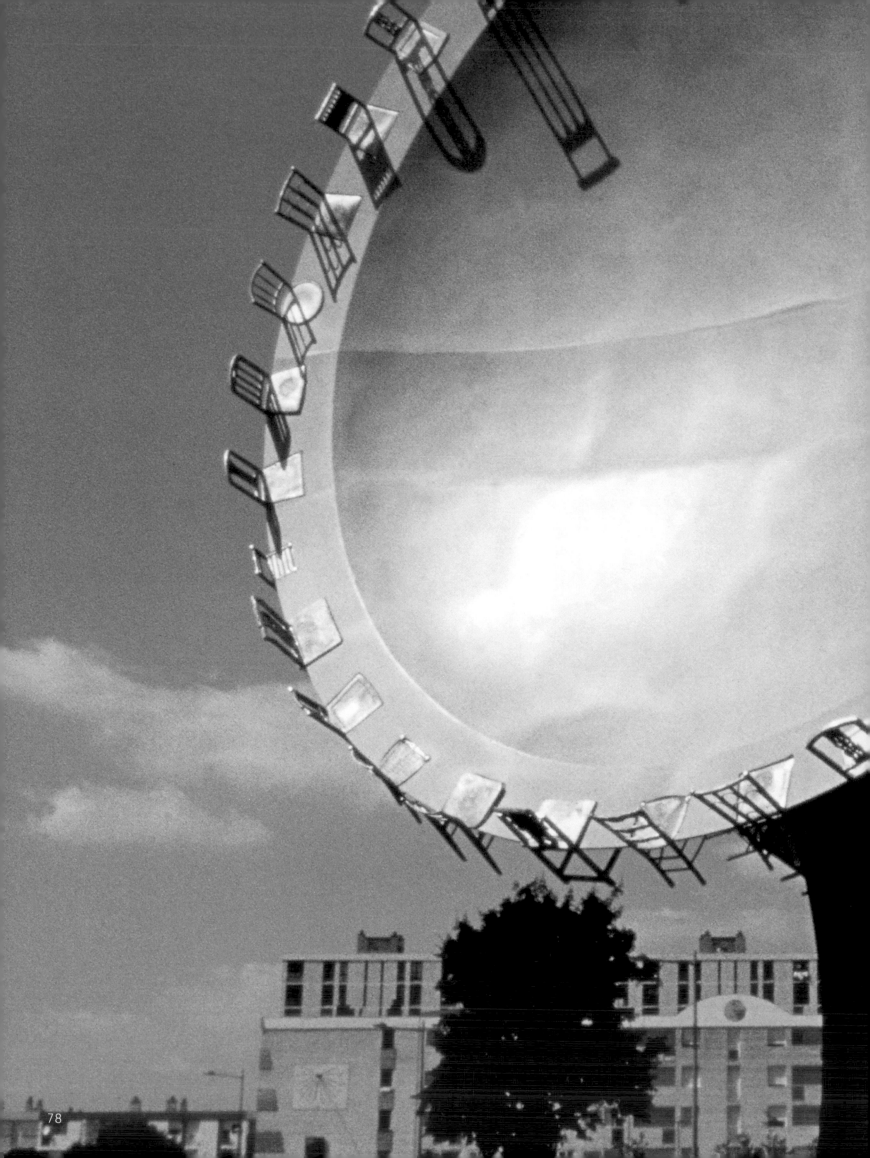

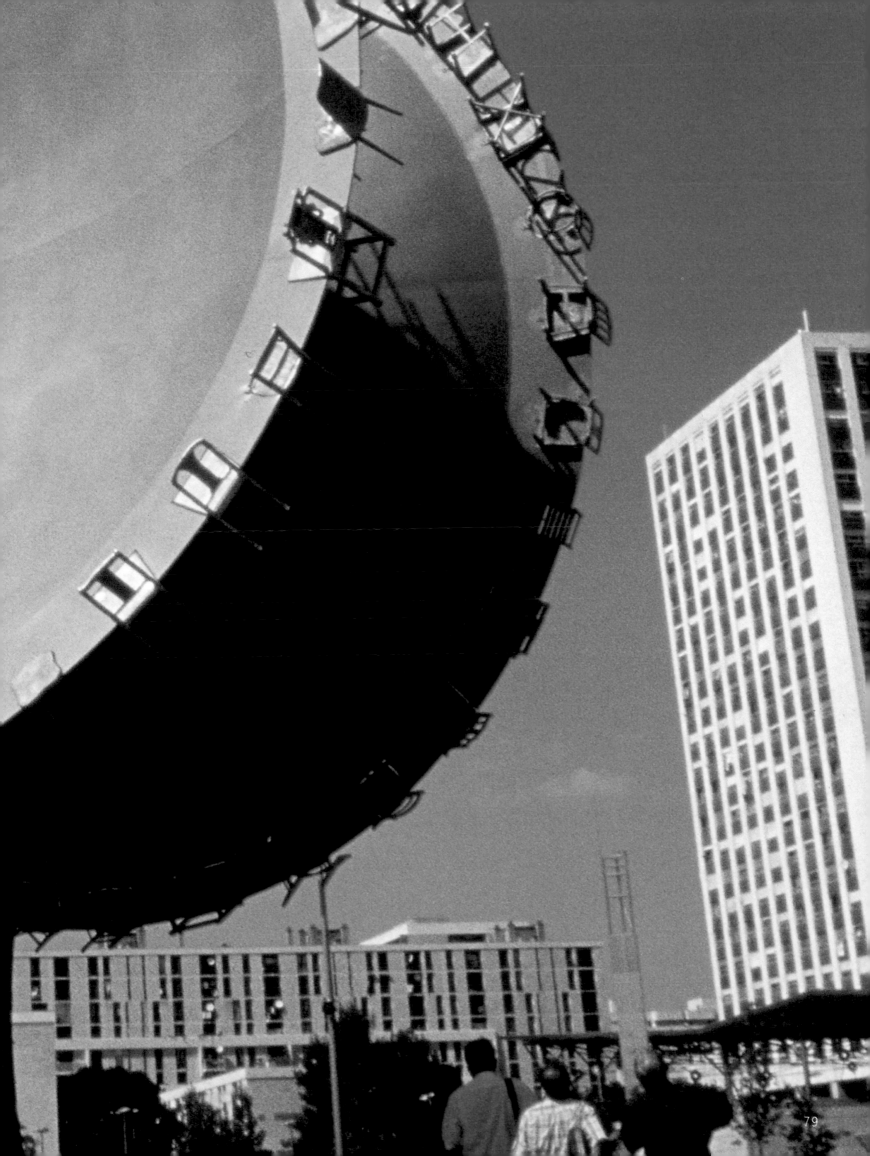

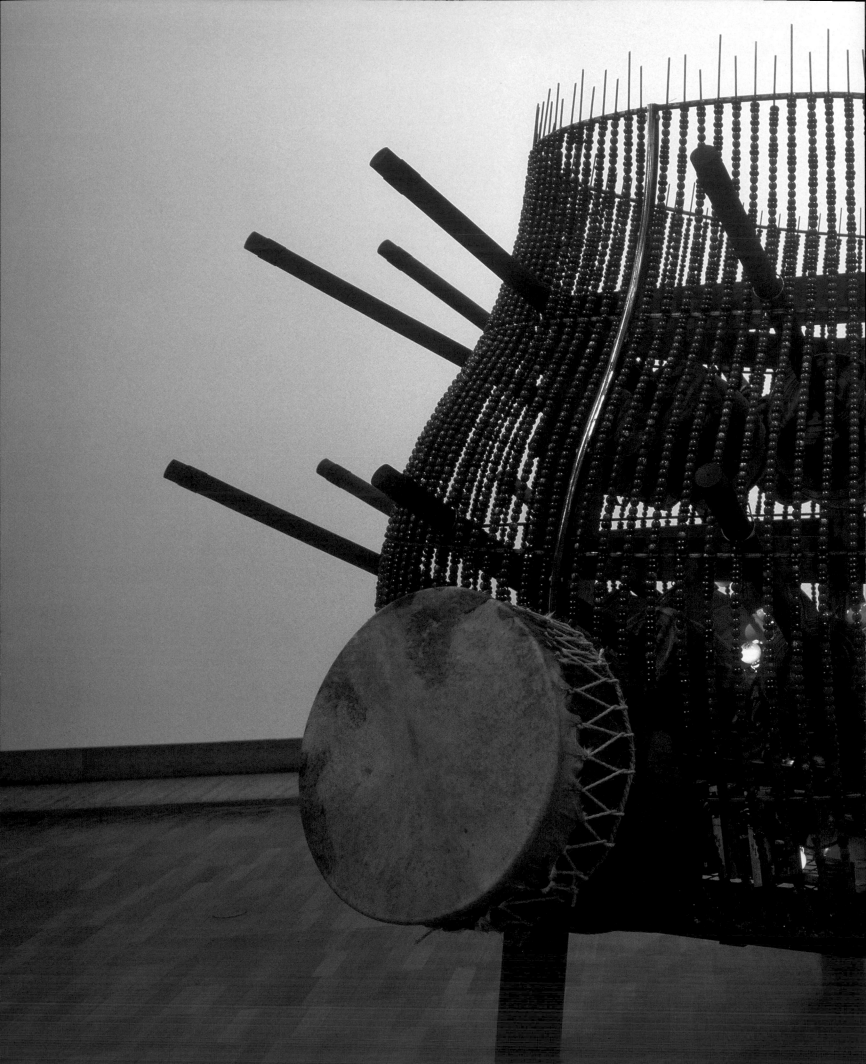

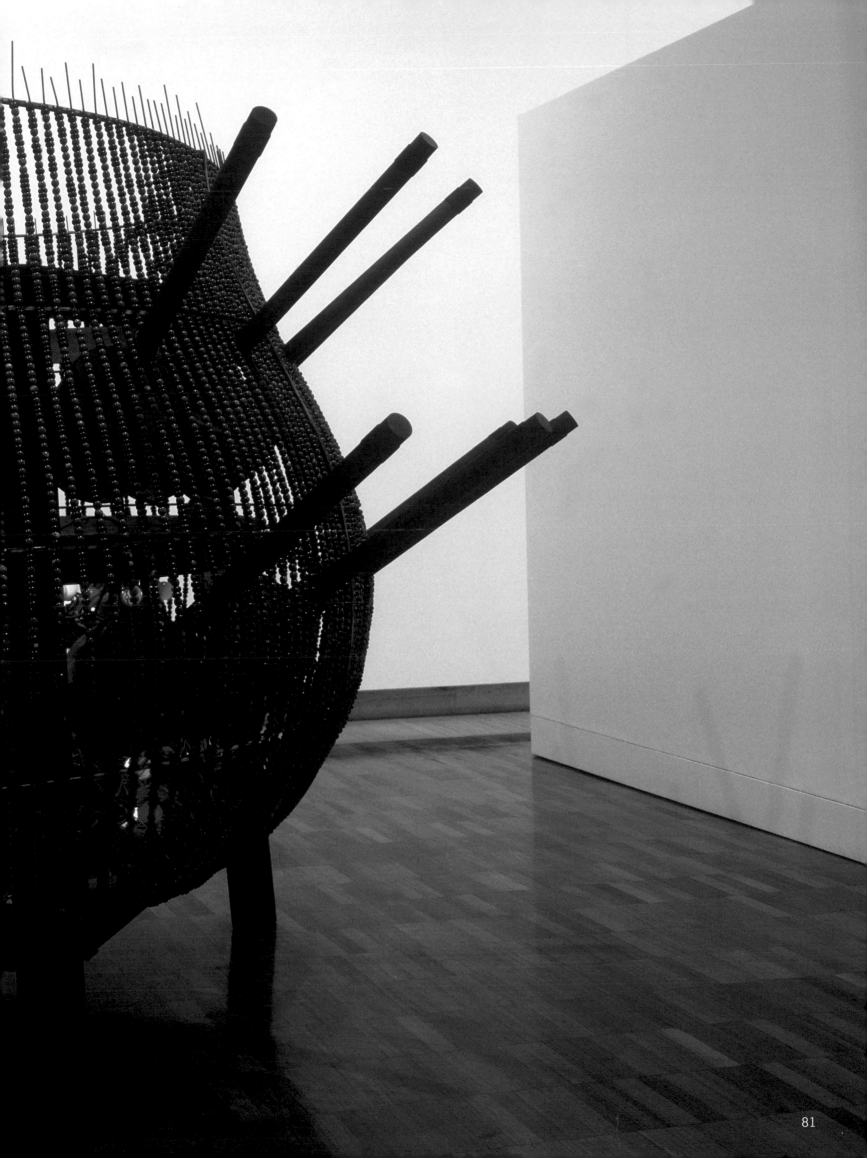

1998

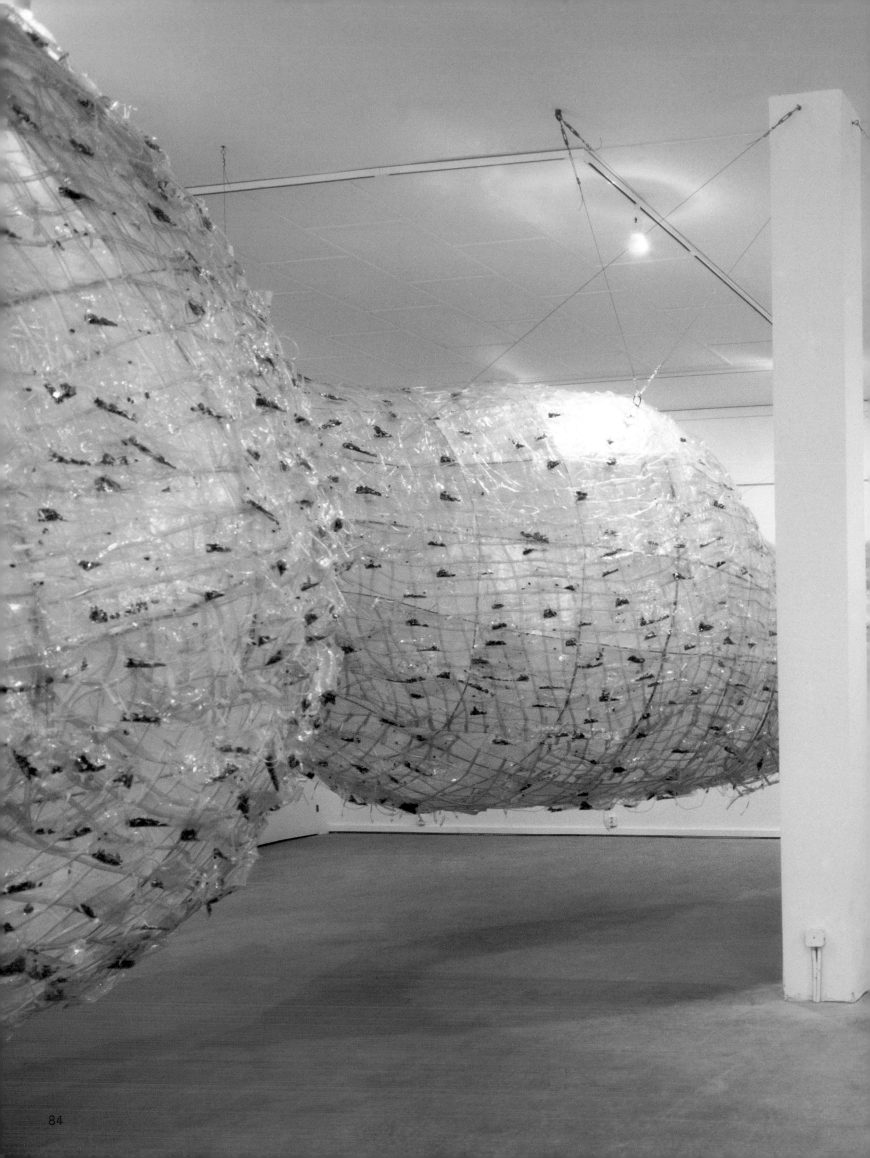

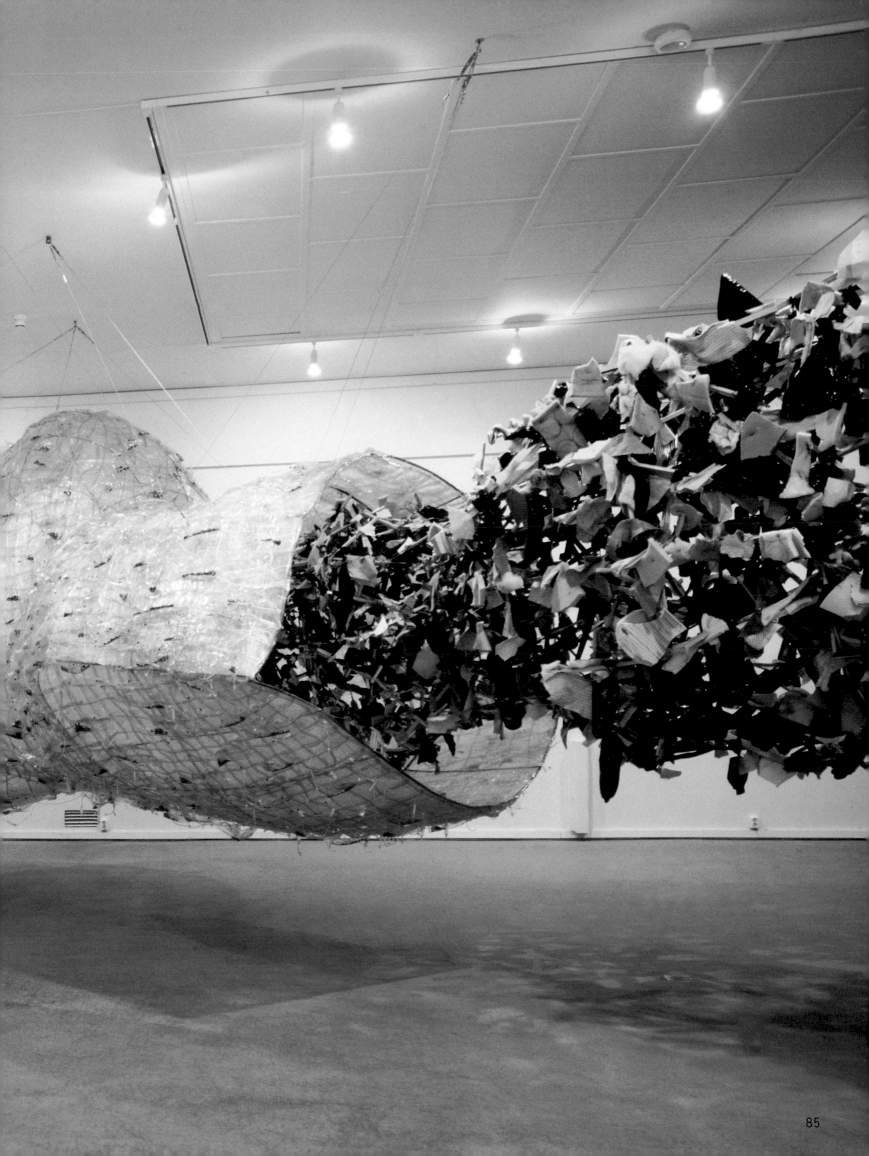

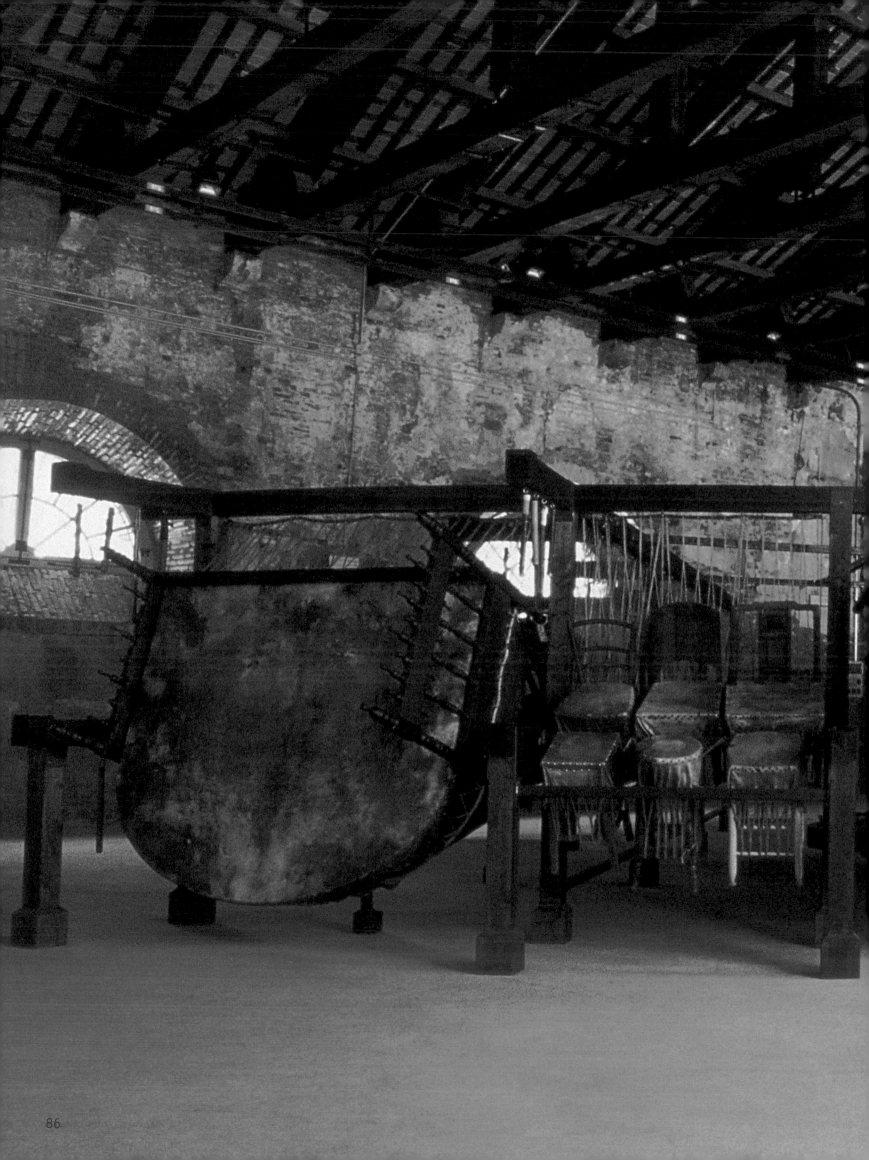

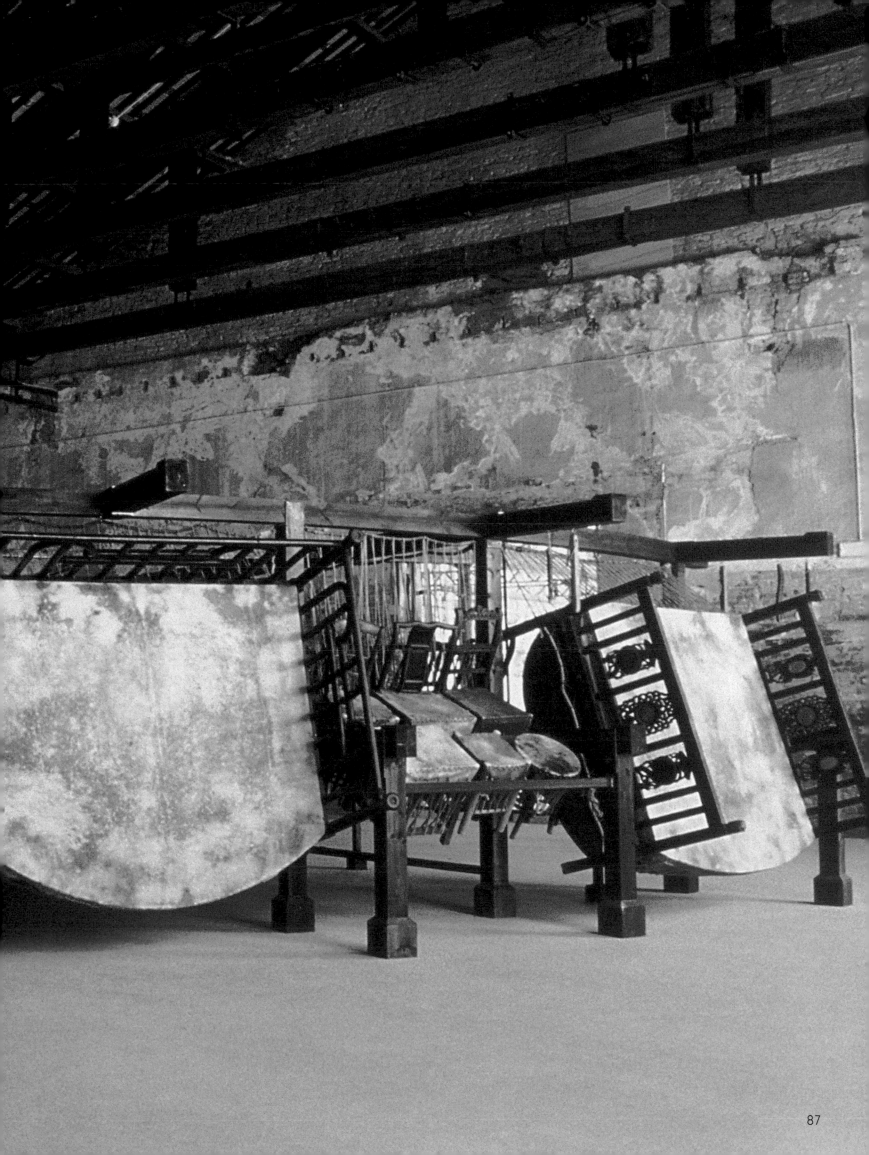

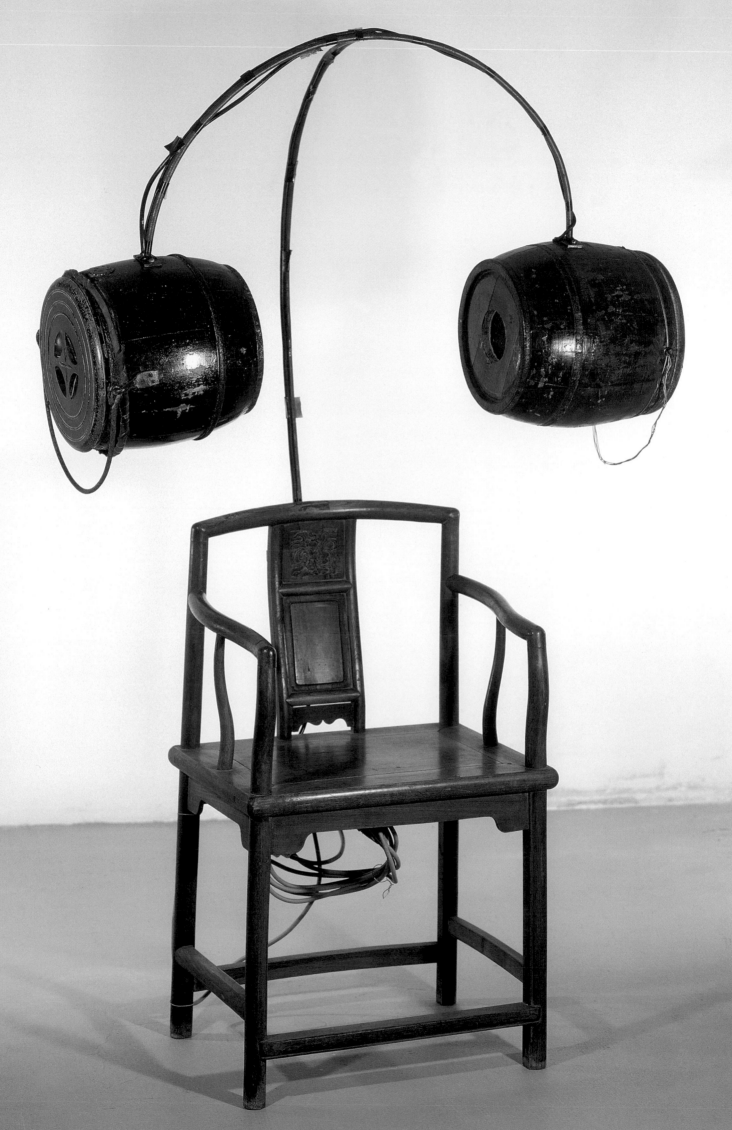

89

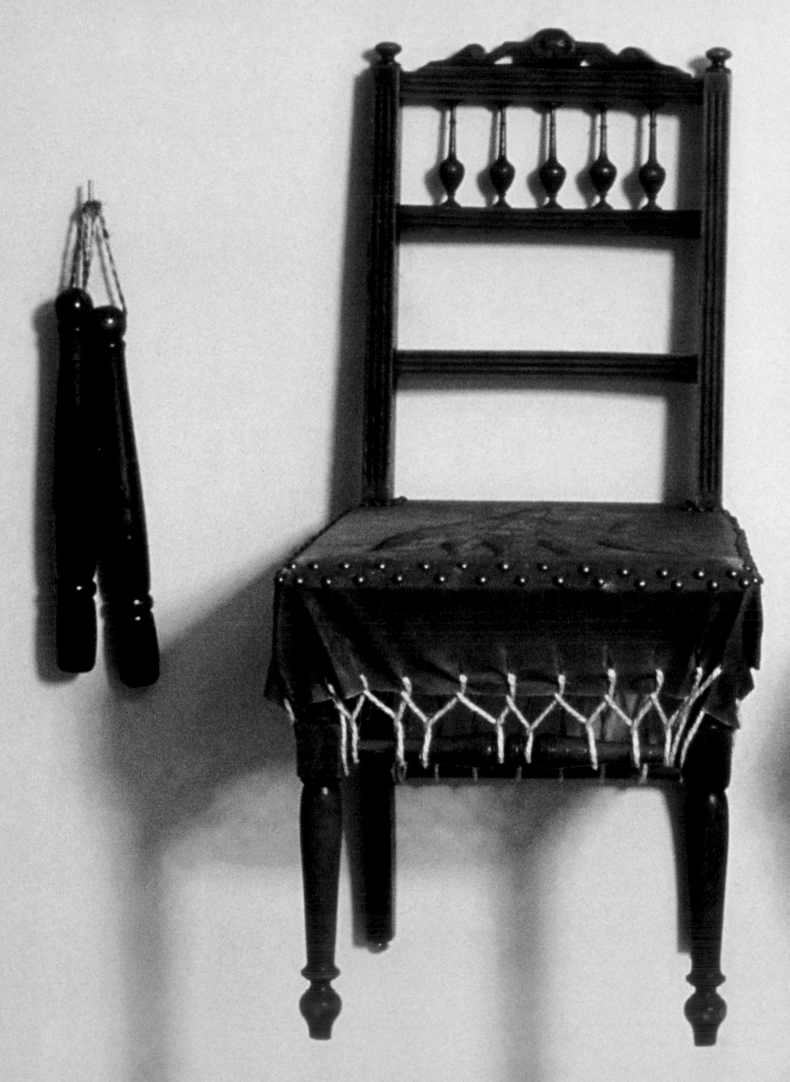

90

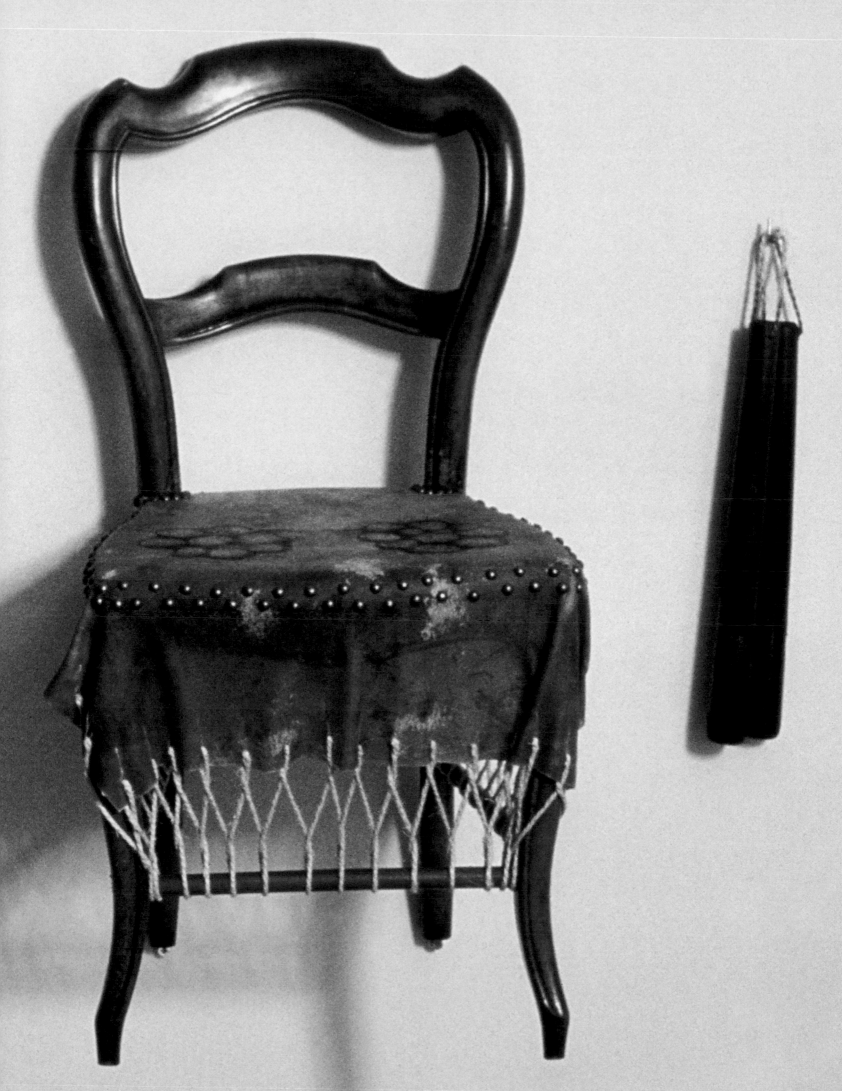

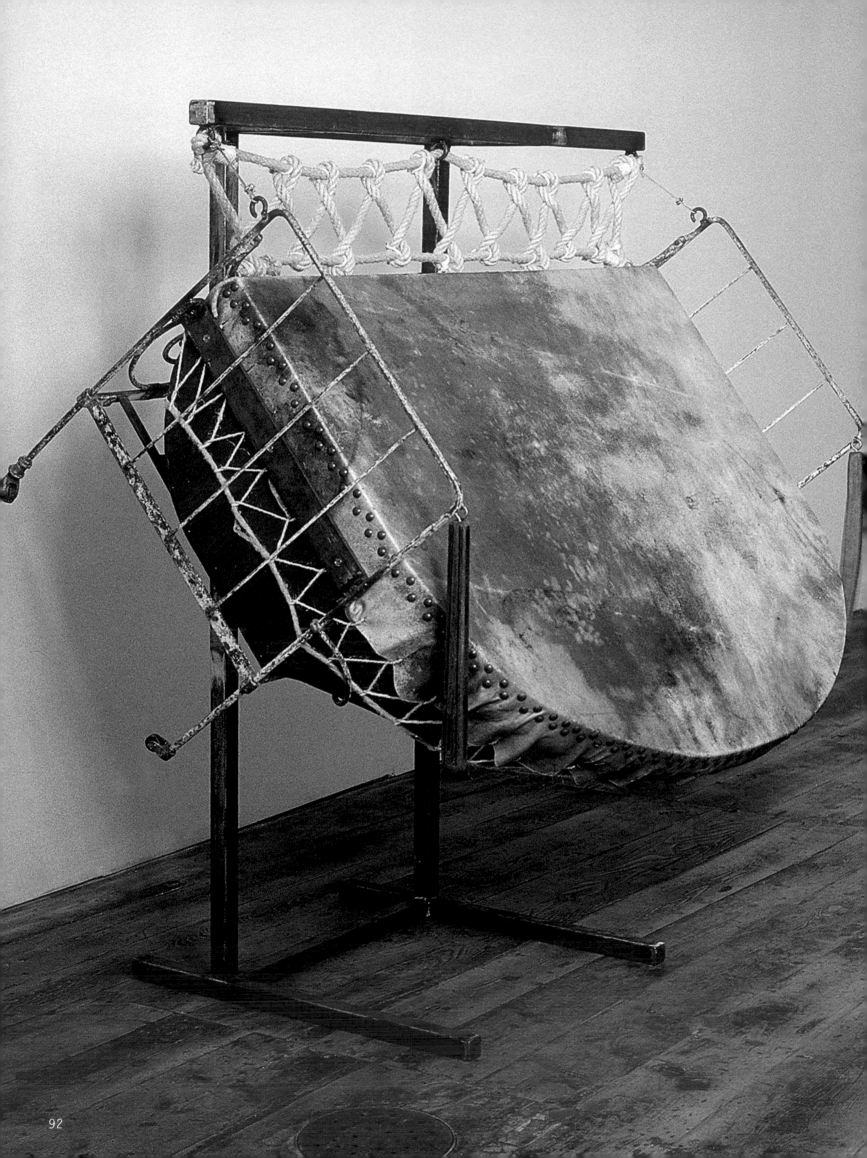

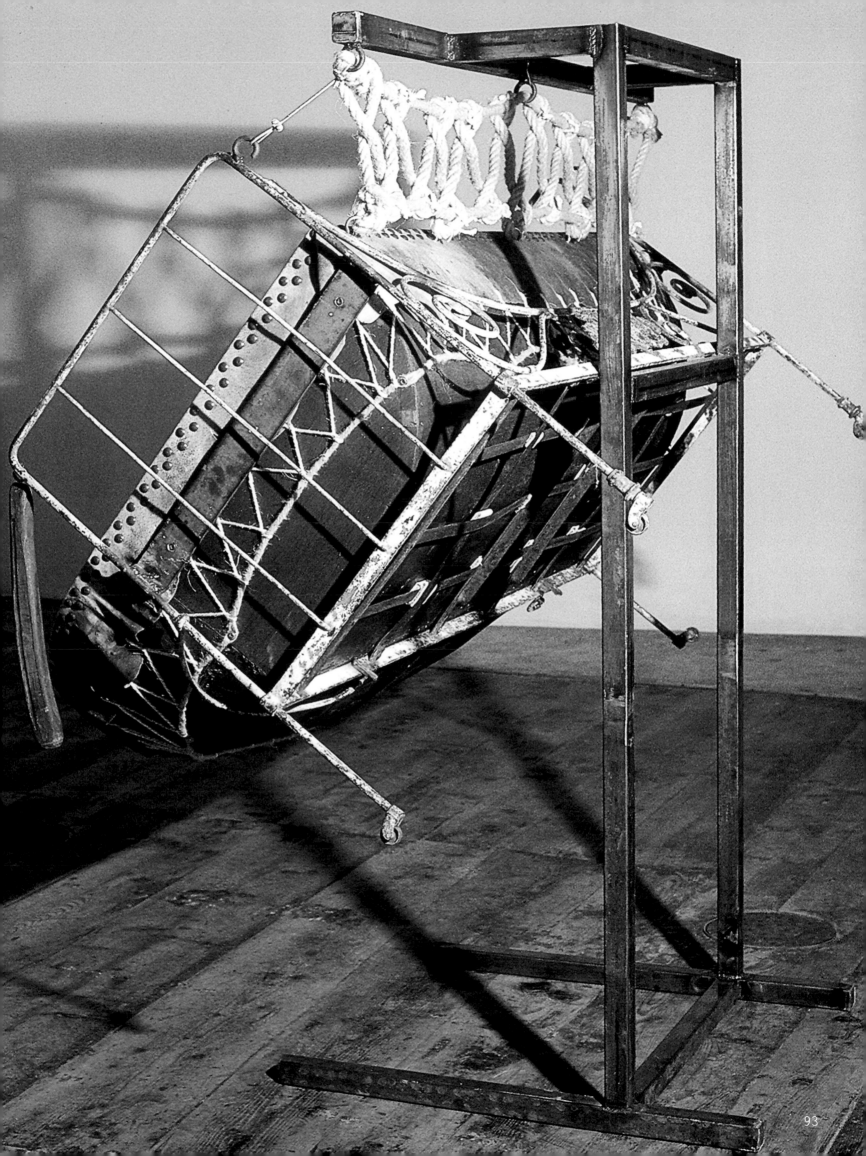

1997

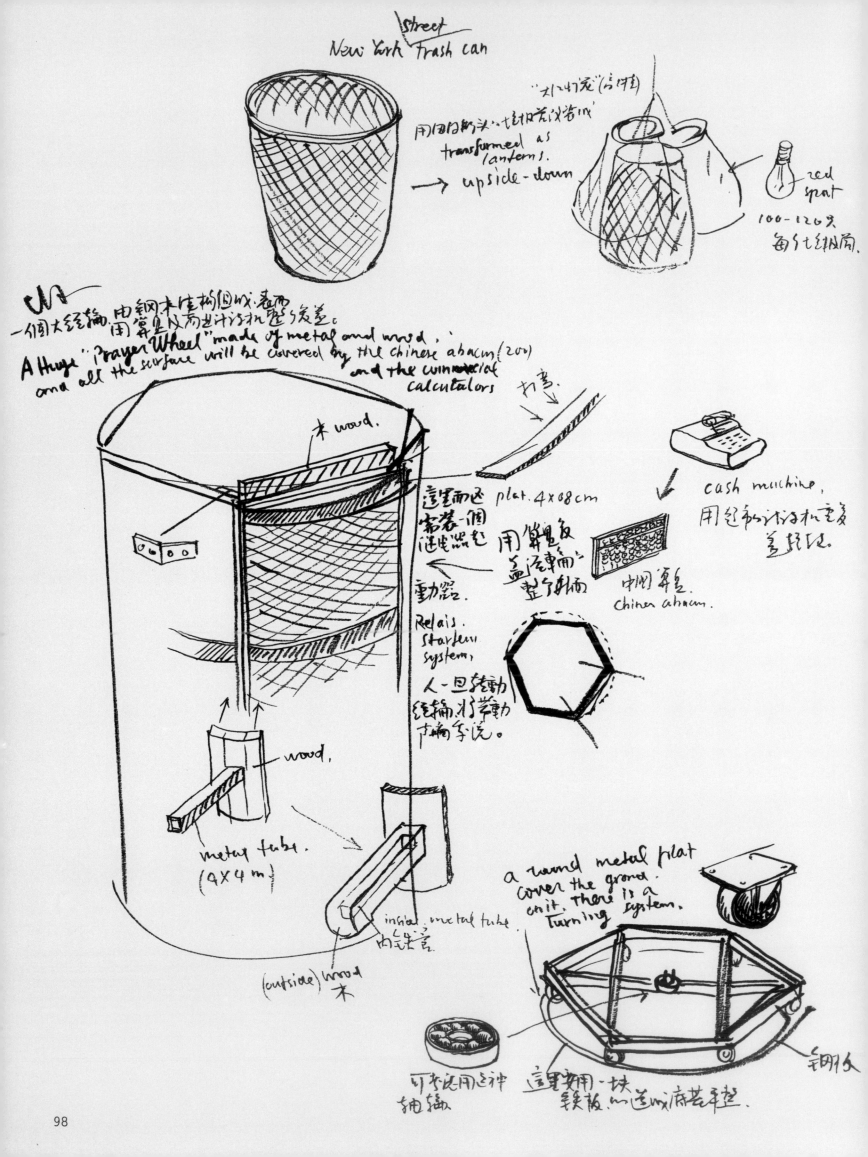

New York Street Trash can

用旧的纸头些封拉成纸管成 transformed as lanterns.
→ upside-down

"火灯笼"(局部)
red spot
100-120火
每红七秒拟间.

一個大経輪. 用鋼木結構做成, 畫而
用算盤以商业計算机整全发盖.
A Huge "Prayer Wheel" made of metal and wood, and all the surface will be covered by the chinese abacus (200) and the commercial calculators

木 wood.

打童.

cash machine.
用包括計算机重复
盖起来.

這里而过
需裝一個
遂速器地.

plat. 4x08cm

用算電及
盖汽車輪.
整合料桶

中國算盤.
Chinese abacum.

動器.
Relais.
Starten
system.

人一旦轉動
経輪将帯動
内輪手滚.

wood.

metal tube.
(4x4 m)

inside. metal tube.
内滚管.

a round metal plat cover the grond unit. there is a turning system.

(outside) wood
木

可考虑用这种
軸輪

這里要用一块
鋼板以达成麻若车型.

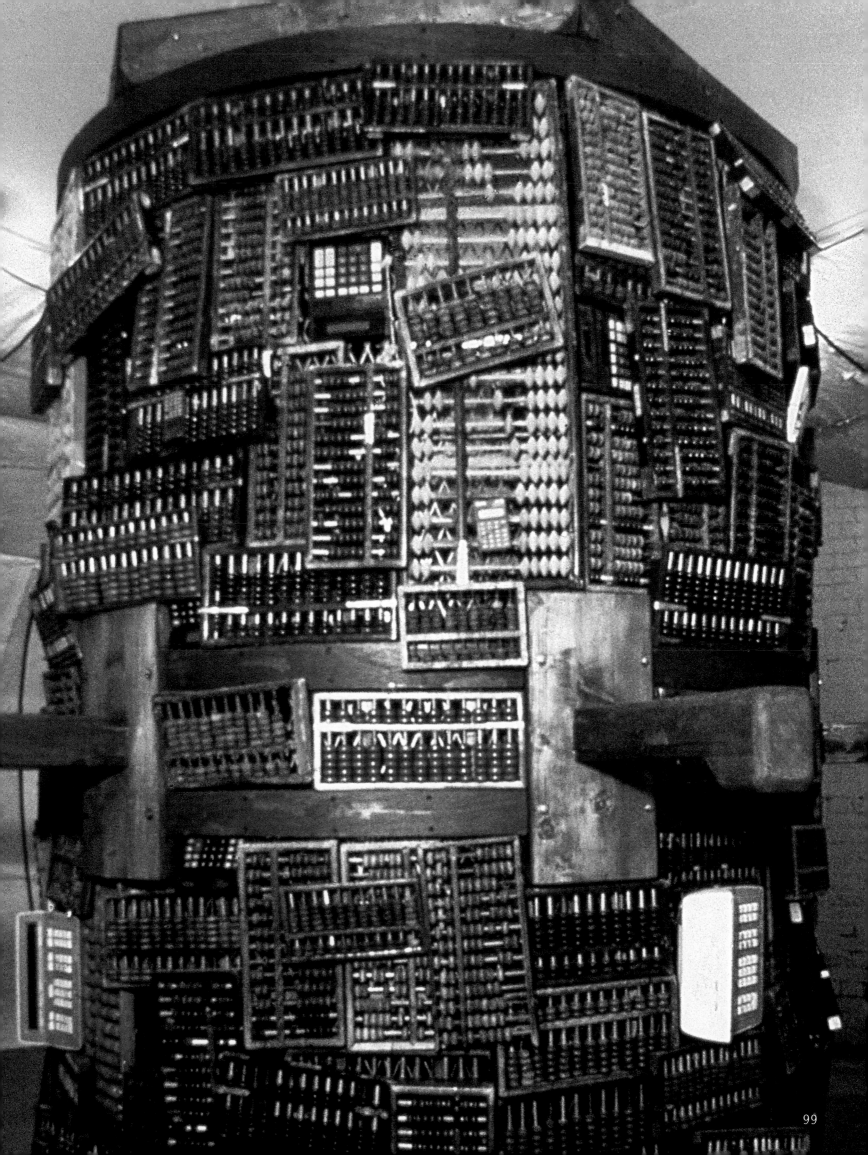

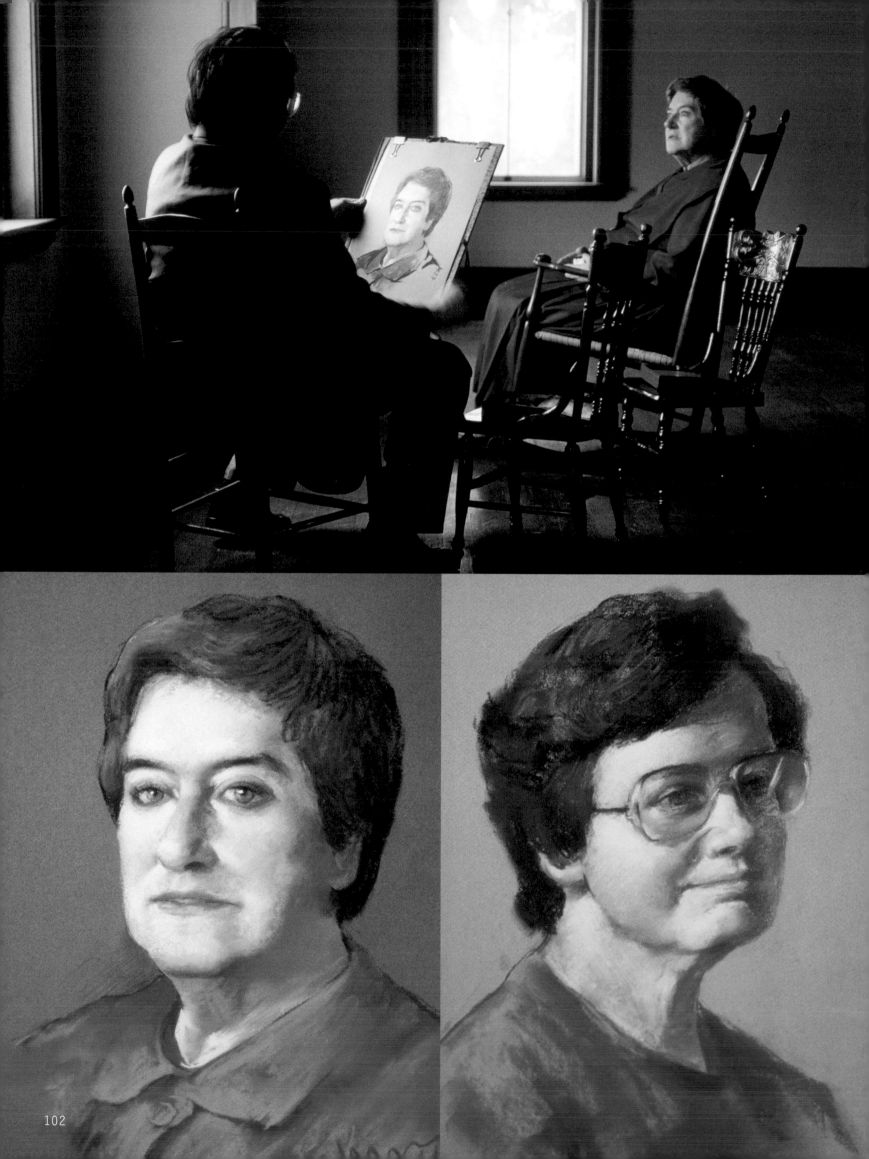

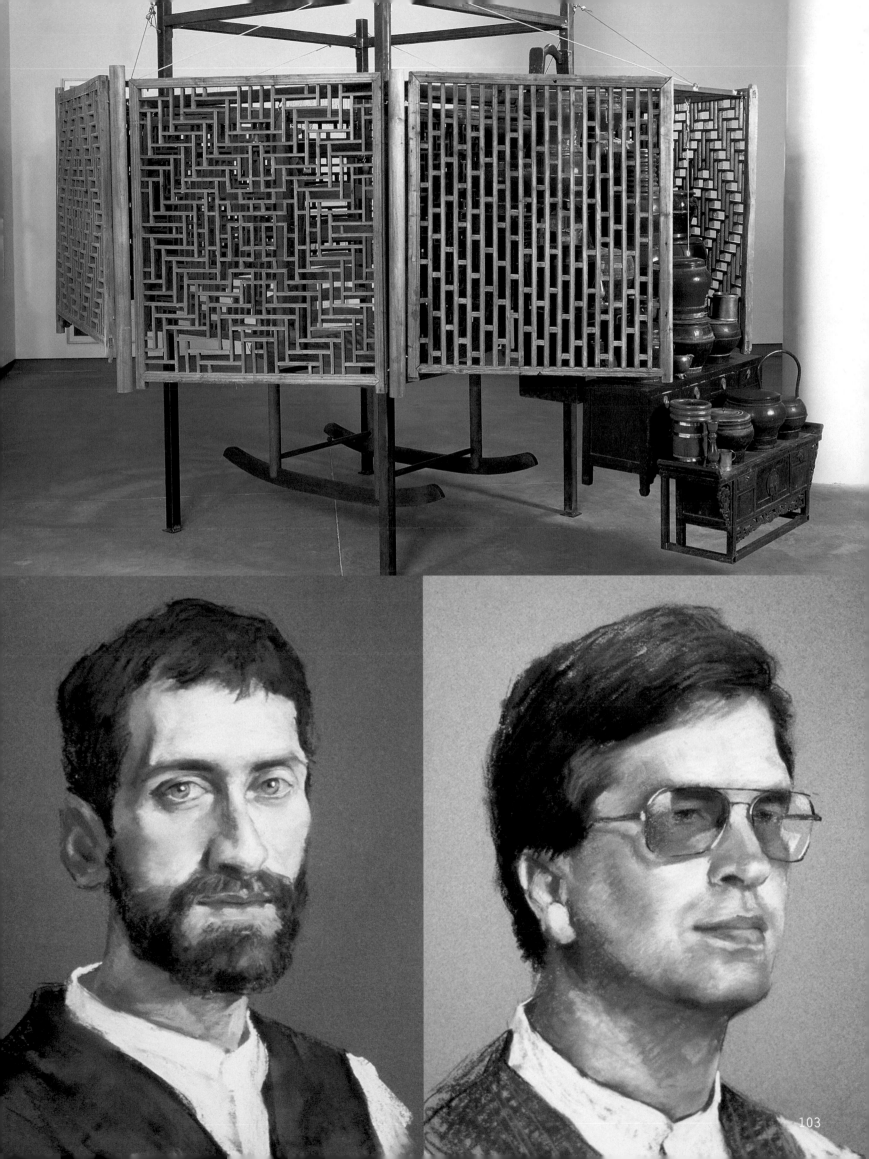

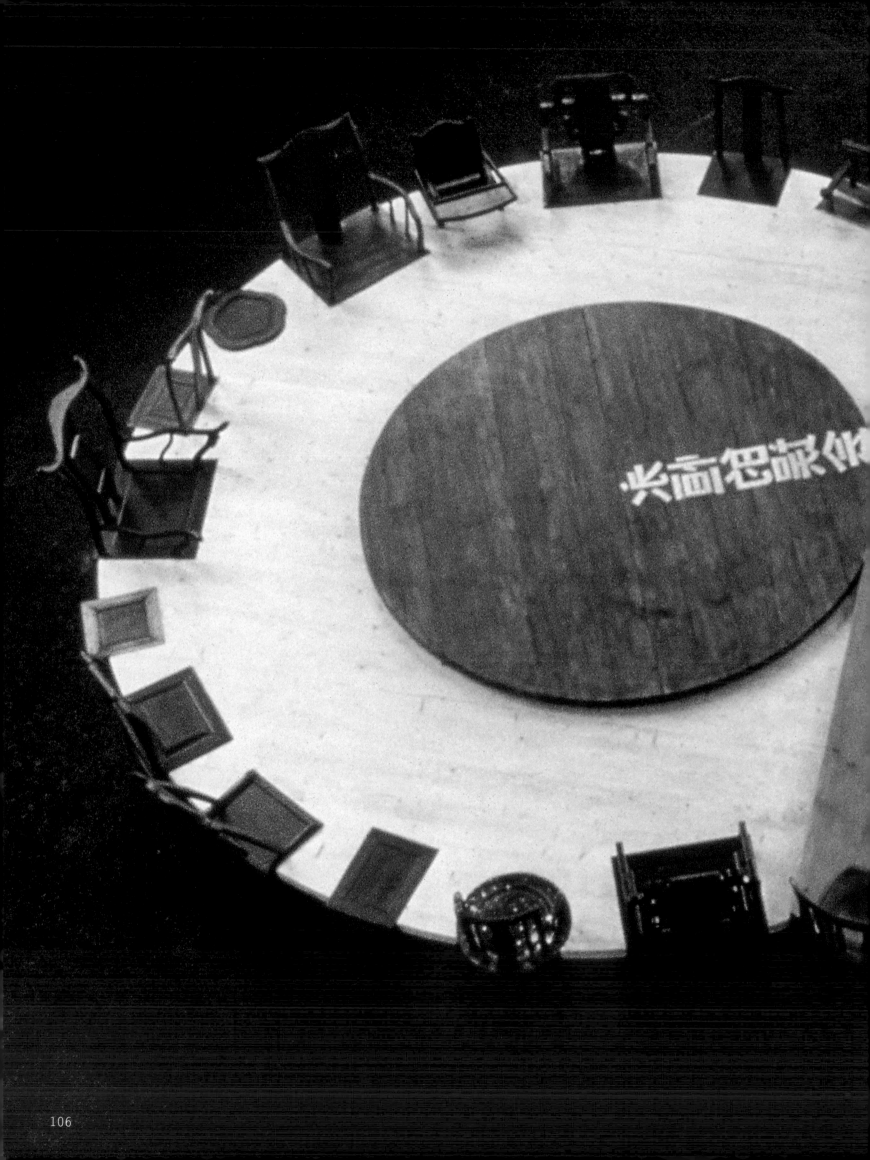

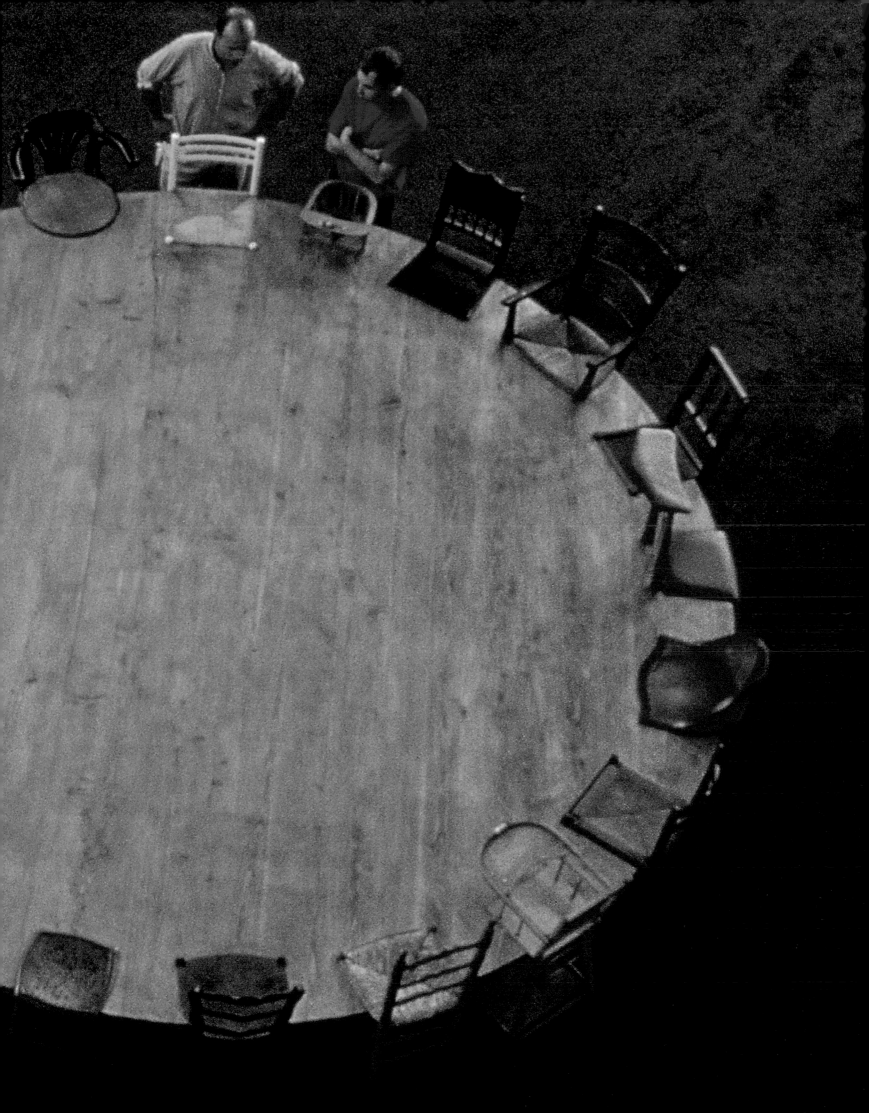

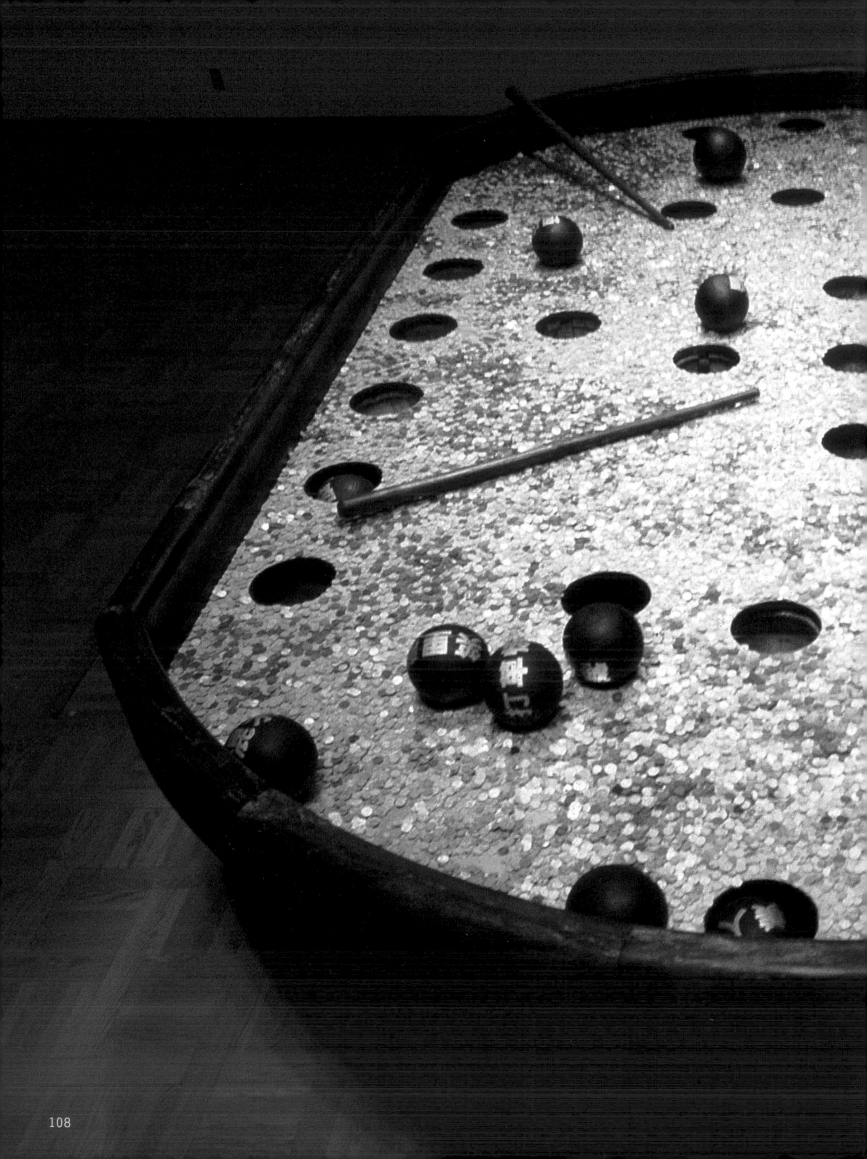

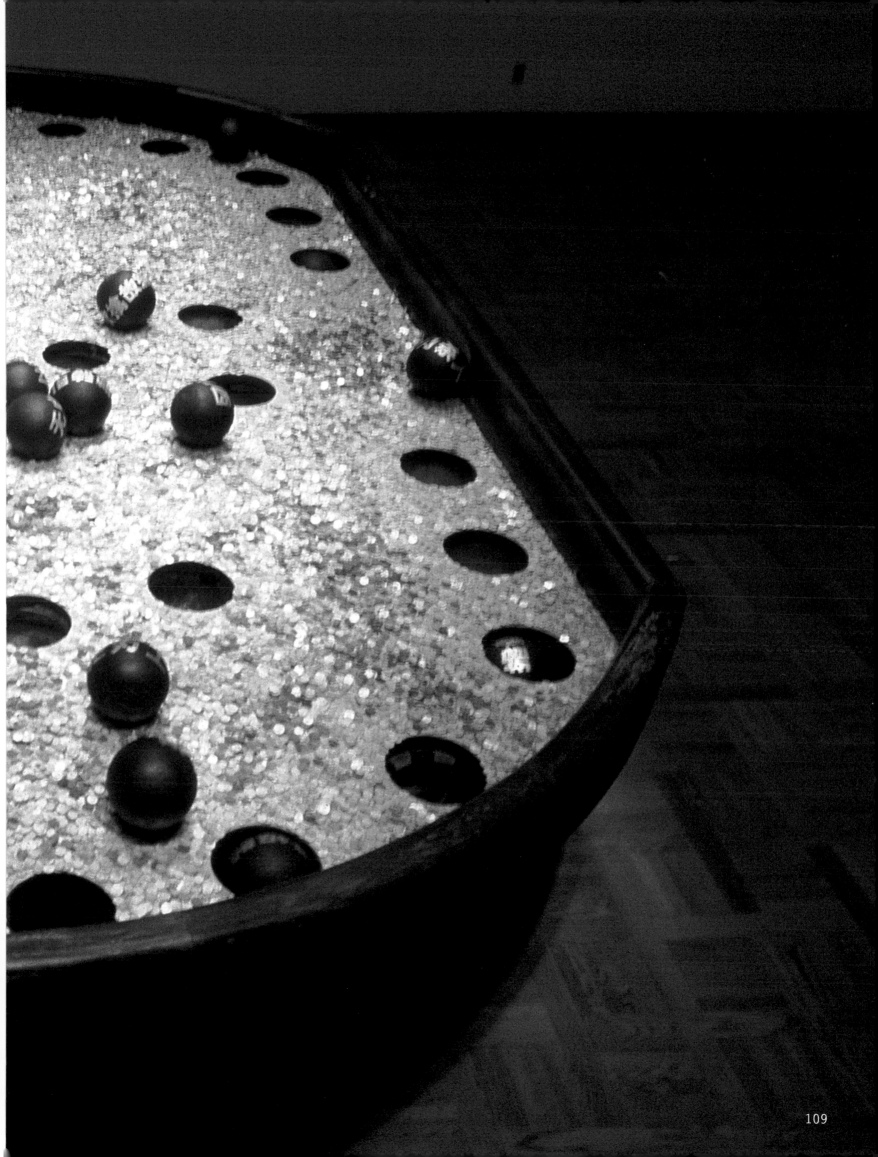

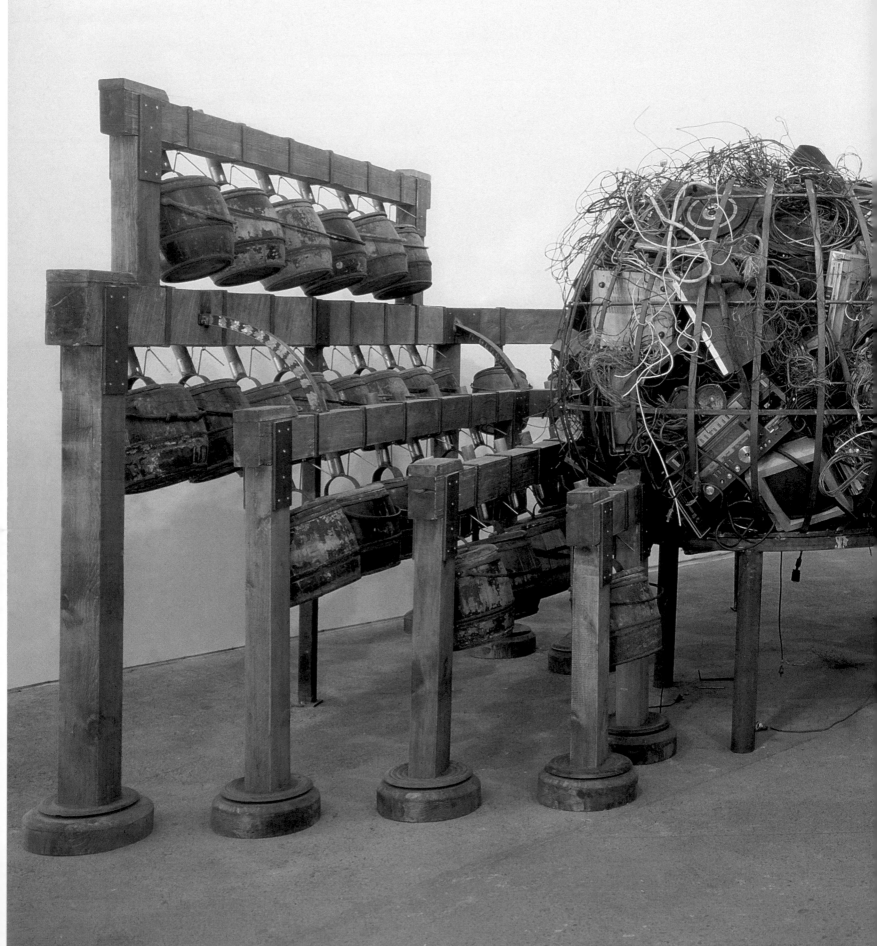

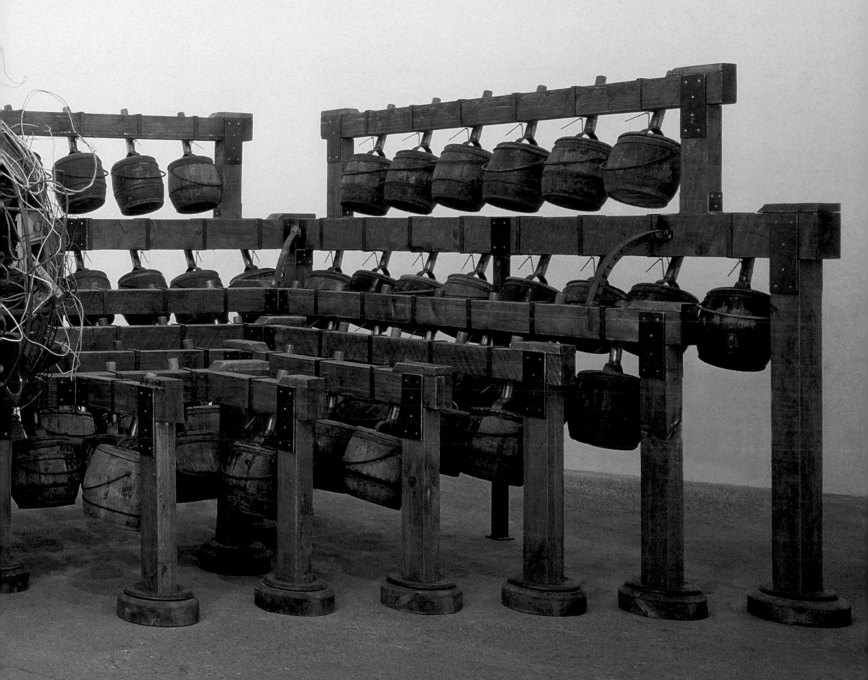

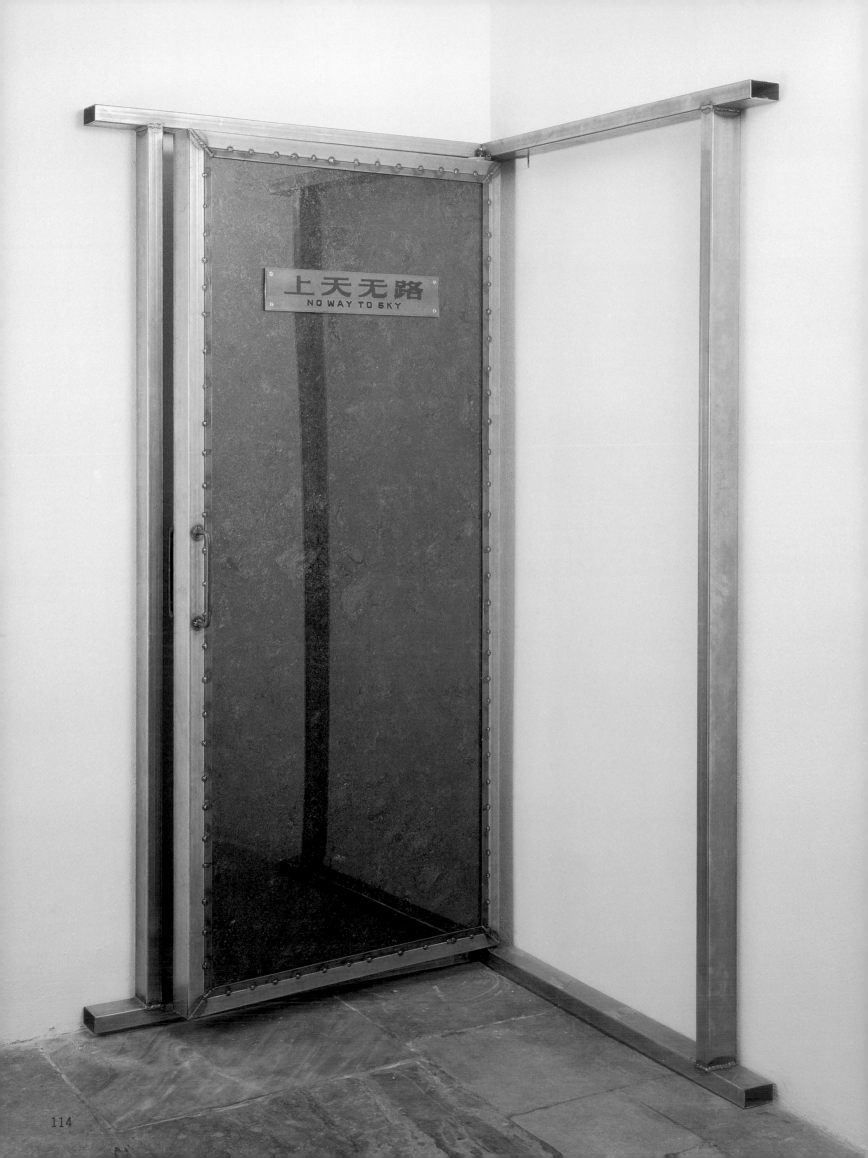

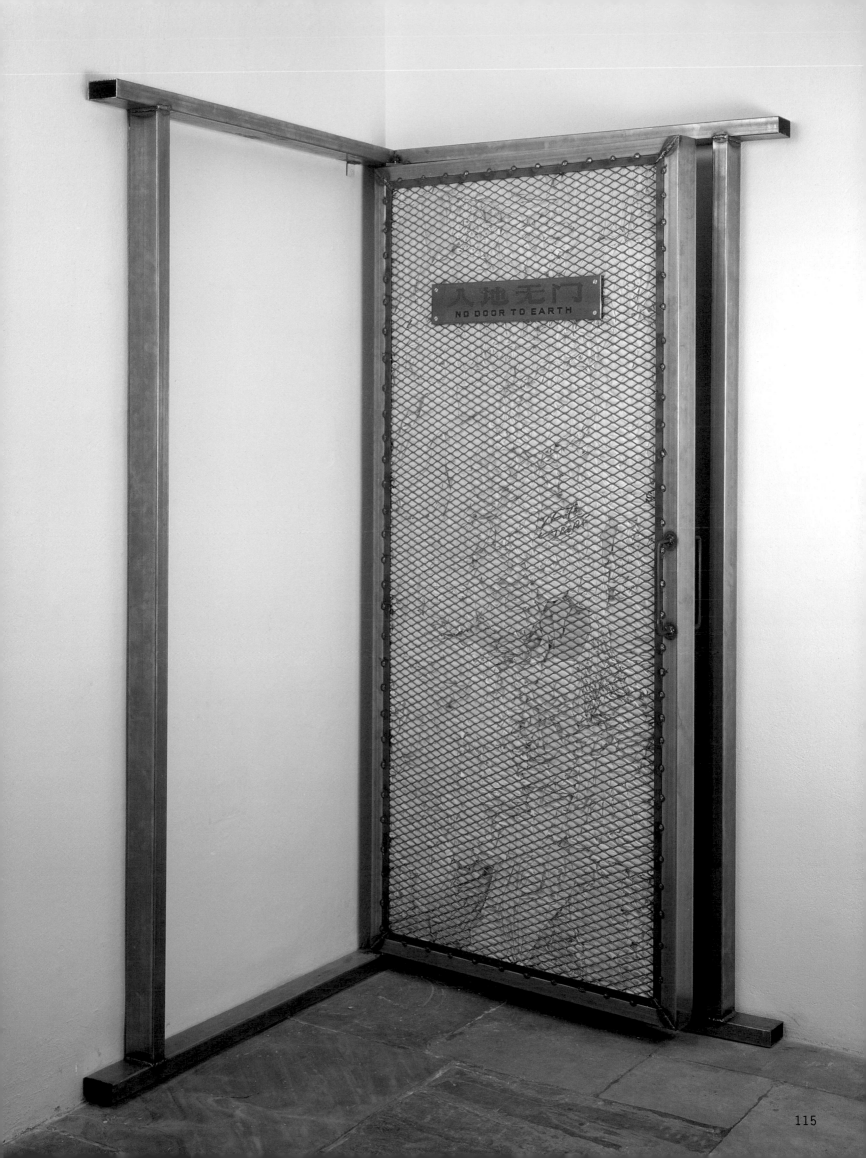

入地无门
NO DOOR TO EARTH

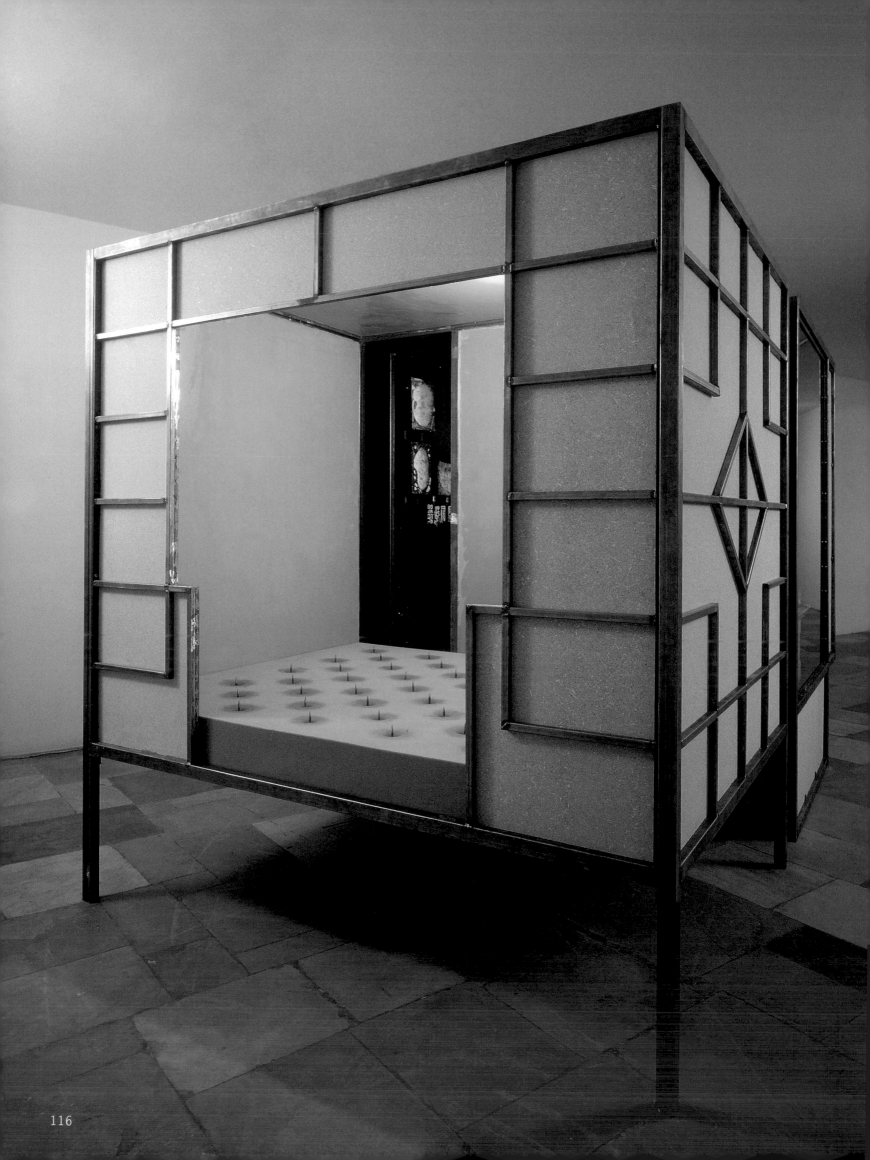

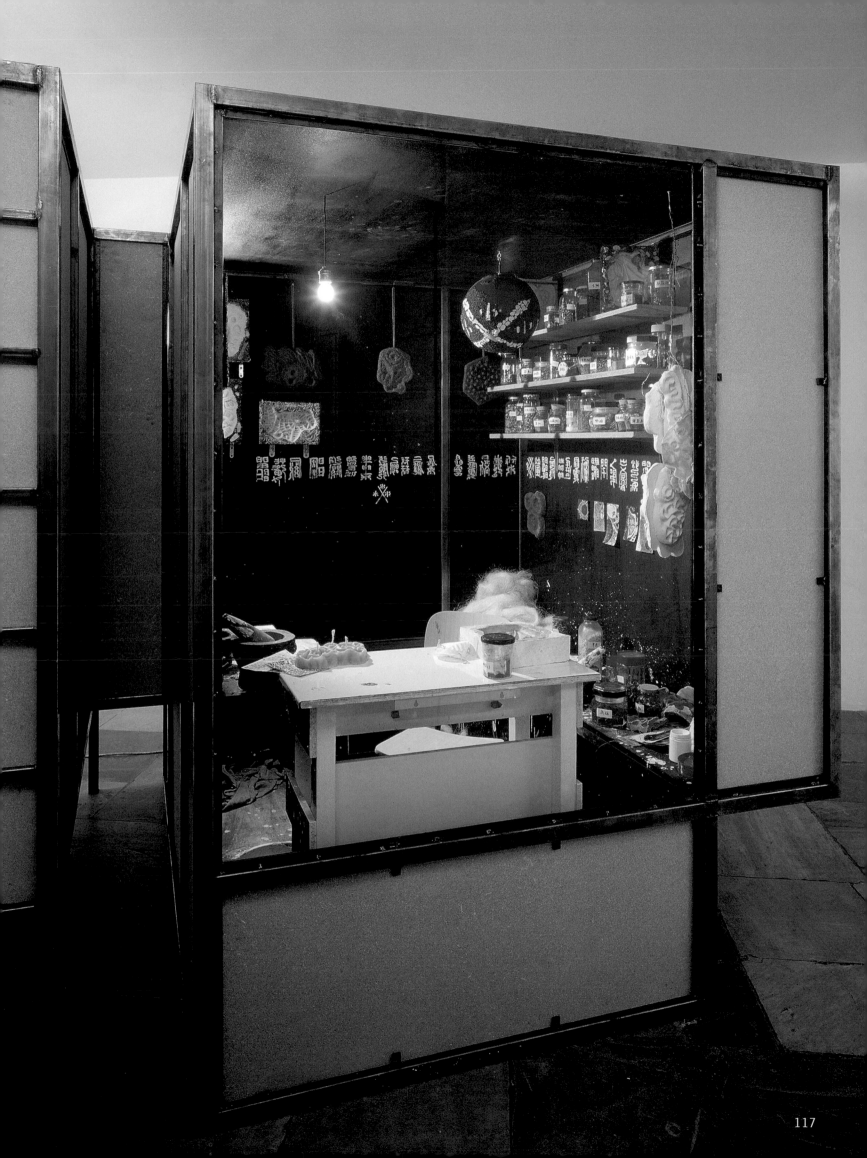

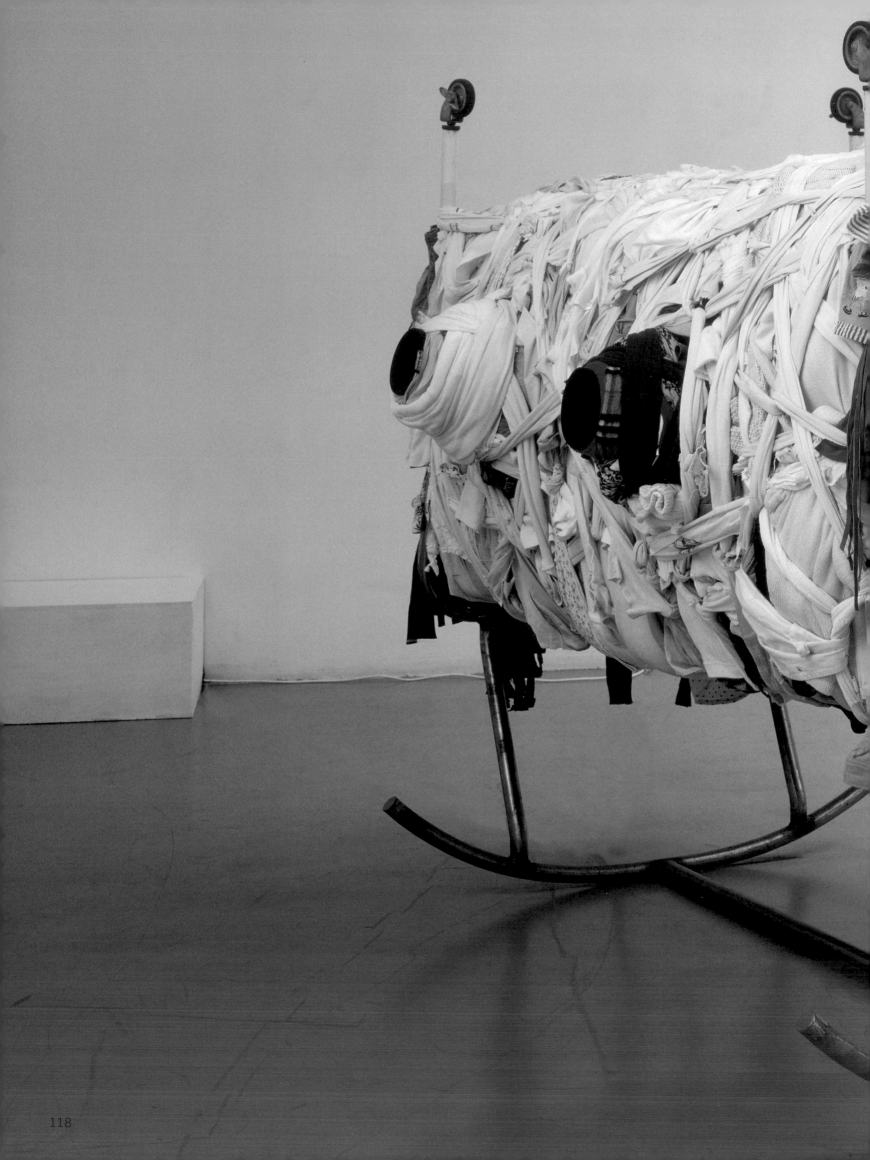

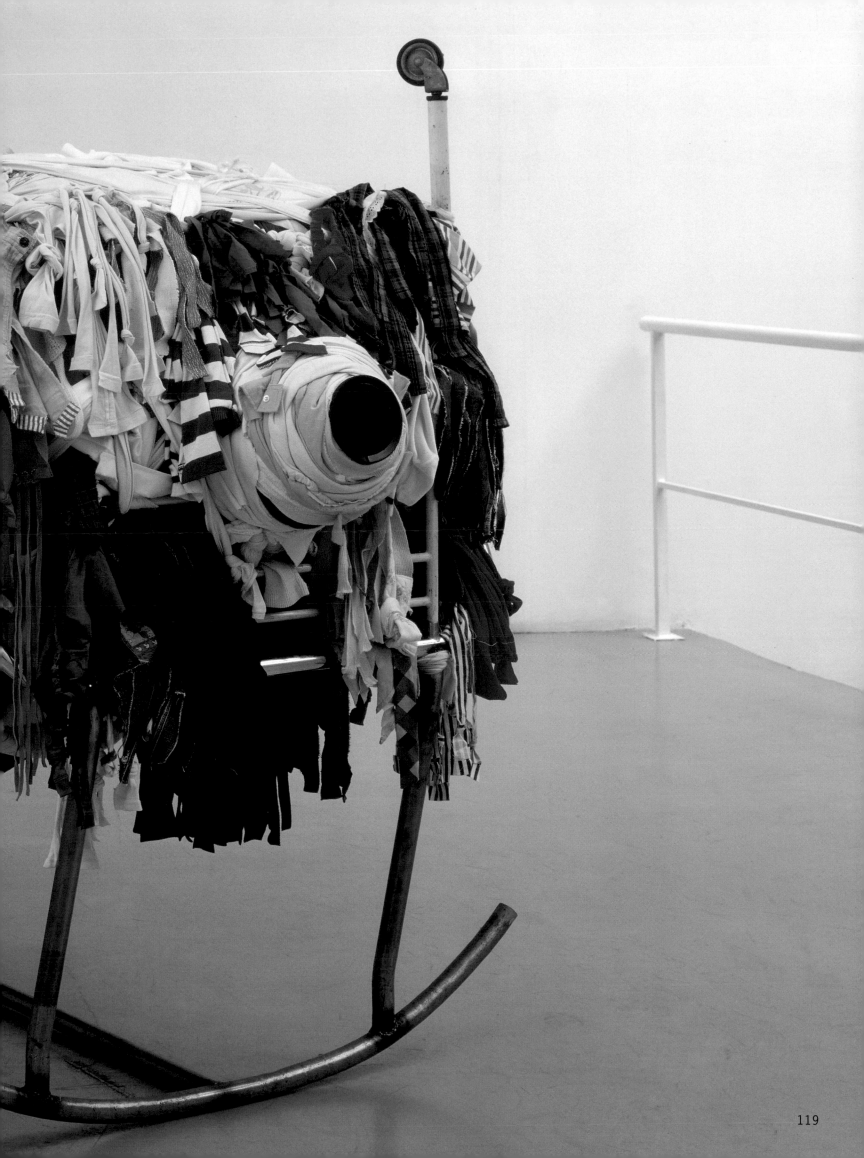

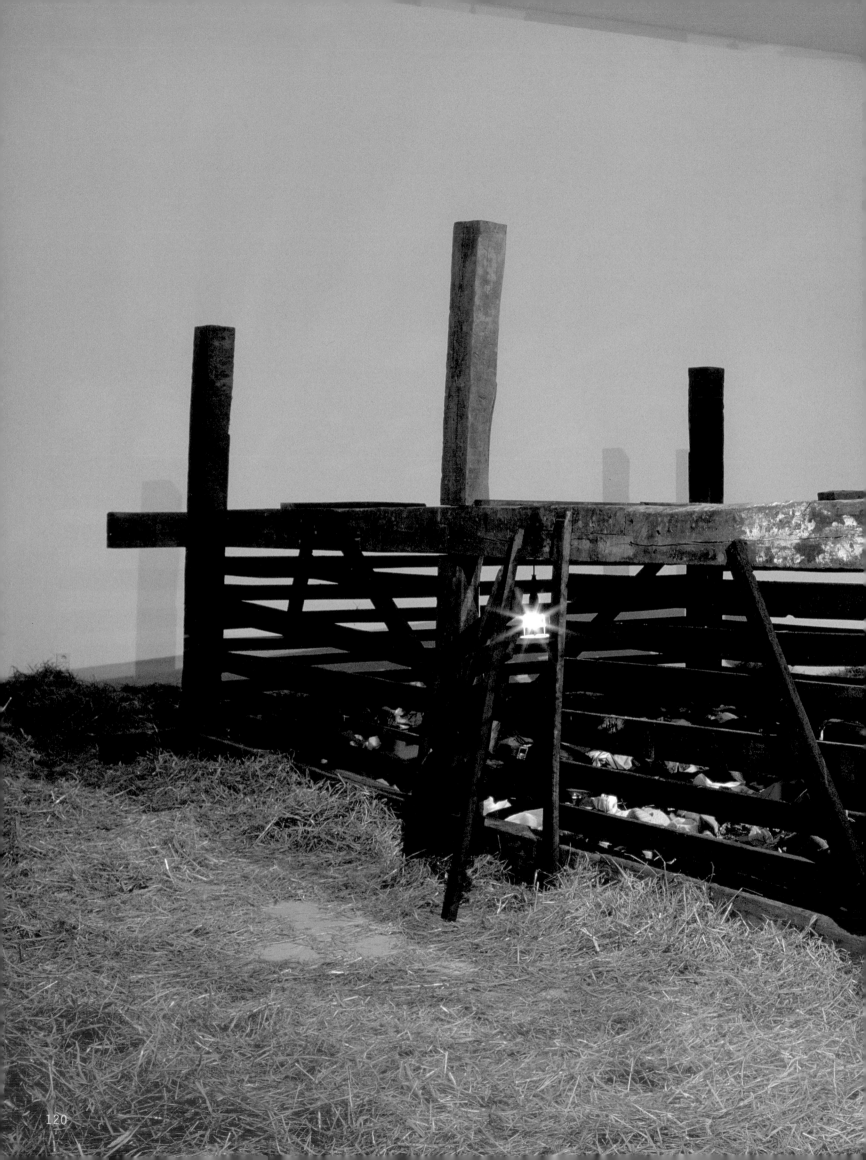

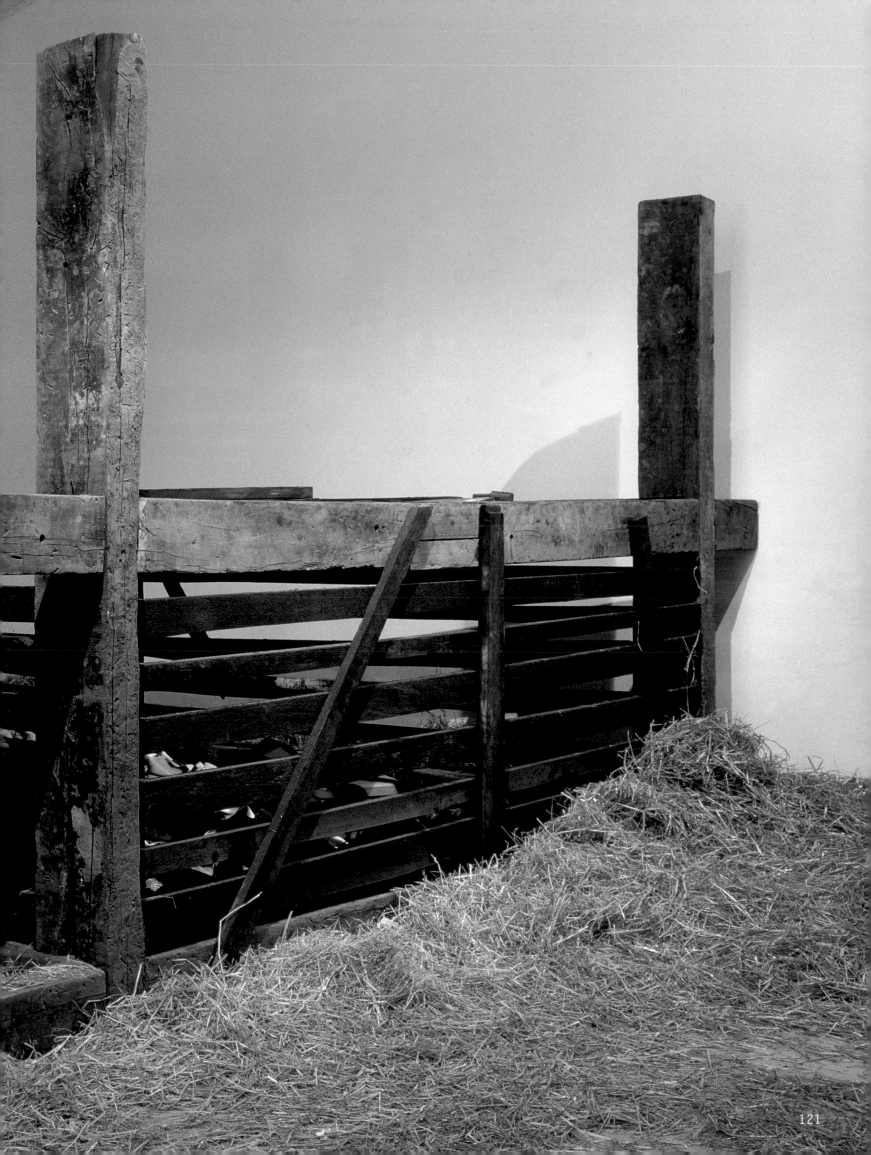

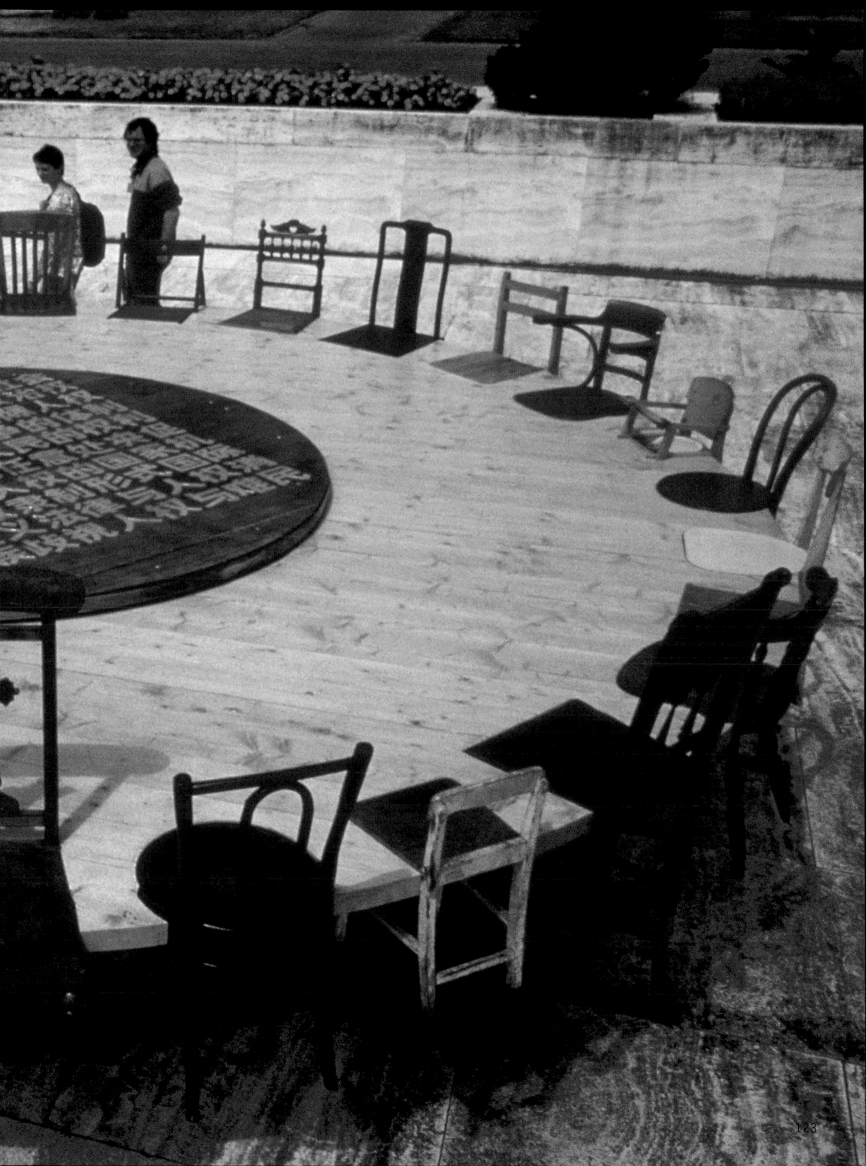

1993-1994

128

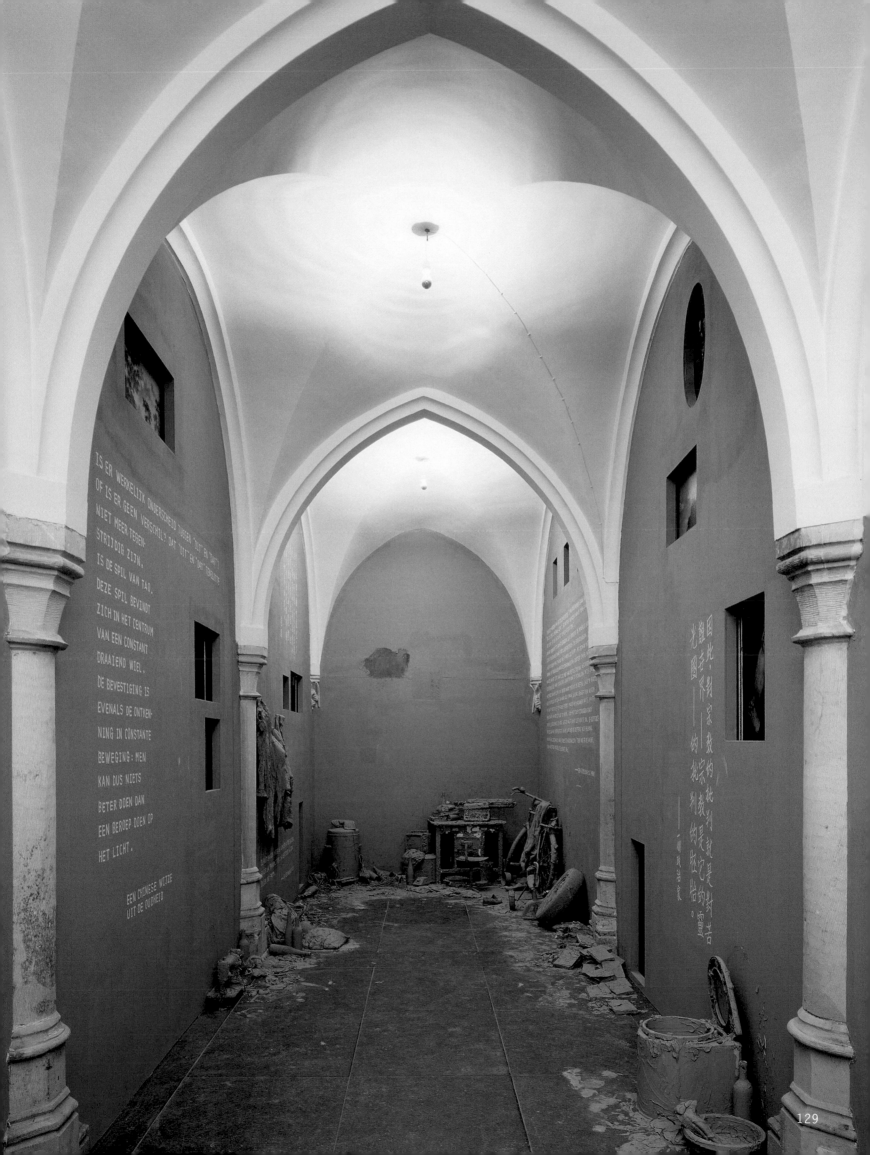

IS ER WERKELIJK ONDERSCHEID TUSSEN "DIT" EN "DAT"?
OF IS ER GEEN VERSCHIL? DAT "DIT" EN "DAT" TEGELIJK
NIET MEER TEGEN-
STRIJDIG ZIJN,
IS DE SPIL VAN TAO.
DEZE SPIL BEVINDT
ZICH IN HET CENTRUM
VAN EEN CONSTANT
DRAAIEND WIEL.
DE BEVESTIGING IS
EVENALS DE ONTKEN-
NING IN CONSTANTE
BEWEGING: MEN
KAN DUS NIETS
BETER DOEN DAN
EEN BEROEP DOEN OP
HET LICHT.

EEN CHINESE WIJZE
UIT DE OUDHEID

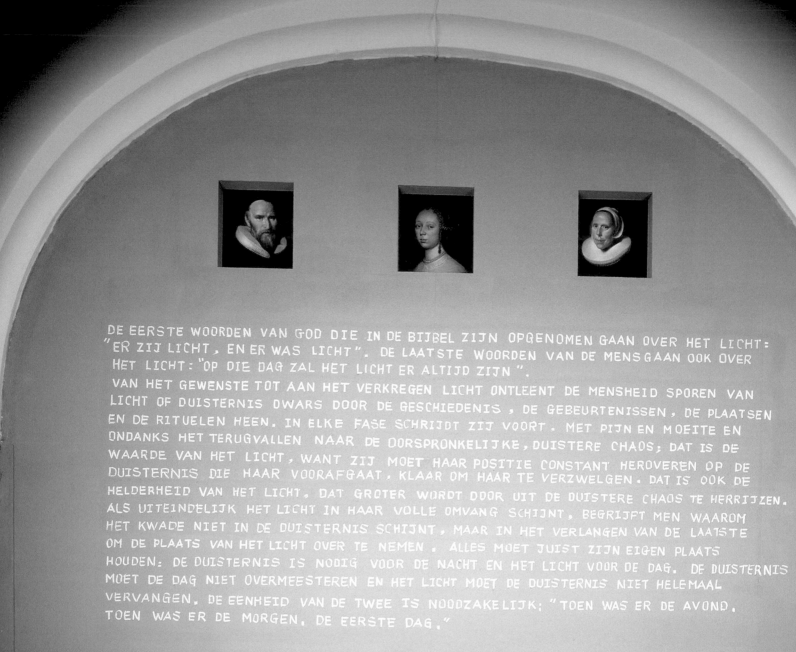

DE EERSTE WOORDEN VAN GOD DIE IN DE BIJBEL ZIJN OPGENOMEN GAAN OVER HET LICHT:
"ER ZIJ LICHT, EN ER WAS LICHT". DE LAATSTE WOORDEN VAN DE MENS GAAN OOK OVER
HET LICHT: "OP DIE DAG ZAL HET LICHT ER ALTIJD ZIJN".
VAN HET GEWENSTE TOT AAN HET VERKREGEN LICHT ONTLEENT DE MENSHEID SPOREN VAN
LICHT OF DUISTERNIS DWARS DOOR DE GESCHIEDENIS, DE GEBEURTENISSEN, DE PLAATSEN
EN DE RITUELEN HEEN. IN ELKE FASE SCHRIJDT ZIJ VOORT. MET PIJN EN MOEITE EN
ONDANKS HET TERUGVALLEN NAAR DE OORSPRONKELIJKE, DUISTERE CHAOS; DAT IS DE
WAARDE VAN HET LICHT, WANT ZIJ MOET HAAR POSITIE CONSTANT HEROVEREN OP DE
DUISTERNIS DIE HAAR VOORAFGAAT, KLAAR OM HAAR TE VERZWELGEN. DAT IS OOK DE
HELDERHEID VAN HET LICHT, DAT GROTER WORDT DOOR UIT DE DUISTERE CHAOS TE HERRIJZEN.
ALS UITEINDELIJK HET LICHT IN HAAR VOLLE OMVANG SCHIJNT, BEGRIJFT MEN WAAROM
HET KWADE NIET IN DE DUISTERNIS SCHIJNT, MAAR IN HET VERLANGEN VAN DE LAATSTE
OM DE PLAATS VAN HET LICHT OVER TE NEMEN. ALLES MOET JUIST ZIJN EIGEN PLAATS
HOUDEN: DE DUISTERNIS IS NODIG VOOR DE NACHT EN HET LICHT VOOR DE DAG. DE DUISTERNIS
MOET DE DAG NIET OVERMEESTEREN EN HET LICHT MOET DE DUISTERNIS NIET HELEMAAL
VERVANGEN. DE EENHEID VAN DE TWEE IS NOODZAKELIJK: "TOEN WAS ER DE AVOND.
TOEN WAS ER DE MORGEN. DE EERSTE DAG."

——— EEN GODSDIENSTIG MENS

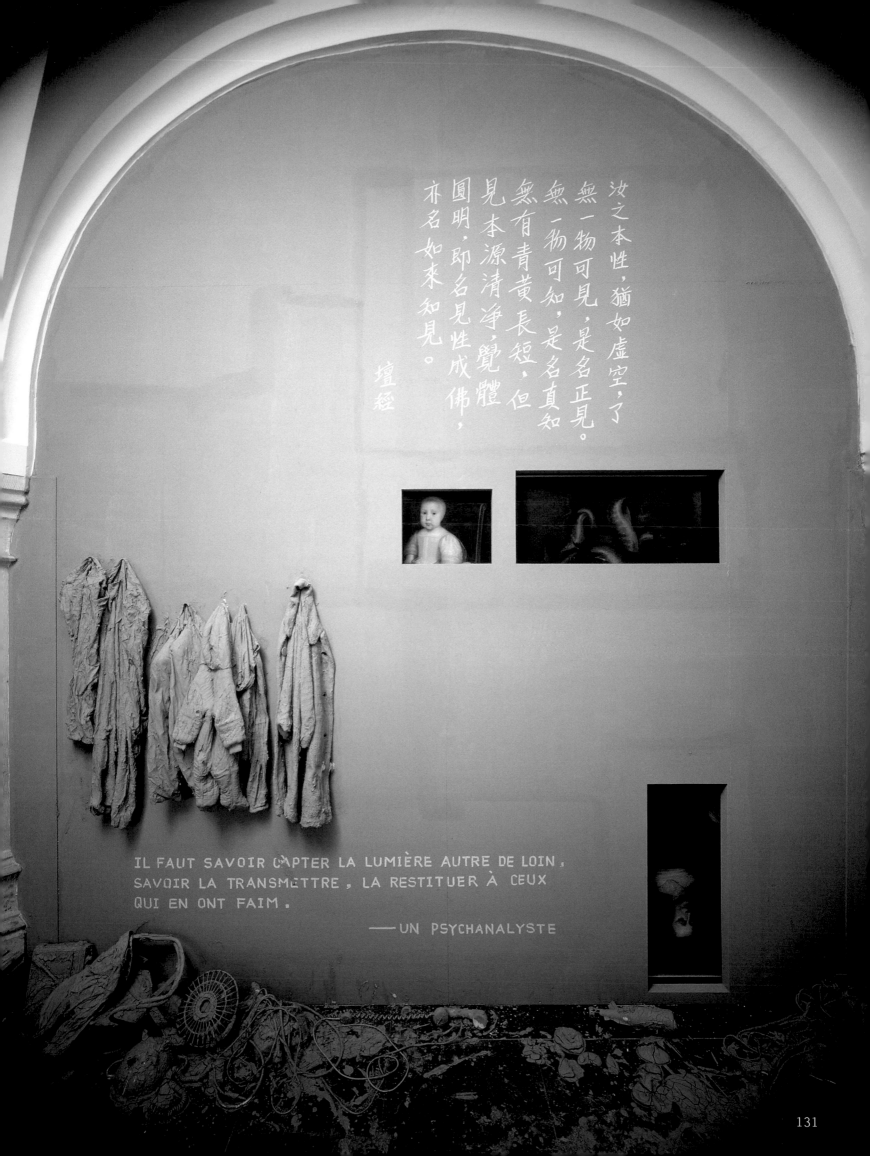

汝之本性，猶如虛空，了無一物可見，是名正見。無一物可知，是名真知。無有青黃長短，但見本源清淨，覺體圓明，即名見性成佛，亦名如來知見。

壇經

IL FAUT SAVOIR CAPTER LA LUMIÈRE AUTRE DE LOIN,
SAVOIR LA TRANSMETTRE, LA RESTITUER À CEUX
QUI EN ONT FAIM.

—— UN PSYCHANALYSTE

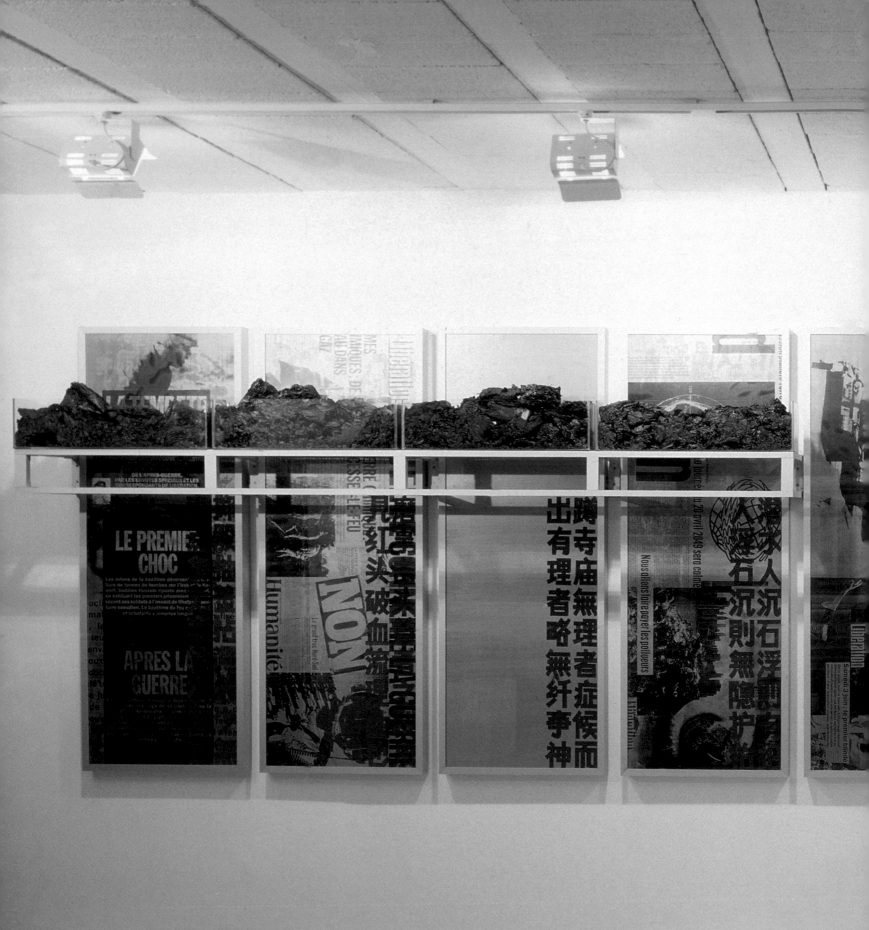

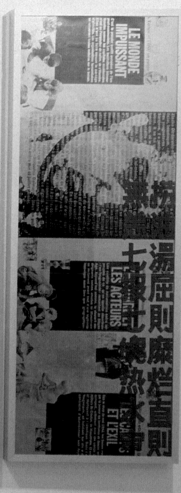

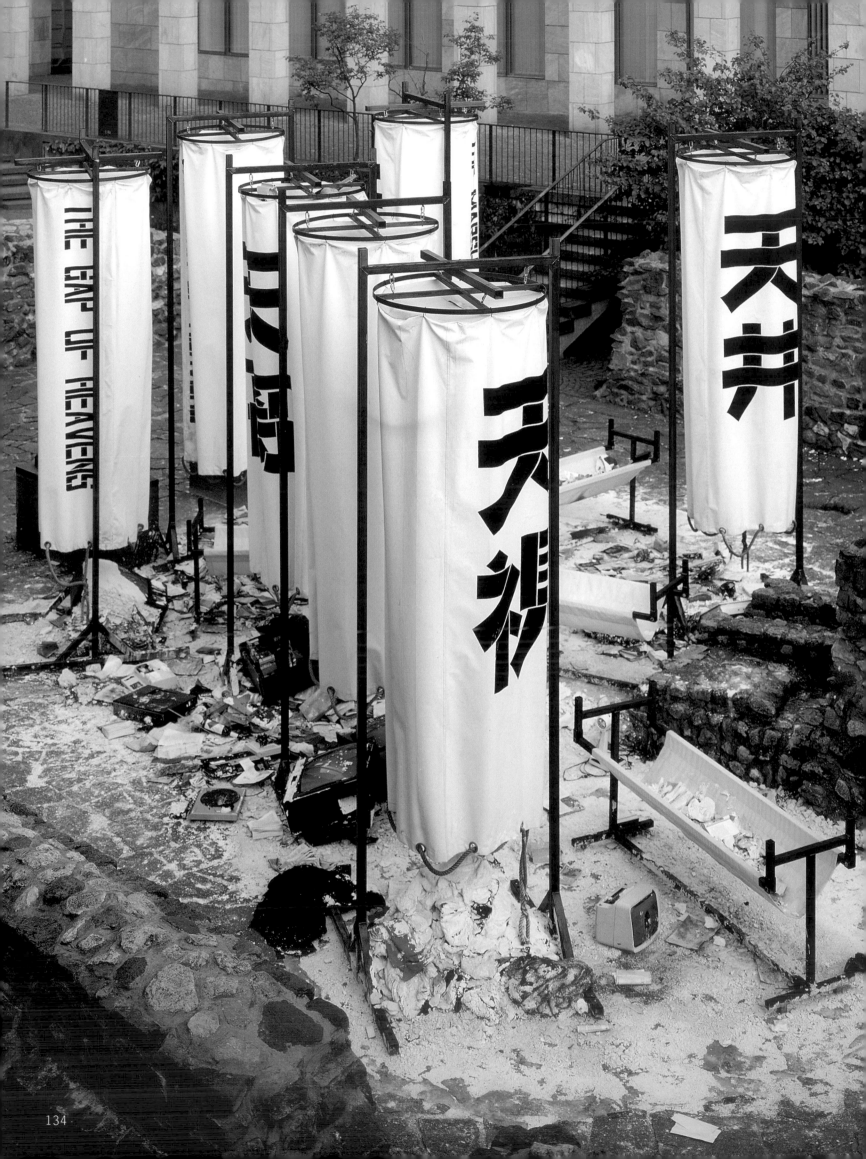

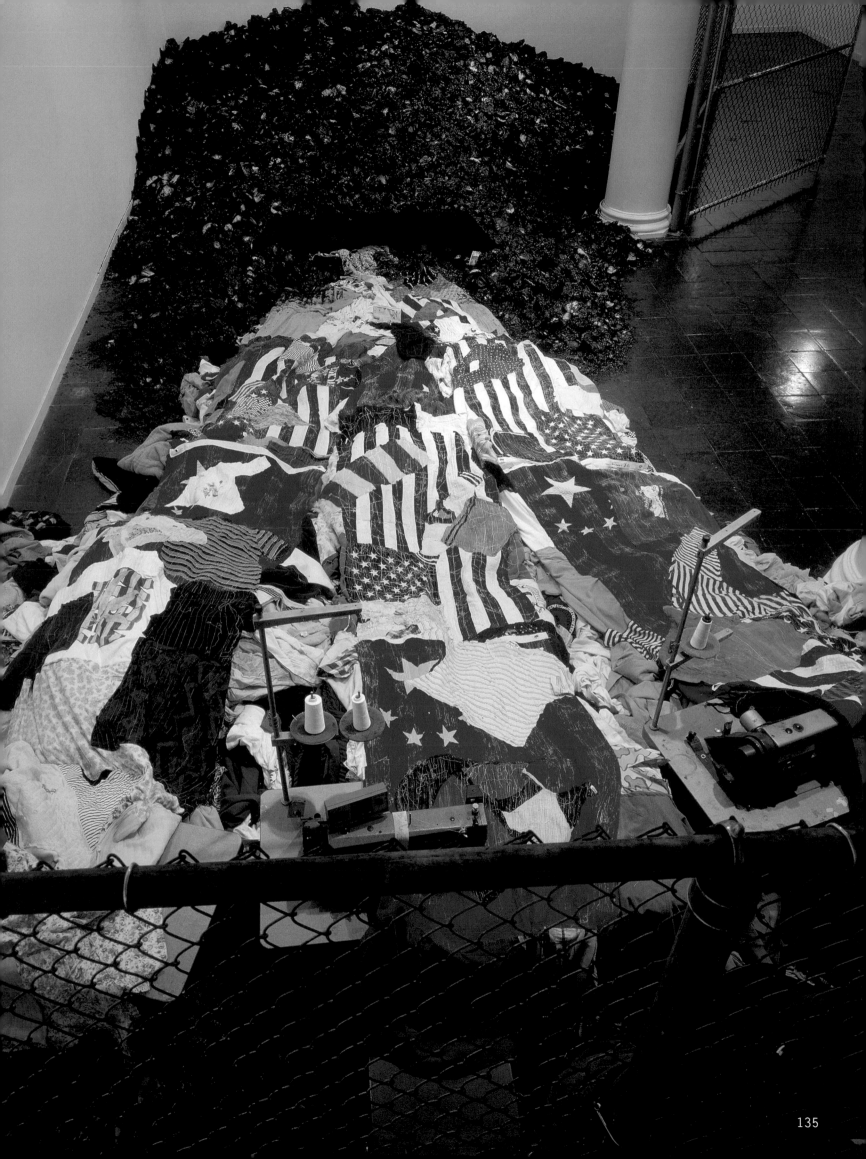

1991-1992

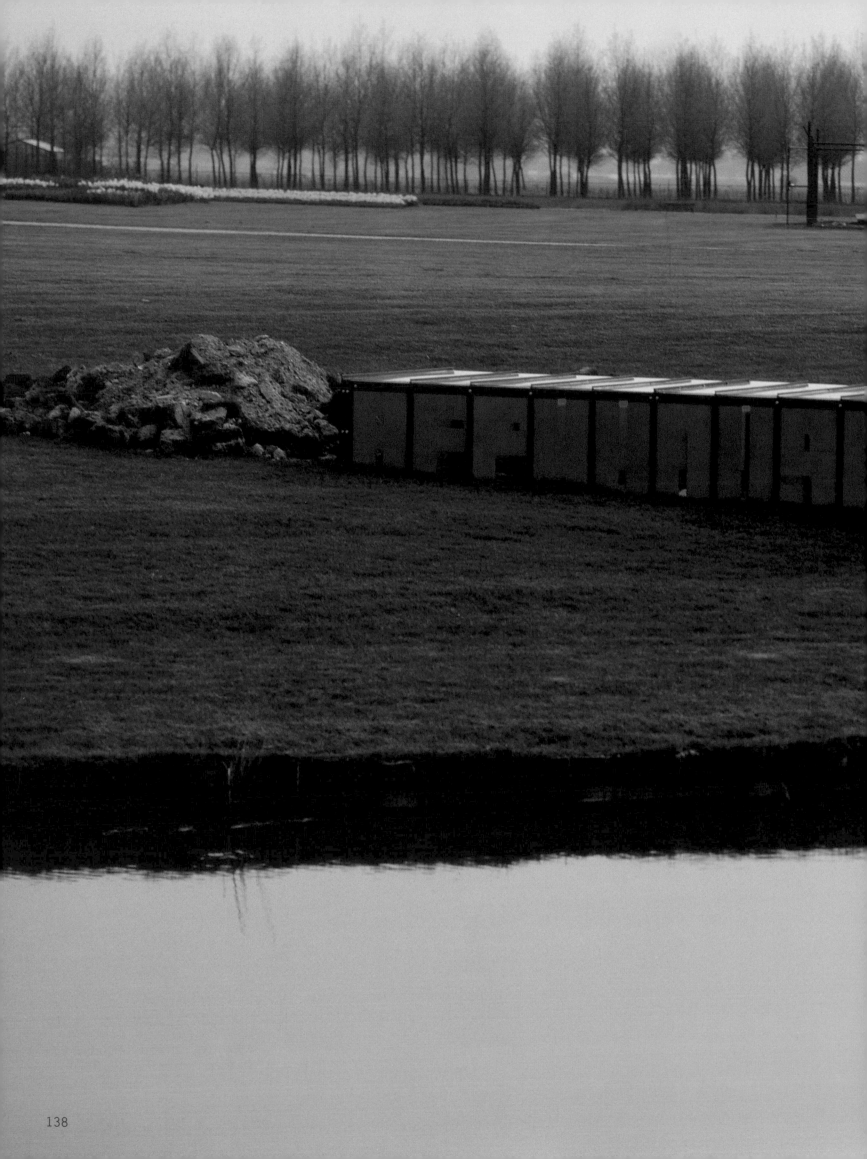

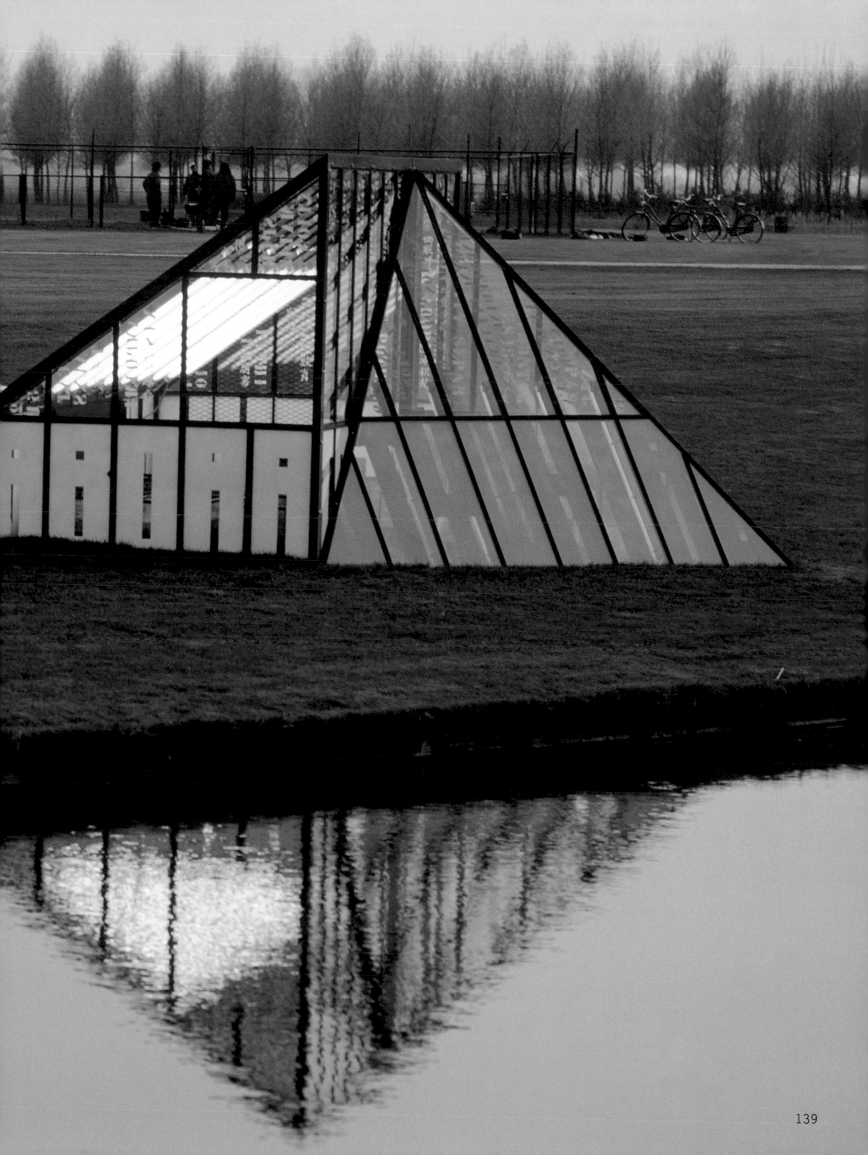

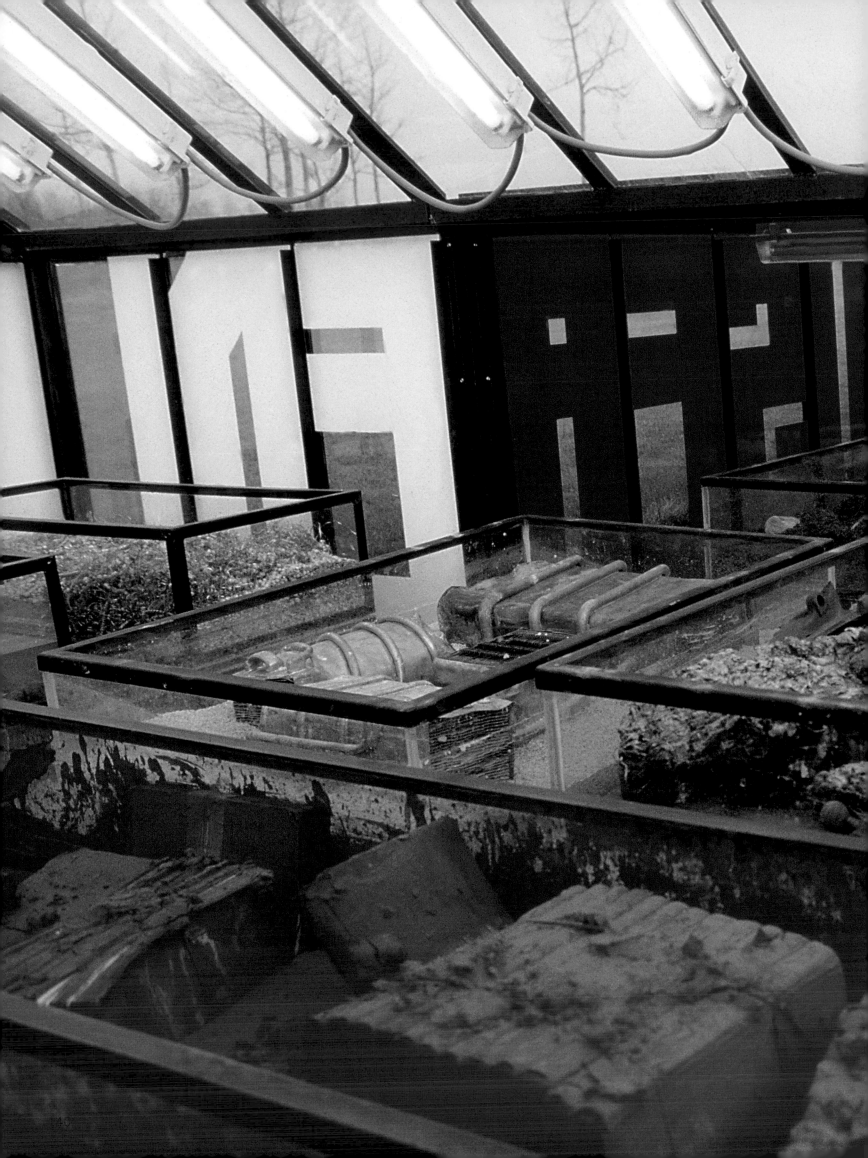

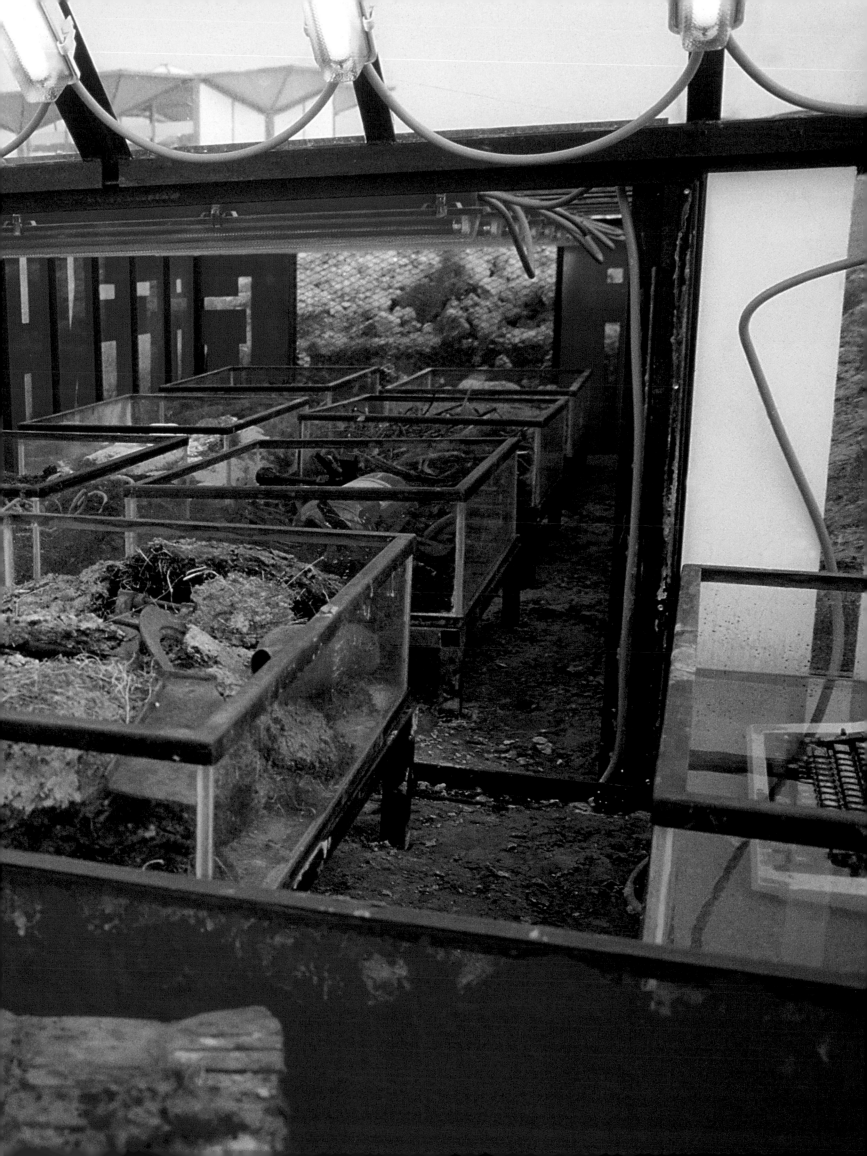

1990

154

Tributes

在 [] 爲藝術家的同時，[]
[]作意在審視自我，檢[]

爲醫生我也夢想。藝術創
自我，　并最終觀察世界
　　　　。　陳箴

This portrait of Chen Zhen was drawn in Central Park on May 17, 2002 by Li Ming. Li Ming was born in Beijing and for the last three years has lived and worked in New York. Chen Zhen supported himself as a portrait artist when he first arrived in Paris.

Who will bow and bend like the willow, who

 will turn and twist and reel

In the gale of simple freedom, from the bower

 of union flowing

Who will drink the wine of power, dropping

 down like a shower

Pride and bondage all forgetting, Mother's

 wine is freely working

Oh ho, I will have it, I will bow and bend to

 get it

I'll be reeling, turning, twisting, shake out all

 the starch and stiff'ning

-Shaker song, taught to us during the summer of 1996 at Sabbathday Lake, Maine

Sylvie ßlocher

Sometimes I go to see him

CHEN

ZHEN

MY SCHOOLMATE CHEN ZHEN
Cai Guo-Qiang

Chen Zhen and I were schoolmates. When I entered the Shanghai Drama Institute, though, in 1981, he was already close to graduating. He was the president of the school's student council and a leader in the Shanghai college student association. Had he continued down that road, we all thought he could have easily become the president of the school one day or, if he wasn't careful, a local party leader of the communist youth. He could have even been promoted to the central government. But unfortunately he had leukemia, which not only changed his personal history but also may have led him to become a great artist.

In around 1985, when I was organizing a show of young Fujian and Shanghai artists, my wife Hong Hong and I went to Chen's home to pick up a painting for the exhibition. I remember the visit very clearly: recuperating after an episode of illness, he was pale and swollen from the rest, nourishment and probably the medicines, but full of passion and energy as always. His wife, Xu Min, meanwhile, was ever so gentle and lovely. Pregnant at the time, she showed us canvas after canvas of Chen's work in a series entitled "*Qi You Tu*" (Energy Movement Pictures). He also had a thick stack of his own writings on his work and on *qi* (energy force), though I don't know if they were ever published. The paintings were quite large, gray and astringent in tone. Unlike much avant-garde work in China at the time, they were not exaggerated or extravagant, yet they were very distinctive. I picked two or three of the smaller canvases for the show, because lack of funding demanded that we physically carry all of the work with us on the train.

In 1986 Chen went to France and I went to Japan. We didn't see each other again until 1990, when we were both in an exhibition in Aix-en-Provence. He was tanned and looked very healthy, but seemed to have gone through some struggle. He wore a photographer's vest, and seemed to me very much an artist — very different from the leader figure he had been in our school days. But he was as well spoken as ever and had kept his ability to delegate and his power to think analytically. After that, our contacts became much more frequent. We would often work on several exhibitions together within a single year. Much to my envy, Chen was fluent in both French and English, and was always helping me out. The only consolation for me was that I didn't need to work so hard as a result.

In 1999 we spent several weeks together in Salvador, Brazil, for a Quiet in the Land project. Always working and rarely taking holidays, Chen was surprised at how cheap everything was when our families vacationed together then. He was a great sportsman, could pick up any sport and play it well. He always demonstrated to us that he was the best, but at that time, he also began to recognize that his son, Chen Bo, had grown to be a worthy contender. On the opening day of the exhibition, while I worked with the students from my class to prepare our cannons to fire for the opening ceremony, it started to rain. We were all completely soaked, and barely got the cannons to shoot. I wanted to go home and change, but Chen insisted on staying to watch the performances of the other artists; he didn't want to miss anyone. So I went by myself, and came back with a change of clothes for him but he refused them, saying he was almost dry already.

It was in Brazil that Chen used candles for the first time, a medium he would explore until the end. In that last year he also worked with crystals and medicines, becoming very focused on the body and health. Each work was stronger than the last, full of spiritual energy. His art, life, and body had merged into one. The ideas were crystallized to the core. They reminded me of that paper he had written years earlier on *qi*. We had worked so well together over the last decade of his life. Each of us always understood and appreciated what the other one was doing. Every time we met he brought news and stories about people and events in the art world. We worked on many exhibitions together, met many people together, and played together in this arena, like schoolmates playing soccer after class, sometimes with other people, sometimes with each other. And here, Chen Zhen, though you are not present to play, your game is still going on.

ALWAYS HAPPY WITH YOU

chen loves basket ball

CHEN ZHEN

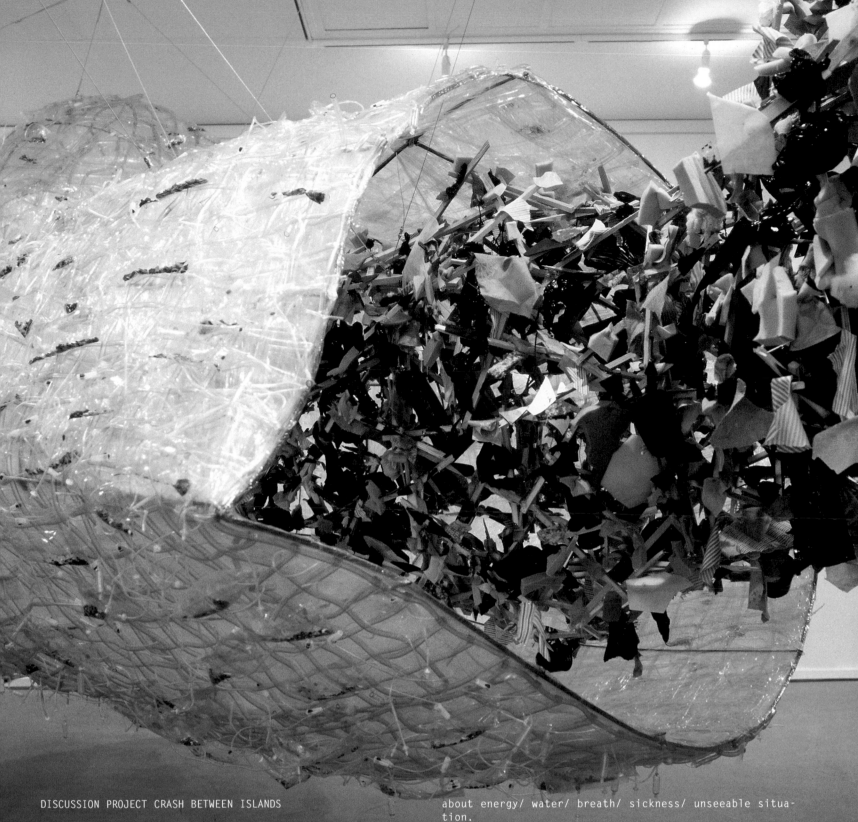

DISCUSSION PROJECT CRASH BETWEEN ISLANDS

Chen and I started by talking about what elements in the museum we were intrigued with and what about these elements we find could translate into our project. This space was not as large as we had assumed from seeing the photos. Although we found it to be a neutral space it presented some problems for our early idea of a high and low situation. (Sky, cloud / ceiling, water / sub underneath).
Immediately we changed perspective of what we had to do, how we would have to work in the space. Chen talked about an image of a boat rudder suspended from the ceiling and I talked about the fish trap I saw with its basket like appearance. Our second idea involved the notion of a trap catching whatever came into its body. I believe that this was a significant object because it brought us into a dialogue about the relationship of a virus to its host, not as a linear relationship but as a cycle constantly changing position. We started with nothing again. Talking

about energy/ water/ breath/ sickness/ unseeable situation.
We talked about steam, sound, residue of impulses until Chen started talking about his illness, his virus, trying to maintain a balance. Our conversation turned to medicine dependency and finding strength in your position regardless of what it is. I mentioned to Chen that we should use water but we both agreed that this may be too literal. How to form liquid? We spoke about the energy of the project that it should be nothing of form. Then we came back to the idea of the trap, one form inside the other. This idea of a double trap, a sort of co-dependency became very interesting. Trap as a situation, sexual, virus/hosts, rudder. Movement change alters.

Nari Ward

Arkipelag· From Crash Between Islands to In(ter)fection,
1998
Sjohistoriska Museet, Stockholm, Sweden
Collaboration with Chen Zhen

175

Artist´s Statements

PRECIPITOUS PARTURITION
1999

A dragon-snake like body of 25 meters long made of inflated black bicycle inner tubes, hides in-between the roof and the ceiling (wood roof beam) in one of the Museum's rooms. At the central part of this body, the big tripe of the "dragon" is giving birth to countless toy cars (painted in black, about 3—5cm). This spasm of birth gives us an impression of invasion and catastrophe around the body and in the space, and shows at the same time a power and energy of generation and multi-plication.

During a trip to China several years ago, I saw a government slogan "Year 2000th, 100,000,000 Chinese will have their own cars. Welcome to China for the competition of automobile indus-try!" Isn't this parturition "from bicycles to cars" a metaphor of this ambition or future cata-strophe? An image of future Asian cities and the entire world?

Chen Zhen

HUMAN CONSTELLATION
1998

Human Constellation is based on the idea of sym-bolically gathering the citizens of Paillade (with the chairs) around a sphere (two half-spheres) like a large family, a constellation. The project maintains a physical and visual simplicity in order to explore various complex questions: equality, conviviality, dialogue, universality, difference, tolerance, meeting, etc.

It builds itself up into space like a circle in motion, a verticality for the human spirit between the earth and the sky.

Chen Zhen

INVOCATION OF WASHING FIRE
1999

The project presents an ironic and critical metaphor for the "medical-alchemical treatment" of the inner disease of Asia's success and its crises. The "fever" is characterized by diverse diagnostics such as making up for lost time; quickly having what Westerners have; following the latest fashion of Microsoft; razing all that is old; selling the earth to attract foreign investments; encouraging "cultural self-colonial-ism" for urbanism, etc. This is considered by the project as the "fire." It needs to be cooled down or purified — "Washing Fire."

This "furnace," through its abacus-wall, washing stove chamber and high-tech trash can, reflects contradictory layers of our time: old and new, money and spirit, materialization and immaterial-ity, desire and calmness... It's a contemporary alchemy of human contradictions, a metaphor of the globe.

In the Chinese alchemy, the fire could be cooled down and purified by water, but it could also be also harmonized and even reinforced by water. According to the transmutable logic of the "five elements" in Chinese philosophy, the water could "produce" the gold. Doesn't "Invocation of Washing Fire" also become a tower of Asia's desire and future utopia by its own destiny?

Chen Zhen

IN(TER)FECTION
An installation by Chen Zhen & Nari Ward, from *"crash between islands"* to *"In(ter)fection."*
1998

We continued our discussion after our visit to the National Maritime Museum.
Brief summary of our talk:
— What's the significance of doing a collabora-tive project? We are not the representatives of two continents, but two islands — two individu-als, how can we make a work which challenges our creative process?
— It is not a bi-cultural meeting in the general sense of multiculturalism but an encounter on the level of confrontation, even conflict between two energies.
— We would like to construct a relationship of mutual penetration, a field of vitality and strength yet fragile and dependent.
— The project is to have an inner linkage to the context of the Museum. We will attempt to escape the all too evident dialogue in relation to "the site" towards a more personal interaction.
— We will undertake a voyage of ideas, thoughts, emotions and change, focusing beyond the external towards a "biological meeting" — a kind of in(ter)fection between us.
Installation:
Two huge trap-like structures enter the middle of the space from opposite walls. One is a metal structure covered by 1500 transparent I.V. bags and plastic tubes; another is bedsprings, glass, found objects, wire strapping, silicone and black stencil ink. In the middle the dense glass area penetrates the transparent bags as if a violent flow invades a fragile territory which, in turn, conceals its body like a trap for grasping the penetrator.
Is this a double trap, which is becoming a mutual protection? Could the fragility and aggressive-ness of glass and perfusion bags be interpreted as the "virus" and "antibody" for an in(ter)fec-tion? How does this project translate into a life model: the crash, the birth, the experience, the death and the possible rebirth?

Chen Zhen & Nari Ward

JUE CHANG
"Fifty Strokes to Each" (Buddhist maxim)
1998
Jue Chang = The original meaning: "The Peak of Poetic Perfection"
Could be interpreted: "The Ultimate of Human Voice (Music)"
"Jue Chang" is a huge "percussion instrument" comprised of about 100 "drums" transformed from chairs (about 100) and beds (about 5) collected from different parts of the world (mainly from the Middle-East).
At least sixty "drum-batons" are made by transforming police clubs, fragments of arms and ammunition, stones, and all kinds of branches, pieces of wood, metal tubes, etc.
Throughout the duration of the exhibition, viewers will be informed that they can play with this instrument as they wish.
The opening of the exhibition will be a "Concert." The first part of which will be organized (ideally, three Tibet Buddhists will be invited to play the Overture). The second part will be played by the professional musicians, and the third part will be improvised by the audience.
In the "Jue Chang," the idea of "beat" or "strike" comes from Chinese Buddhist (Zen) tradition. "Bang He" (giving a lesson with a stick) means that the person who wants to pray to Buddha or talk about the spiritual side of Buddha should be beaten, because the real "Buddhist Heart" can never be spoken or written to. "Fifty Strokes to Each" means that the two parties in a dispute or conflict should each be given fifty strokes (on the buttocks). According to Buddhism, "this is the most efficient way for settling a conflict." In contemporary terms, one should show self-restraint in order to achieve tolerance. This Buddhist "beating" and "striking" tradition has inspired the idea of the huge "percussion instrument" for "Jue Chang."
Here, the "beating" or "striking" does not imply a continuity of real violence, but instead, it leads to a kind of self-awareness — "drumming an awakening into the mind." It is a kind of metaphorical expression: instead of striking people, one beats (drums) the place (object) where people sit or sleep; one can also see it as a "medical treatment:" "poison against poison" (a very characteristic Chinese concept).
To emphasize the power of this metaphor, "Jue Chang" is composed of three elements and two levels of confrontation: the drums, the drum-batons and the drummers (three elements); the confrontation between the drum (symbolizing man) and the drum-baton (representing violence), on the one hand, and the meeting between the whole instrument (including the batons), and the visitors or audi-

ence (drummers) on the other. With the participation of the "audience," this "percussion instrument" suddenly becomes a source of music, a "hollow voice," which transcends language and writing, becoming a kind of spiritual ceremony and "contemporary sorcery." So, the absurd, incisive and ironical sense of the project is sublimed by this music, which can be made by everyone.
"Jue Chang" is a unique "plastic installation." It is not only a "communicational object," but also an "object of creation" in which the audience is actively involved. It provides a "collective experience" and "transexperience." It alludes to the seriousness through music, while staining the heaviness, even violence, with poetry.
For me, "Jue Chang" is a conceptual and emotional project. The creation of "Jue Chang" was stimulated by the historical and actual contexts of the Middle-East, but must not necessarily apply to this region alone: "Jue Chang" questions generally all kinds of disputes and conflicts in the world (national, religious, territorial, political, social, ideological, economical and cultural), and tries to "offer" an efficient solution. By trying to translate the negative into positive, and to consider the negative from a positive state, "Jue Chang" presents itself as "the possibility of attaining self-enlightenment and self-revelation," making the Ultimate of Human Voice. Hopefully, after the show at the Tel Aviv Museum of Art, "Jue Chang" will travel around the world, beaten, stricken and drummed by all people.

Chen Zhen

PRAYER WHEEL
"Money Makes the Mare Go" (Chinese slang)
1997
"Prayer Wheel" is an installation physically based on two spatial points: "pass through" and "underground."
The first point is linked with the labyrinth-like structure of a huge building. The idea of putting a turning wheel between passages is intended to allow everyone to "pass through" this object. The second point is related to the atmosphere in the basement, which is very cold, humid, fantastic and dreamy. So the "paper temple" and the "trash-lanterns" become a dialogue with such an environment.
"Prayer Wheel" is also a reminder of my own experience in Tibet during the three months before I left my country. Turning the prayer wheel was a very important ritual of my daily experience that gave me many strange feelings and tremendous mental illuminations.
In this project, the sense of the wheel is metaphorically transformed. Capitalism is becoming the world religion, which implies that every-

body should "pass through" this wonderful dream of monetary wealth, even in my own country of China, which still remains a communist-socialist society.

Trying to bring good luck to the people, "Prayer Wheel" insinuates ironically that the human mind is like a "turning machine of coins" with an obsession for prosperity.

People turn the wheel praying for wealth; "Money Makes the Mare Go," and thus the World.

Chen Zhen

FU DAO / *FU DAO*
"Upside-down Buddha / *Arrival at Good Fortune*"
1997

In spring 1993, after 8 years of living and working in the West, I came back to China for the first time to experience the tremendous changes and tried to realize the actual mutation and the future tendency in Asia through a city like Shanghai. After frequent visits and through observations and inspirations from such a massive area, along with my experience in conceiving and realizing my projects in the different Asian countries, I found that this Oriental world has not only already taken shape economically and politically as a energetic block which contends with Europe and America and incontestably decentralizes the world, but also creates a very intensive "central territory of eastern-western conflict" in terms of culture. In other words, one should, as an Asian artist, not only refer to the movements in the West to prove the existence of differences and hybrids in order to question or disclose the colonialist root of western-centralism and to create "my own world" in the West, but one should also be conscious that Asia is just "the biggest center of conflict between East and West."

In winter 1995, when I entered a restaurant in Shanghai, I saw a strange thing: a big Chinese word "good fortune" was written upside-down on the door. I asked what had happened. "You shouldn't look at the word, but read it," a friend said. I understood suddenly: the pronunciation of the word "upside-down" is the same as "arrival at good fortune."

The project "Fu Dao/Fu Dao" interrogates: how does the oriental tradition of "getting wealth" function as it is mixed with and echoed through the different folk conventions, the superstitious beliefs and religious rituals in the recent Western materialized society? What is the relationship and meaning in today's Asia between the Buddha and divinity or money, or politics and power, otherwise and spirituality? How will the Asian people construct our own modern society, contemporary culture and particular political

system in such a background where the omnipresence of Buddha and the confusion between the spirit of dematerialization and the obsession of prosperity dominates?

Chen Zhen

OPENING OF CLOSED CENTER
1997

The Quiet in the Land is an unique experience. It was an unbelievable chance, for someone who is Chinese, to have an idea of how the Shakers live in such a special context, to experience their spiritual world and to re-experiment the quality of rural life and hand-work. But it was also an incredible occasion, which made me recall the "Re-education in the Countryside" during the Cultural Revolution. It reminds me also of my three month stay in Tibet, just before I left China for the West, where I had a tremendous mental illumination from living with the Tibetans. For me, the essential meaning of this experience would be to re-find the natural quality of human beings; to re-judge the value of materialization and de-materialization in our mind and to re-estimate the balance, in relation to the creation, between the "visual," the "conceptual" at the intellectual level and the "experiential" — "experimental" concerning life. In other words, it questions where the fundamental inspiration of art today comes from.

So, such a inter-superposition of my own experiences between past-recent, oriental-occidental and "I-others" enhances and deepens what I call "Transexperiences."

The *Opening Of Closed Center* is a dialogue and a continuous reflection of this experience.

It interrogates: what is the meaning for contemporary man of "sitting" in such a disturbing world? Is there a double sense of the objects of everyday life, both on the material and spiritual level? Is it necessary for it to be "closed," by being more open?

The idea of "sitting" comes from the Buddhist and Zen tradition: sitting in the "sphere," sitting against the wall, sitting for seeing and thinking nothing, and sitting as an eternal sleeping. The *Opening Of Closed Center* is a "chair of Nirvana," a "bedroom of emptiness."

The installation consists of three suspended parts on a metal structure: a "room-bed" like space which is horizontally closed and vertically half-open. In the middle of this room, there is a "closed-circle" chair with the legs of cradle system and a suspended altar on which is filled the objects which play a role as the basic inseparable materials for life, and the protection for "the closed sitting," the meditation.

In the exhibition space, the *Opening Of Closed*

Center will be surrounded by another work called *My Diary in Shaker Village* (27 frames) which are fixed on the wall. Hence the *Opening Of Closed Center* is confronted with the *Diary* in a way such that what is "intimate" (the diary) becomes an open dialogue with the Shakers (through the portraits) and the public, as a "life-exchange." What is "un-intimate" (a chair) becomes on the contrary, a self-closed space. Here, if the "Chair of Nirvana" is a metaphor of the "timeless-sitting," the *Diary* reflects, in an almost opposite way, the "daily experience" reminding me of a Buddhist maxim: "Living means the experience of one day after another."

Chen Zhen

CHAIR OF NIRVÂNA
1997
A group of chairs (10–12) from various cultures are gathered and transformed into a single large chair.
This chair is composed like a "self-contained circle" that maintains a single space for maximum concentration. As a Chinese proverb says, a chair "entering in this world without any vulgarity." A chair that questions spiritual isolation through the quotidian. A chair that belongs to everyone. The base of this chair is metamorphosed by a balancing act, such as a cradle that suggests the eternal cycle of human life and the eternity of the spirit.

Chen Zhen

ROUND TABLE — SIDE BY SIDE
1997
Concerning *Round Tables*
Round Table was initially a project consisting of a series of three different tables. The idea of collecting and sending the chairs from one continent to another was closely tied to the realization of three tables which would be destined to remain — as the "markers of the world" — on the three continents (Asia, Europe, and America) the artist has lived and worked in for many years. The first table was based on the sense of the "around:" a meeting, a dialogue, a negotiation, perhaps even a transaction.
The second table will be based on the concept of the "side by side:" a metaphor of the "eternal misunderstanding," which is born out of how the desire to interact is frequently faced with the impossibility of truly reaching across differences in cultures and ideologies.
The third table will be tied to the idea of "face to face:" the insinuation of opposing elements, the arguments, the political and cultural conflicts around the world, and the confrontation between wealth and poverty, etc. This project

will be realized in South America.
The project of these three tables is my metaphorical vision of the world seen though my personal experiences, which have been very nomadic and decontextualized for almost 30 years: 10 years during the Cultural Revolution, 10 years of Chinese Reform, and 10 years in the West.

Chen Zhen

DAILY INCANTATIONS
1996
The idea of "Daily Incantations" comes from my personal experience during China's Cultural Revolution. Every morning, the noise of washing chamber pots rose and fell on my way to school. Stepping into the school and coming into my ears were the "daily incantations" — every morning, all people were forced to gather to read Mao's "Red Books" in order to "cleanse the soul." If the first is an everyday exercise of the city's life, a part of the traditional heritage, the latter is a result of political pressure, a religious inculcation or "a mental insensitiveness." Such a double "incantation" of everyday life and "mental insensitiveness" is in fact an essential element of human history as well as a basic aspect of today's life.
The main material in the work is the old Shanghai style chamber pot. What is interesting to me about it is that it is, first of all, not art. It is an ordinary object for daily use. The Chinese have a double concept about the chamber pot: the first is that most people view it as an ugly thing. The second is that those who believe in superstition think that the chamber pot is the "son and grandson stool." It helps to propagate and reproduce, and to carry the generations onward: an ugly thing with a great value. The intrinsic duality of this object is very close to the inner quality of what I would like to find in my artistic reflection and to express through my work. Furthermore, in line with Western urban policies, a chamber pot is a thing to be discarded, a thing that is becoming extinct. Therefore, it has a close relationship with such concepts as "the West," "modernization," and "supplanting the old with the new."
Such a duality is reinforced by the title itself. The word *Zhou*, translated as "incantation," has both negative and positive connotations. While it refers to the weaving of spells and verbal charms, it can also mean the swearing of a deadly curse. The mixture of the sound of chamber pot washing and political preaching creates a kind of religious atmosphere which makes one experience the pleasure of transcendence from the mundane noises to the sacred, mental insensitiveness.

Chen Zhen

Captions

(32&33) *Zen Garden*, 2000
Alabaster, metal, wood, plastic plants, light
175 x 340 x 300 cm
Collection: Anthony T. Podestà, Washington, D.C.
Courtesy of Galleria Continua, San Gimignano, Italy
Photo: Attilio Maranzano

(34) *Project Mental — "Zen Garden n.5,"* 2000
Chinese ink on paper
100 x 70 cm
Collection: Desiree and Franco, Torino, Italy
Courtesy of Galleria Continua, San Gimignano, Italy
Photo: Ela Bialkowska

(35) *Project Mental — "Zen Garden n.4,"* 2000
Chinese ink on paper
100 x 70 cm
Courtesy of Galleria Continua, San Gimignano, Italy
Photo: Ela Bialkowska

(36–39) *Diagnostic Room*, 2000
Chinese ink on paper, timber, chamber pots, metal, glass,
straw, ashes from newspapers, 378 Chinese medicinal herbs,
pumpkins
Waiting room: 198 x 350 x 350 cm, 6 drawings: 150 x 80 cm
each, consulting room: 240 x 400 x 378 cm
Produced for GAM, Torino, Italy
Collection: GAM

(40&41) *Nightly Imprecation*, 2000
Chamber pots, wood, metal, Plexiglas, bed, ventilator, balls,
motion-sensor
245 x 910 x 380 cm
Installation view: Art & Public, Geneva, Switzerland
Collection: private
Photo: Art & Public, Geneva, Switzerland

(42) *Silent Sound*, 2000
Chairs, chamber pots, iron, sound system, small bronze bells
176 x 140 cm
Produced for GAM, Torino, Italy
Courtesy of Galleria Continua, San Gimignano, Italy

(43) *Bathroom*, 2000
Iron bathtube, chamber pots, metal, red lights, sound system
180 x 105 x 70 cm
Collection: Andrea Pelù, Firenze, Italy
Courtesy of Galleria Continua, San Gimignano, Italy
Photo: Ela Bialkowska

(44&45) *Jardin Lavoir*, 2000
Beds, metal, basins, waterworks, objects
2000 x 1800 x 600 cm
Installation View: Cimaise & Portique, Centre départemental
d'art contemporain, Albi, France

(46&47) *Danser la Musique*, 2000, maquette
Metal, bronze, rope, cloth, sockets, everyday objects
500 x 500 cm
Installation: Art for the World
Project chosen by the Jury of the exhibition Playground and
Toys, Rome, Italy

(48&49) *Maison Portable*, 2000
Mixed media, wood, metal, candles
203 x 65 x 120 cm
Collection: Private
Courtesy of Art & Public, Geneva, Switzerland

(50&51) *Inner Body Landscapes*, 2000
Five iron structures, colored parafin wax candles
Yellow: 120 x 130 x 90 cm
Red: 130 x 120 x 80 cm
White: 121 x 173 x 91 cm
Black: 210 x 111 x 80 cm
Violet: 142 x 100 x 60 cm
Total dimensions variable
Collection: Anthony T. Podestà, Washington, D.C.
Courtesy of Galleria Continua, San Gimignano, Italy
Photo: GAM Torino-Maurizio Elia

(52) *Study for "Inner Body Landscapes,"* 2000
Chinese ink on paper
70 x 100 cm
Collection: Anthony T. Podestà, Washington, D.C.
Courtesy of Galleria Continua, San Gimignano, Italy
Photo: Ela Bialkowska

(53) *Study for "Inner Body Landscapes,"* 2000
Chinese ink on paper
100 x 70 cm
Collection: Private
Courtesy of Galleria Continua, San Gimignano, Italy
Photo: Ela Bialkowska

(54) *Autel de lumière*, 2000
Children's chairs, candles
38 x 39 x 84 cm
Collection: Xavier and Karine Donck, Deinze, Belgium
Courtesy of Galleria Continua, San Gimignano, Italy
Photo: Attilio Maranzano

(55) *Autel de lumière*, 2000
Children's chair, candles
68 x 36 x 37 cm
Collection: AGI, Verona, Italy
Courtesy of Galleria Continua, San Gimignano, Italy
Photo: Ela Bialkowska

(56&57) *Six Roots Bed II*, 2000
Hospital bed, candles, white bulbs, tile
132 x 220 x 97 cm
Installation view: Museum of Contemporary Art, Zagreb,
Croatia

(58) *Black Broom*, 2000
Rubber tubes, syringe needles, timber, metal
300 x 50 cm
Collection: AGI, Verona, Italy
Courtesy of Galleria Continua, San Gimignano, Italy
Photo: GAM Torino-Maurizio Elia

(59) *Bibliothèque Musicale*, 2000
Chamber pots, electronic material, sound system
240 x 118 x 70 cm
Collection: Private, Asiago, Italy
Courtesy of Galleria Continua, San Gimignano, Italy
Photo: Ela Bialkowska

(60&61) *Crystal Landscape of Inner Body*, 2000
Crystal, iron, glass
95 x 190 x 70 cm
Collection: Anthony T. Podestà, Washington
Courtesy of Galleria Continua, San Gimignano, Italy
Photo: Attilio Maranzano

(62) *Study for "Crystal Landscape of Inner Body,"* 2000
Chinese ink on paper
100 x 70 cm
Courtesy of Galleria Continua, San Gimignano, Italy
Photo: Ela Bialkowska

(63) *Study for "Crystal Landscape of Inner Body,"* 2000
Chinese ink on paper
100 x 70 cm
Collection: David H. Broillet, Geneva, Switzerland
Courtesy of Galleria Continua, San Gimignano, Italy
Photo: Ela Bialkowska

(64&65) *Field of Synergy*, 2000
Iron children beds, plastic tubes, wooden Chinese bed, light,
fan, motion-sensor,
polystyrene balls, fabric
2000 x 1330 x 900 cm
Courtesy of Galleria Continua, San Gimignano, Italy
Photo: Attilio Maranzano

(66&67) *Project Mental – "Field of Synergy n.2,"* 2000
Chinese ink on paper
70 x 100 cm
Courtesy of Galleria Continua, San Gimignano, Italy
Photo: Ela Bialkowska

(68&69) *Lumière Innocente*, 2000
Bed, spots, plastic tubes
115 x 80 x 85 cm
Collection: Larry Warsh
Courtesy of Galleria Continua, San Gimignano, Italy
Photo: Ela Bialkowska

(70&71) *Purification Room*, 2000
Found objects, clay, walls, floor
Variable dimensions
Produced by Galerie Ghislaine Hussenot

(74-75) *Precipitous Parturition*, 1999
Bicycle inner tubes, toy cars, metal, fragments of bicycle,
silicone, painting
2600 x 150 cm (variable)
Collection: Xu Min

(76-77) *Crystal Ball*, 1999
Beads of Chinese abacus and buddhist rosary, timber, metal,
glass, physiological solution
250 x 150 x 145 cm
Collection: Rosa and Gilberto Sandretto, Milan, Italy
Courtesy of Galleria Continua, San Gimignano, Italy
Photo: GAM Torino-Maurizio Elia

(78&79) *Human Constellation*, 1998–2000
Metal, aluminum casting chairs
1280 x 950 x 600 cm
Collection: The city of Montpellier
Photo: Chen Zhen

(80&81) *Invocation of Washing Fire*, 1999
Installation, timber, metal, sound, abacus beads, wooden
chamber pots, red light globes; broken calculators, cash reg-
isters, computers and television sets
390 x 340 x 250 cm
Collection: Queensland Art Gallery, Brisbane, Australia
Photo: Richard Singer

(84&85) *In(ter)fection*, 1998
Metal, I.V. bag and plastic tube, Chinese natural medicine,
bed springs, glass, found objects, silicone, stencil ink
2000 x 1000 x 380 cm
In collaboration with Nari Ward

(86&87) *Jue Chang — Fifty Strokes to Each*, 1998
Wood, iron, chairs, beds, leather, ropes, nails, objects
244 x 980 x 1000 cm
Installation view: Aperto Over All, 48th Venice Biennial,
Venice, Italy
Produced by Tel Aviv Museum of Art
Collection: Annie Wong Art Foundation, Hong Kong
Photo: Chen Zhen and Xu Min

(88) *Couverture*, 1998
Bamboo bed, nuts, metal
210 x 90 x 140 cm
Collection: Neda Young

(89) *Chair of Concentration*, 1998
Chair, chamber pots, sound system
180 x 106 x 60 cm
Courtesy of Galerie Ghislaine Hussenot, Paris

(90&91) *Un-interrupted Voice*, 1998
Chairs, skin with drawings, wood
80 x 120 x 40 cm
Collection: Paolo and Serena Gori, Prato, Italy
Courtesy of Galleria Continua, San Gimignano, Italy
Photo: Ela Bialkowska

(92-93) *Un-interrupted Voice*, 1998
Children's bed, skin, wood, iron
171 x 152 x 97 cm
Collection: Rosa and Gilberto Sandretto, Milan, Italy
Photo: Ela Bialkowska
Courtesy of Galleria Continua, San Gimignano, Italy

(96&97) *Prayer Wheel — "Money Makes the Mare Go" (Chinese
Slang)*, 1997
Chinese abacus, calculators, cash registers, metal, wood,
sound system
600 x 700 x 280 cm (the wheel is 240 x 240 x 250 cm)
Installation view: P.S.1 Contemporary Art Center, New York
Photo: Chen Zhen

(98) *Study for Prayer Wheel — "Money Makes the Mare Go"
(Chinese Slang)*, 1997
Chinese abacus, calculators, cash registers, metal, wood,
sound system
Courtesy of the artist and Xu Min

(99) *Prayer Wheel — "Money Makes the Mare Go" (Chinese
Slang)*, 1997 (detail)
Chinese abacus, calculators, cash registers, metal, wood,
sound system
600 x 700 x 280 cm (the wheel is 240 x 240 x 250 cm)
Installation view: P.S.1 Contemporary Art Center, New York
Photo: Chen Zhen

Courtesy of the artist
(100&101) *Fu Dao/Fu Dao, upside-down Buddha-arrival at good
fortune*, 1997
Metal, bamboo, Buddha statues, found objects
800 x 550 x 350 cm
Courtesy of the artist

(102) *My Diary in Shaker Village*, 1997
Documentation of a portrait in progress
Collection: Penny Mc Call Foundation
Courtesy of the artist

(102&103) *My Diary in Shaker Village*, 1997
27 framed elements: paper, photo, pencil, Chinese ink, wood,
glass
56 x 61 cm each
Collection: Penny Mc Call Foundation
Courtesy of the artist

(103) *Opening of Closed Center*, 1997
Wood, metal, found objects
345 x 300 x 250 cm
Installation view: Institute of Contemporary Art at Maine
College of Art
Collection: Penny Mc Call Foundation

(104) *Chair of Nirvana*, 1997
Chair, wood, metal
160 x 130 x 130 cm
Courtesy of the artist

(105) *Study for Chair of Nirvana*, 1997
Chair, wood, metal
160 x 130 x 130 cm
Courtesy of the artist
Collection: Gilles Fuchs

(106&107) *Round Table (Side by Side)*, 1997
Wood, chair, metal
180 x 630 x 450 cm
Installation view: Maison de Lyon, Lyon
Collection: Xu Min
Photo: Chen Zhen

(108&109) *Game Table*, 1996–1997
Coins of Chinese and Korean money, wood, chamber pot
500 x 360 x 120 cm
Installation view: Shanghai Art Museum,
Shanghai and Sonje Museum of Contemporary Art, Kwangju
Collection: Pierre Hubert, Geneva

(112&113) *Daily Incantations*, 1996
Night stools, wood beams, steel, electronic debris, sound mix

of the ritual cleaning of the stools
700 x 350 x 230 cm
Installation view: Deitch Projects, New York
Collection: Da Kis Joannou

(114-115) *No Way to Sky, No Door to Earth (Homage to Duchamp)*, 1995
Metal, Plexiglas, clothes, ashes from newspapers
210 x 112 x 112 cm
Courtesy of Bernier/Eliades Gallery, Athens, Greece

(116-117) *Obsession of Longevity*, 1995 (detail)
Metal, wood, plaster, Chinese medicines, paraffin wax, foam rubber, objects
355 x 200 x 220 cm
Collection: Xu Min
Courtesy of Bernier/Eliades Gallery, Athens, Greece

(118&119) *Cradle*, 1995
Hospital bed, clothes, sound system, wood, metal
155 x 175 x 250 cm
Collection: FNAC
Courtesy of Galerie Ghislaine Hussenot

(120&121) *Bouverie*, 1995
Mixed media
650 x 380 x 260 cm
Installation: Nouveau Musée/Institut Villeurbanne

(122&123) *Round Table*, 1995
Wood, metal, chairs from 5 continents
180 x 550 x 550 cm
Installation view: United Nations Palace, Geneva, Switzerland
Collection: United Nations

(126&127) *Resonance*, 1994
Metal bell, loud speaker, broken and calcined chair
1000 x 1000 x 500 cm (approx.)
Installation view: Kröller-Müller Museum, Otterlo, Germany
Collection: Kröller-Müller Museum, Otterlo, Germany

(128—131) *Light of Confession*, 1993
250 paintings of the Museum's collection, wood, objects, clay
2000 x 400 x 350 cm
Installation view: Central Museum Utrecht, Utrecht, The Netherlands
Photo: Centraal Museum Utrecht, Utrecht, The Netherlands

(132&133) *Le jugement divin*, 1993
Earth, skull, fabric, photos, glass, aluminum, wood, newspaper
606 x 220 x 62 cm
Courtesy of the artist

(134) *Sacrifice in the Heaven's Well*, 1993
Object, metal, plaster, canvas
1200 x 800 x 450 cm
Installation view: Frankfurter Kunstverein & Schirn

Kunsthalle, Frankfurt, Germany

(135) *Field of Waste*, 1994
Chinese and American flags, newspaper, clothing, sawing machine, metal
1500 x 1000 x 280 cm
Installation view: The New Museum of Contemporary Art, New York
Photo: Wang Gong-Xing

(138—141) *Green-house / Red-laboratory / White-tomb*, 1992
Glass, painting, neon, aquariums, newspaper ashes, clothes, chemical fertilizer, oil change, fire extinguisher, scrap, books, lead pipes, batteries, motors, telephones, calculator, printing machines, metal cutting, bulbs, water, sand, stones, earth, coal cow-dung, pigment powder, Chinese rice, bat excrements, flowers seeds, tree bark and branches
Installation view: Floriade Parc, Zoetermeer, The Netherlands

(142&143) *Find Reincarnation In Another's Corpse*, 1992
Earth, objects, wood, Plexiglas, painting, photograph
800 x 750 x 182 cm (variable)
Collection: Xu Min

(144&145) *Eruption Future / Future Eruption*, 1992
20 tons bauxite, water, aluminum bar (one ton), luminous case, aluminum bathtub, aluminum objects800 x 150 x 120 cm (approx.)
Installation view: ARTS 04, Contemporary Art Center, Saint Rémy-de-Provence, France
Collection: Xu Min

(146&147) *Sleeping Tao*, 1992
Water, earth, pigment, objects, light-box, metal, neon, wood
250 x 150 x 195 cm
Courtesy of the artist

(148—151) *La Porte de Renaissance/The Door of Re-birth*, 1992
Bent ventilation pipes, found objects, scanners of human lungs, black material, red spot lights, earth
815 x 235 x 170 cm (variable)
Installation view: Espace des arts, Colomiers, France

(154-155) *Le Passage, Le Circuit*, 1990 (detail)
Trailor, stone, water, metal, glass, wood, projector, journals
1450 x 1400 x 350 cm
Installation view: Pourrières, France
Photo: Chen Zhen

(156&157) *Hanging / Detaching World*, 1990
99 objects hanged in a burnt forest
1000 m² (approximately)
Installation view: Pourrières, France

Biography

CHEN ZHEN

b. 1955, Shanghai, China

d. 2000, Paris, France

STUDY AND TEACHING

1973
Shanghai Fine-Arts and Craft School, Shanghai, China.

1976
Professor of Shanghai Fine-Arts and Craft School, Shanghai, China.

1978
Shanghai Drama Institute (speciality: stage design), Shanghai, China.

1982
Professor of Shanghai Drama Institute, Shanghai, China.

1986
Ecole Nationale Supérieure des Beaux-Arts, Paris, France.

1989
Institut des Hautes Etudes en Arts Plastiques, Paris, France.

1991
Visiting Artist-Professor at Ecole Nationale Supérieure des Beaux-Arts, Paris, France.

1993–1995
Professor at Institut des Hautes Etudes en Arts Plastiques, Paris, France.

1997
Visiting Professor at CCA, Center for Contemporary Art, Kitakyushu, Japan.

1995–1999
Professor at Ecole Nationale des Beaux-Arts, Nancy, France.

GRANTS AND PRIZES

1989
L'Institut des Hautes Etudes en Arts Plastiques of Paris, France.

1990
The Pollock-Krasner Foundation, New York.

1991
Erwin und Gisela von Steiner Foundation, Munich, Germany.

1992
"Fonds d'Incitation à la Création," The French Ministry of Culture, Paris, France.

1993
"Fonds d'Incitation à la Création," The French Ministry of Culture, Paris, France.

1995
The Pollock-Krasner Foundation, New York.

1996
Penny McCall Foundation, New York.

"Fonds d'Incitation à la Création," The French Ministry of Culture, Paris, France

1997
Penny McCall Foundation, New York.

"'97 Kwangju Biennial Award," South Korea.

1998
Annie Wong Art Foundation, Hong Kong.

1999
Annie Wong Art Foundation, Hong Kong.

SOLO EXHIBITIONS

1990
Chen Zhen, Hangar 028, Paris, France, with the collaboration of Musée Départemental des Vosges (cat.).

1991
Chen Zhen, Valentina Moncada Gallery, Rome, Italy (cat.).

Chen Zhen, Ecole Nationale Supérieure des Beaux-Arts, Paris, France (cat.).

Momification of Ready-made, Dany Keller Gallery, Munich, Germany.

1992
Re-birth Door, Espaces des Arts, Colomiers, France (cat.).

Objects Illuminated during the Night, Vivita Gallery, Florence, Italy.

Sleeping Tao, Le Magasin, Centre National d'Art Contemporain de Grenoble, Grenoble, France (cat.).

Future Eruption, Arts 04, Centre d'Art Contemporain de St-Rémy-de-Provence, France (cat.).

1993
Polymorph, Michel Rein Gallery, Tours, France.

Light of Confession, Centraal Museum Utrecht, The Netherlands.

Room of Altars, Lumen Travo Gallery, Amsterdam, The Netherlands.

The Fire-Water as a Purification, Dany Keller Gallery, Munich, Germany.

1994
Field of Waste, The New Museum of Contemporary Art, New York (video-cat.).

Chen Zhen, Ecole Nationale des Beaux-Arts of Nancy, France.

1995
Field of Purification, Ghislaine Hussenot Gallery, Paris, France.

No Way to Sky, No Door to Earth, Jean Bernier Gallery, Athens, Greece.

1996
Daily Incantations, Deitch Projects, New York.

Permanent Digestion, Musée Léon Dierx, La Réunion, France (cat.).

Chen Zhen, Centre International d'Art Contemporain, Montreal, Canada (cat.).

1997
Fu Dao / Fu Dao, Upside-down Buddha / Arrival at Good Fortune, CCA-Center for Contemporary Art, Kitakyushu, Japan (book).

1998
Chen Zhen and Ken Lum, Catriona Jeffries Gallery, Vancouver, Canada.

In(ter)fection: Chen Zhen and Nari Ward, in the framework of "Archipelago: Crash Between Islands-Stockholm, Cultural Capital of Europe '98", National Maritime Museum, Stockholm, Sweden (cat.).

Jue Chang / Fifty Strokes to Each, Tel Aviv Museum of Art, Helena Rubinstein Pavilion for Contemporary Art, Tel Aviv, Israel (cat.).

Between Therapy and Meditation, Ghislaine Hussenot Gallery, Paris, France.

1999
Between Therapy and Meditation, ADDC-Espace Culturel François. Mitterand, Périgueux, France (cat.).

2000
Nightly Imprecation, Art & Public, Geneva, Switzerland.

In Praise of Black Magic, GAM, Galleria Civica d'Arte Moderna e Contemporanea, Turin, Italy (cat.).

Jardin Lavoir, Cimaise & Portique – Centre Départemental d'Art Contemporain, Albi, France (cat.).

Six Roots, MOCA-Museum of Contemporary Art, Zagreb, Croatia (cat.).

Dancing Body Drumming Mind, Deitch Projects, New York.

Field of Synergy, Continua Gallery, San Gimignano, Italy.

One Bed, Different Dreams, Ghislaine Hussenot Gallery (FIAC), Paris, France.

Daily Incantations, Museum of the Music, Paris, France.

2001
Chen Zhen, Serpentine Gallery, London, United Kingdom.

Homage to Chen Zhen, 3a Rassegna d'Arte Contemporanea, Bari, Italy.

2002
Metaphors of the Body at the National Museum of Contemporary Art, Athens, Greece.

Résidence Résonance Résistance, CCC-Centre de Création Contemporaine, Tours, France.

Inner Body Landscape, ICA-Institute of Contemporary Art, Boston, Massachusetts.

GROUP EXHIBITIONS

1990
Laboratoire, curated by Pontus Hulten, Russian Museum, St. Petersburg, Russia (cat.).

Chine Demain Pour Hier, curated by Fei Da-Wei, Pourrières, France (cat.).

Von mir aus, Dany Keller Gallery, Munich, Germany (cat.).

1991
Sous le signe de …, Centre Lotois d'Art Contemporain, Figeac, France (cat.).

Parcours Privés, curated by Adelina von Fürstenberg, Paris, France (cat.).

L'Art de la Lecture, FRAC, Alsace, France (cat.).

East Wind, Asian American Art's Center, New York.

1992
Allocaties/Allocations-Art for a Natural and Artificial Environment, curated by Maria-Rosa Boezem, Floriade den Haag-Zœtermeer, The Netherlands (cat.).

3011, curated by Jérôme Sans, Galerie des Archives, Paris, France.

La technologie dans l'art, Vivita Gallery, Florence, Italy.

Paesaggio con Rovine, curated by Achille Bonito Oliva, Museo Civico di Arte Contemporanea, Gibellina, Italy (cat.).

1993
Energotopes, curated by Démosthènes Davvetas, French Institute of Athens, Greece. Centre d'Art Contemporain Iléana Tounta of Athens and French Institute of Salonique (cat.).

PROSPECT 1993, Frankfurter Kunstverein und Schirn Kunsthalle, Frankfurt, Germany (cat.).

Plötzlich ist eine Zeit hereingebrochen, in der alles möglich sein sollte, curated by Udo Kulterman, Kunstverein Ludwigsburg, Germany.

Devant, le futur, curated by Pontus Hulten, "Taejon Expo'93," South Korea (cat.).

Trésors de Voyage, curated by Adelina von Fürstenberg, 45th Venice Biennial, Venice, Italy (cat.).

Before the sound of the beep–a Parisian exhibition, curated by Jérôme Sans, 22 galleries, Paris, France (cat.).

Concession perpétuelle, Museum Léon Dierx, La Réunion, France (cat.).

The Silent Energy, curated by David Elliot, The Museum of Modern Art, Oxford, United Kingdom (cat.).

Rencontres dans un couloir, curated by Hou Hanru, 12 Rue Lacordaire 15ere, Paris, France.

Thalatta, Thalatta, curated by Achille Bonito Oliva, Museo Internazionale d'Arte Contemporanea, Termoli, Italy (cat.).

Viennese Story, curated by Jérôme Sans, Wiener Secession, Vienna, Austria (cat.).

1994
L'œuvre a-t-elle lieu?, curated by Daniel Buren and Witte de With, Centre for Contemporary Art, Rotterdam, The Netherlands (cat.).

In altre parole, Valentina Moncada Gallery, Rome, Italy.

Out of the Centre, curated by Hou Hanru and Jari-Pekka Vanhala, Pori Art Museum, Finland (cat.).

"Le Shuttle," Künstlerhaus Bethanien, Berlin, Germany.

Heart of Darkness, curated by Marianne Brouwer, Kröller-Müller Museum, Otterlo, The Netherlands (cat.).

1995
Dialogue de Paix, curated by Adelina von Fürstenberg, Palais des Nations Unies, Geneva, Switzerland (cat.).

25 Jahre Galerie, Dany Keller Gallery, Munich, Germany (cat.).

10e Bourse d'art monumental d'Ivry, Centre d'Art Contemporain, Ivry, France (cat.).

On Board, curated by Jérôme Sans and Karin Schorm, Venice Biennial, Venice, Italy (cat.).

Shopping, CAPC Musée d'art contemporain, Bordeaux, France (cat.).

Aperto 95, le Nouveau Musée, Villeurbanne, France (cat.).

Dada-Fluxus-Tecno, Vivita Gallery, Florence, Italy.

Infra sound, curated by Jérôme Sans, Woche die Bildenden Kunst, Hamburg, Germany (cat.).

1996
1st Shanghai Art Biennial, Shanghai Art Museum, Shanghai, China (cat.).

Artistes Français de A à Z, Gabrielle Maubrie Gallery, Paris, France.

Shopping, Deitch Projects, New York (cat.).

Sites et Artistes, Villette-Amazone, Paris, France (cat.).

Origin and Myths of Fire, The Museum of Modern Art, Saitama, Japan (cat.).

The Quiet In The Land, curated by France Morin, Sabbathday Lake Shaker Village, Maine (cat.).

1997
Parisien/ne/s, curated by Hou Hanru, Camden Art Centre, London, United Kingdom (cat.).

Fueki-Ryuko: Chinese Contemporary Art at the Midst of Changing Surroundings, organised by Fumio Nanjo and Associates in three cities: Tokyo, Osaka, Fukuoka, Japan (cat.).

Meditations, organised by Art for the World, Médersa Ibn Youssef, Marrakech, Morocco (cat.).

L'Autre, Lyon Biennial, curated by Harald Szeemann, Maison de Lyon, Lyon, France (cat.).

In-between the Limits, curated by Fei Da-wei, Sonje Museum of Contemporary Art, South Korea (cat.).

The Quiet in The Land, curated by France Morin, ICA, Maine College of Art, Portland, Maine.

Hybrid, Kwangju Biennial, curated by Richard Koshalek, Kwangju, Korea (cat.).

Hong Kong, etc., 2nd Johannesburg Biennial 1997, curated by Hou Hanru, Johannesburg, South Africa (cat.).

Cities on the Moves, curated by Hans-Ulrich Obrist and Hou Hanru, Wiener Secession, Vienna, Austria (cat.).

Artist Projects, The Re-opening Show of P.S.1 Contemporary Art Center, Long Island, New York.

1998
Futur à Rencontrer, Passage de Retz, Paris, France.

Passage(s), Centre International d'Art Contemporain, Montreal, Canada.

The Edge of Awareness, organised by Art for the World, Headquarters of WHO, Geneva; P.S.1 Contemporary Art Center, New York; SESC de Pompéia, São Paulo, Brazil (cat.).

Cities on the Moves, curated by Hans-Ulrich Obrist and Hou Hanru, CAPC Musée d'art Contemporain, Bordeaux, France; P.S.1 Contemporary Art Center, New York.

The Quiet in The Land, curated by France Morin, ICA, Boston, Massachusetts.

Desire of Home, Kunsthalle Tyrol, Tyrol, Austria.

1st Biennale de Montréal, curated by Claude Gosselin, Montreal, Canada.

1998 Taipei Biennial: Site of Desire, curated by Fumio Nanjo, Taipei Fine Arts Museum, Taiwan (cat.).

Global Vision: New Art from the 90's, curated by Katerina Gregos, The Dakis Joannou Collection-Deste Foundation for Contemporary Art, Athens, Greece (cat.).

Gare de l'Est, curated by Hou Hanru and Enrico Lunghi, Casino de Luxembourg, Luxembourg (cat.).

1999
Cities on the Move, curated by Hans-Ulrich Obrist and Hou Hanru, Louisiana Museum of Modern Art, Humlebaek, Denmark; Hayward Gallery, London, United Kingdom; Museum of Contemporary Art, Helsinki, Finland.

Tales of the Tip, organised by Fundament Foundation, Praktijkbureau Beeldende Kunstopdrachten of the Mondrian Foundation, Breda, The Netherlands.

Jardin Secret, curated by Jean Louis Pradel, Hopital Charles Foix, Ivry s/Seine, France.

Magical Reality of Unnatural, curated by Jérôme Sans, Kunsthause Bregenz, Austria.

Aperto over All, 48th Venice Biennial, Venice, Italy.

Between Artificial and Nature, curated by Giovanna Nicoletti, Brunico, Italy.

In de Ban Van de Ring, curated by Annemie Van Laethem, Provenciaal Centrum voor Beeldende Kunsten, Hasselt, Belgium.

The Quiet in the Land: Everyday Life, Contemporary Art and Projeto Axé, curated by France Morin, Salvador, Brazil.

Let's get Lost, curated by Jérôme Sans, Central Saint Martin's College of Art and Design, London, United Kingdom.

Street Life, curated by Jérôme Sans, Project Row House, Houston, Texas.

3rd Asia-Pacific Triennial of Contemporary Art, Queensland Art Gallery, Brisbane, Australia.

Kunstwelten im Dialog, curated by Marc Scheps, Museum Ludwig, Cologne, Germany.

The 1999 Carnegie International, curated by Madeleine Grynstejn, Carnegie Museum of Art, Pittsburgh.

2000
Art Grandeur Nature, Parc Départemental de la Courneuve, La Seine-Saint-Denis, France.

The Quiet in the Land: Everyday Life, Contemporary Art and Projeto Axé, curated by France Morin, Museum of Modern Art of Bahia, Salvador, Brazil.

Paris pour Escale, curated by Hou Hanru, Eveline Jouanno, Marie-Sophie Carron and Aurélie Voltz, ARC, Musée d'Art Moderne de la Ville de Paris, Paris, France.

Collection, Kirishima Open-Air Museum, Kagoshima, Japan.

Continental Shift, Ludwig Forum, Aachen, Germany.

Playground & Toys for Refugee Children, organised by Art for the World, Musée International de la Croix Rouge, Geneva, Switzerland.

2001
Platea dell'Umanità, 49th Venice Biennial, Venice, Italy.

Made in Italy, curated by Achille Bonito Oliva, Milan Triennial, Italy.

El Mundo Nuevo, comunicación entre les artes, curated by Achille Bonito Oliva, Valence Biennial, Spain.

2002
Busan Biennial, South Korea.

Bibliography

PERIODICALS

1990

Aldighieri, Marion. "Des chinois chez Cézanne," *L'Autre Journal*, July 1.

De Candia, Mario. "Il Piacere dell' Occhio," *Trovaroma*, Rome, Italy, January 31.

"Chen Zhen," *Flash Art*, Milan, Italy, April/May.

Coen, Vittoria. "Chen Zhen," *Art-Magazine*, n.54, October-November.

Corbi, Anna Maria. "Chen Zhen, il superamento dell'oggetto," *Next*, Summer.

Dalesio, Gabriella. "Chen Zhen," *Segno*, n.101–102, February/March.

Debecque-Michel, Laurence. "Chine demain pour hier," *Art press*, n.151, Paris, France, October, p.102–103.

Ganzlen, Friederike. "Die Spur des Dinge, Chen Zhen's Ausstellung 'Ready- made' Mummification," *Das Neue China*, Berlin, Germany, December, p.35–36.

Giovanelli, Guglielmo. "Il giovane Chen Zhen al suo primo vernissage," *Roma*, Rome, Italy, February 11.

Guttman, Cynthia. "Mao's children fly avant-garde flag," *International Herald Tribune*, October, p.26–27.

Guzzi, Domenico. "Cosi un cinese diventa neoeuropeo," *Arte*, February.

Leauthier, Alain. "Un parapluie chinois sur la dissection provençale," *Libération*, Paris, France, July 16.

Legros, Hervé. "Nuit de Chine à Pourrières," *Beaux-Arts*, n.81, Paris, France, July-August.

Wiedemann, Christoph. "Grenzganger," "Kulturschock als Motor," *Noema Art Journal*, Karlsruhe, Germany, October, p.22.

1991

Dalesio, Gabriella. "Chen Zhen," *Segno*, Italy, February-March, p.101–102.

Guttman, Cynthia. "Mao's Children Fly Avant-Garde Flag," *International Herald Tribune*, Arts and Antiques, October, p.26–27.

Iovane, Giovanni. "Chen Zhen," *Titolo*, Italy, Spring.

1992

Barak, Ami. "Entre chien et loup, Chen Zhen, Pat Steir," *Art press*, n.172, Paris, France, p.85.

Bost, Bernadette. "Les sens et la voie," *Le Monde*, Paris, France, June 12.

Breerette, Geneviève. "Chen Zhen à Grenoble," *Le Monde*, Paris, France, July 10.

Cincinelli, Saretto. "Chen Zhen," *Flash Art*, n.168, Milan, Italy, June-July, p.124.

Gaston, Marguerite. "Muraille 8, Chen Zhen à l'Espace des Arts," *Flash*, Toulouse, France, April.

Gauville, Hervé. "Chen Zhen à Colomièrs," *Libération*, Paris, France, April 16.

Heartney, Eleanor. "Skeptics in Utopia," *Art in America*, n.80, New York, July, p.76–81.

Jammeti, Michel. "Chen Zhen à l'Espace des Arts, le plasticien de la récupération," *La Dépêche du Midi*, Toulouse, France, April 1.

Jover, Manuel. "Chen Zhen," *Beaux Arts*, n.104, Paris, France, September, p.113.

Lambrecht, Luk. "MAGASIN," *Die Morgen*, June 20.

Pagneux, Jean. "Le fil d'Ariane," *L'Argus de la Presse*, Paris, France, June 6.

Perrand, Sylvie. "Trois parcours différents," *Le Dauphiné Libéré*, Grenoble, July 22.

Sperandio, Silvia. "Totem quotidiani Brillano nella sacra notte," *Arte*, n.228, April, p.23.

1993

Giroud, Michel. "Chen Zhen," *Kanaleurope*.

Gliewe, Gert. "Widerstand mit Bildern," *AZ feuilleton*, Munich, Germany, December 9.

Hanru, Hou. "Zen and the Art of Contemporary China," *Flash Art*, n.173, Milan, Italy, November-December, p.64.

Metzger, Rainer. "Prospect '93," *Kunstforum*, n.123, p.306–309.

Piguet, Philippe. "Chen Zhen," *La Croix*, Paris, France, July 4.

Sonna, Birgit. "Aktuell in Münchner Galerien," *Süddeutsche Zeitung*, n.288, Munich, Germany, June 14.

1994

Cotter, Holland. "Installations Addressing Ethnic Identity — Chen Zhen/Huang Yong Ping," *The New York Times*, New York, May 20.

Levin, Kim. "Chen Zhen/Huang Yong Ping," *The Village Voice*, New York, May 31

Marcelis, Bernard. "L'œuvre a-t-elle lieu? (Does the Work of Art Take Place?)," *Art Press*, n.193, Paris, France, July–August, p.166.

Schmidt, Barbara U. "Chen Zhen, the Fire-Water as the Purification," *Kritik*, n.1, p.116.

Vermeijden, Marianne. "Met een gasmasker op naar gedroogde mest kijken," *NRC Handelsblad*, Rotterdam, The Netherlands, March 25.

Wesseling, Janneke. "Reageren op het niets," *NRC Handelsblad*, Rotterdam, The Netherlands, April 22.

Yi-Qing, Yu. "Chen Zhen & Huang Yong Ping," *World Weekly*, May 22.

1995

Amar, Sylvie. "A Few Reflections on L'oeuvre a t-elle lieu?," *Witte de With Cahier*, n.3, Rotterdam, The Netherlands, February, p.44–47.

Anselmi, Inels. "Dialogues de Paix," *Kunstforum*, n.132, November–January, p.322–325.

Doswald, Christoph. "Biennale de Venise," *Kunstforum*, n.131, August-October, p.174.

Jung, Lee Sanders. "Chinese Hand Laundry & Field of Waste," *Space*, South Korea.

Koplos, Janet. "Huang Yong Ping and Chen Zhen at the New Museum," *Art in America*, n.83, New York, January, p.104–105.

Riding, Alan. "Politics, This is Art. Art, This Is Politics," *The New York Times*, New York, August 10.

Römer, Stefan. "Le Shuttle," *Kunstforum*, n.129, January–April, p.339–340.

Sinanidis, Mary. "Chen Zhen's Greek Connection," *Athens News*, Athens, Greece, October 24.

1996

Amar, Sylvie. "Walk in the Soho Side etc.," *Art Press*, n.215, Paris, France, July-August, p.68–69.

Barat, Thierry. "Le destin identitaire de Chen Zhen," *Le Quotidien*, La Réunion, France, June 21.

Bruinsma, Max. "Heart of Darkness," *Metropolism*, n.1, Amsterdam, The Netherlands.

Dubourd, David. "Scène de la vie quotidienne," *Le Journal de L'Ile*, La Réunion, France, June 21.

Murat, Laure. "Visite très privée chez les plus grands collectionneurs," *Beaux Arts*, n.11, Paris, France, January, p.56.

Sans, Jérôme. "Chen Zhen," *Artforum*, n.34, New York, January, p.92.

Smith, Roberta. "Culture and Commerce Live Side by Side in Soho," *The New York Times*, New York, September 13.

Tagore, Sundaram. "U.N. 50th Anniversary Exhibition at the League of Nations Building and Ariana Park," *Asian Art News*, p.80.

Yang, Alice. "Daily Incantations," *World Art*, n.4, p.85.

1997

Camhi, Leslie, "Seeing and Believing," *The Village Voice*, New York, September 2.

Coomer, Martin. "Parisien(ne)s," *Time Out*, n.52, March, p.12–19.

Christakos, John. "Surprises from China," *The Daily Yomiuri*, Tokyo, Japan, March.

Curtis, Sarah. "Quiet Confidants," *World Art*, March.

Deliss, Clémentine. "Meditations: Resisting the Seduction of the Space," *Atlantica*, n.17, Paris, p.17.

Gouelle, Jennifer. "Chen Zhen," *Parachute*, Montreal, Canada, March, p.33–34.

Kontova, Helena. "Meditations in Marrakech," *Flash Art*, Milan, Italy, May–June, p.49.

Larson, Kay. "A Month in Shaker Country," *The New York Times*, New York, August 10.

McFadden, Sarah. "The Other Biennial," *Art in America*, n.85, New York, November, p.91.

McQuaid, Cate. "Maine's 'Quiet in the Land' Plumbs Art of Shaker Life," *The Boston Globe*, Boston, August 15.

Millet, Catherine. "Unmapping The Earth," *Art Press*, n.230, Paris, France, December, p.65.

Nagoya, Satoru. "Immutability and Fashion," *Flash Art*, Milan, Italy, May–June, p.110–111.

Sirmans, Franklin. "Harald Szeemann," (interview), *Flash Art*, n.195, Milan, Italy, Fall, p.89.

Szeeman, Harald. "Catalogue of the exhibition 'L'autre,'" Lyon Biennial, *Flash Art*, n.195, Milan, Italy, Summer.

Zaya, Antonio. "Meditations: On Spirituality in Art," *Atlantica*, n.17, Paris, France, p.112–113.

1998

Allerholm, Milou. "Views," *Siksi*, Helsinski, p.80.

Breerette, Geneviève. "A Genève, l'art contemporain affiche une certaine santé," *Le Monde*, Paris, France, July 1.

Dagbert, Anne. "Un futur à rencontrer," *Art Press*, n.233, Paris, France, March, p.9.

Heartney, Eleanor. "The Return of the Red-Brick Alternative," *Art in America*, New York, January, p.58.

Heartney, Eleanor. "La réouverture de P.S.1" ("P.S.1 Reopens"), *Art Press*, n.231, Paris, January, p.70–71.

McSherry, Fred and Cheryl Simon. "Destination: Montreal," *International Contemporary Art Magazine*, November–January.

Nagoya, Satoru. "Dangers of Postmodern Global Conditions," *Flash Art*, n.198, Milan, Italy, January, p.73.

Solomon, Andrew. "As Asia Regroups, Art has a new Urgency," *The New York Times*, New York, August 23, p.31.

Vine, Richard. "Post-Mao Artists in New York," *Art in America*, New York, September, p.117.

Yang, Alice. "Chen Zhen, *Why Asia?*," *New York Press*, New York, p.57–59.

1999

Baradel, Virginia. "Gli italiani, dal fachiro all'aviogetto," *La Nuova Venezia*, Venice, Italy, June 10.

Barilli, Renato. "Ufficio smistamento: per andare altrove," *Corriere della Sera*, Italy, June 12.

Bellet, Harry. "L'exposition internationale de la Biennale de Venise pulvérise les bastions nationaux," *Le Monde*, Paris, France, June 16.

"Chen Zhen," "Exporama," *Art Press*, n.243, Paris, France, February, p.8.

"Chen Zhen," *Art Magazine* (Japanese Review), United Kingdom, September, p.22.

Chessa, Pasquale. "Al gran circo di Venezia," *Panorama*, Venice, Italy, June 17.

Colonna-Cesari, Annick. "La défaite de la peinture," *L'Express*, Paris, France, June 24.

Conway Morris, Roderick. "Biennale Celebrates the Local," *International Herald Tribune*, June 16, p.6.

Cork, Richard. "Does Every City End Up Like This?," *The Times*, New York, May 19.

Dal Lago, Francesca. "Open and Everywhere," *Art Asia Pacific*, p.24–26.

Da-Wei, Fei. "Twenty Chinese Artists," *Flash Art*, n.208, Milan, Italy, October, p.82–83.

Dorfles, Gillo, "Video, foto, marchingegni. E la pittura?," "Biennale: una gran voglia di ricominciare," *Corriere della Sera*, Italy, June 6.

Godfrey, Dominique. "La Chine, le corps et l'esprit," *Sud-Ouest Dimanche*, Bordeaux, France, February 21, p.29.

Greenberg, Sarah. "The Marco Polo Biennale," *The Art Newspaper*, n.94, July–August.

Heartney, Eleanor. "Report from Montreal," *Art in America*, New York, February.

Johnson, Patricia C. "An international group of artists finds provocative ways to bring cultures together," *Houston Chronicle*, Houston, October 24, p.8–9.

Kimmelman, Michael. "The Art of the Moment (and Only for the Moment)," *The New York Times*, New York, April 1, p.1 and 34.

Knott, George. "The urban roller-coaster ride," *Building Design*, May 21.

Mezil, Eric, "L'attirail de Chine," *Beaux-Arts*, Paris, December 15, p.226–229.

O'Hagan, Andrew. "The show must go on," *The Guardian*, London, United Kingdom, May 15.

Panzeri, Lidia. "Venezia, Biennale vademecum," *Il Giornale dell'Arte*, Torino, Italy, June.

Politi, Giancarlo. "The Venice Biennale," *Flash Art*, n.208, Milan, Italy, October, p.77.

Rizzi, Paolo. "Finalmente l'arte impara a divertisi," *Il Gazzettimo di Venezia*, Venice, Italy, June 10.

Ruthe, Ingeborg. "Das Spiel der Enkel und das Augen zum Markt," *Berliner Zeitung*, Berlin, Germany, June 14.

Sans, Jérôme. "Chen Zhen," *Les inrockuptibles*, n.202, Paris, France, June 9.

Searle, Adrian. "Take a left at Hong, a right at kuala Lumpur and there you are...London," *The Guardian*, London, United Kingdom, May 19.

Storr, Robert and Harald Szeeman. "Prince of Tides," *Artforum*, New York, May, p.164.

Vagheggi, Paolo. "Un grande circo allegro," *La Républica*, Lima, Peru, June 11.

Vallora, Marco. "Una biennale sulle labbra di Monica," *La Stampa*, n.157, Milan, Italy, June 10, p.25.

van de Velde, Paola. "De mens gaat ten onder aan zijn afval," *Telegraaph*, Amsterdam, The Netherlands, May 7.

Vetrocq, Marcia E. "The Venice Biennale," *Art in America*, New York, September, p.93.

Vettese, Angela. "Salpando per mari aperti," *Il Sole 24 Ore*, Milan, Italy, June 13.

Woeten, Amy. "Kunstenaars laten zich inspireren door wat ooit is weggegooid," *Nieuw Ginneken*, Ulvenhout, April 28.

2000

Allegretti, Adelinda. "L'arte magica fuggita dall'oriente comunista," *Il Giornale del Piemonte*, Torino, Italy, April 18.

Bouruet-Aubertot, Véronique. "Chen Zhen, Le fugitif spirituel," *Beaux Arts*, n.192, Paris, France, May, p.42.

"Chen Zhen," In Conversation with Hans-Ulrich Obrist, *Atlantica*, n.27, Paris, France, p.4–17.

Cincinelli, Saretto. "Chen Zhen alla Galleria d'Arte Moderna di Torino," *Flash Art*, n.222, Milan, Italy, June-July.

Fiz, Alberto. "Il mercato guarda a oriente," *Milano Finanza*, Milan, January 4.

Gandini, Manuela. "L'energia dei luoghi che nasce dal dolore," *Il Sole 24 Ore*, n.306, Milan, Italy, November 12.

Gavalda, Jean-Marie. "L'art va bon tram," *Libération*, Paris, France, August 27, p.28.

Hanru, Hou and Hans-Ulrich Obrist. "Cities On The Move — A Dialogue," *Art Asia Pacific*, n.25, p.73–74.

Heartney, Eleanor. "Chen Zhen 'entre' les cultures. Paintings to Save His Life," *Art Press*, n.260, Paris, France, September, p.22–26.

Hsiao-Hwei, Yu. "A Seminar of Global Culture Between Chickens and Ducks In A Confused Time-Space," *Chinese Art News*, n.32, May, p.84.

Hsiao-Hwei, Yu. "Chen Zhen, Jardin Lavoir," *Chinese Art News*, n.34, July, p.68.

Morin, France. "The Quiet in the Land: Resistance and Healing through Art," *Art Journal*, n.59, New York, Spring, p.7–10.

Palmeri, Fabiola. "La scultura come cura," *Vernissage*, n.6, May, p.15.

Palmeri, Fabiola. "Lo Zen o l'arte della magia nera," *Il Giornale dell'Arte*, Torino, Italy, April.

Parola, Lisa. "Arrivano i 'cortocircuiti' di Chen Zhen," *La Stampa*, Milan, Italy, April 13.

"Le Train Tram Art" in "Actualité", *Beaux Arts*, n.195, Paris, France, August, p.10

2001

"A Different Drum. Is Chen Zhen's Sculpture Good For You?," *Time Out*, New York, May 23.

"Beat the drum for a man apart," *The Times*, New York, May 9.

"Chen Zhen," intervista/*interview*, *Cité de la Musique*, n.31, Paris, France, December–January, p.14–15.

Cincinelli, Saretto. "Chen Zhen," *Flash Art*, n.226, Milan, Italy, February-March.

Glover, Michael. "Suspended Between East and West," *The Independent*, London, United Kingdom, May 10.

Gandini, Manuela and Margherita Remotti. "Oriente Occidente," *Kult*, n.12, December.

Mango, Marco. "Field of Synergy. Chen Zhen at San Gimignano, Galleria Continua," *Collezioni*, Modena, Italy, January-March.

Muroni, Alessia. "Un libro per Chen Zhen," *Arte e Critica*, n.26–27, Rome, Italy, April–September, p.58.

Obrist, Hans-Ulrich. "Interview with Chen Zhen," *Eutropia*, January, p.101–108.

Searle, Adrian. "Please Do Not Sit on the Artwork," *The Guardian*, London, United Kingdom, May 1, p.12–13.

CATALOGUES

1990

Da-Wei, Fei, Bernard Marcadé, and Yves Michaud. *Chine demain pour hier*, Pourrières, France.

Fauchereau, Serge. *Laboratoire*, Russian Museum, St. Petersburg, Russia.

Huin, Bernard. "Chen Zhen; l'envers vaut l'endroit et vice-versa," *Chen Zhen*, Hangar 028, Paris, France.

Hulten, Pontus. "Chen Zhen," *Chen Zhen*, Hangar 028, Paris, France.

Marcade, Bernard. *Chine demain pour hier*, Pourrières, France.

Michaud, Yves. Catalogue d'Exposition *Chine Demain Pour Hier*, Pourrières, France.

Sans, Jérôme. "L'après-objet," *Chen Zhen*, Hangar 028, Paris, France.

Sans, Jérôme. Interview, *Chine demain pour hier*, Pourrières, France.

1991

Christov-Bakargiev, Carolyn. "Chen Zhen," *Chen Zhen*, Valentina Moncada Gallery, Rome, Italy.

von Fürstenberg, Adelina. *Parcours privés*, Paris, France.

Michaud, Yves. "Chen Zhen," In Conversations, Ecole Nationale Supérieure des Beaux Arts, Paris, France.

Sans, Jérôme. *Chen Zhen* (interview), Valentina Moncada Gallery, Rome, Italy.

Sans, Jérôme. "Interview: Le cimetière du monde des signes," *Sous le signe de...*, Centre Lotois d'Art Contemporain, Figeac, France.

Sans, Jérôme. "Matéria prima — une rose pour l'éternité," *Parcours Privés*, Paris, France.

1992

Davvetas, Démosthènes. "Chen Zhen," Espace des Arts, Colomiers and Arts 04, Saint-Rémy-de-Provence, France.

von Fürstenberg, Adelina. "Chen Zhen," Le Magasin — Centre National d'Art Contemporain, Grenoble, France, p.6–7.

Oliva, Achille Bonito. *Paesaggio con rovine*, Fondation Orestiadi di Gibellina, Gibellina, Italy.

Salvadori, Fulvio. "Chen Zhen," *Chen Zhen*, Le Magasin — Centre National d'Art Contemporain, Grenoble, France. p.10–49.

Sans, Jérôme. Interview in *Chen Zhen*, Le Magasin — Centre National d'Art Contemporain, Grenoble, France, p.50–59.

1993

Cheval, François. *Concession perpétuelle*, Musée Léon Dierx, La Réunion, France.

Davvetas, Démosthènes. *Energotopes*, Contemporary Art Center Iléana Tounta, Athens, and French Institute, Salonika, Greece.

Elliott, David. *Silent Energy*, Museum of Modern Art, Oxford, England, U.K.

Hulten, Pontus. *Devant, le futur*, Taejon Expo '93, South Korea.

Oliva, Achille Bonito. *Thàlatta, Thàlatta!*, Galleria Civica d'Arte Contemporanea, Termoli, Italy.

Salvadori, Fulvio. "Méditerranée: La voie de l'Occident," *Trésors de Voyage*, 45th Venice Biennial, Italy.

1994

Gohlke, Gerrit. *Le Shuttle*, Künstlerhaus Bethanien Berlin, Berlin, Germany.

Hanru, Hou. *Out of Center*, Pori Art Museum, Pori, Finland.

Vanhala, Jari-Pekka. *Out of Center*, Pori Art Museum, Pori, Finland.

1995

Brouwer, Marianne. "Introduction" in *Heart of Darkness*, Kröller Müller Museum, Otterlo, The Netherlands.

von Fürstenberg, Adelina. *Dialogues de Paix*, Palais des Nations, Geneva, Switzerland.

Gohlke, Gerrit. *Le Shuttle*, Künstlerhaus Bethanien, Berlin, Germany.

Hanru, Hou. "A Certain Necessary Perversion" in *Heart of Darkness*, Kröller Müller Museum, Otterlo, The Netherlands.

1996

Cheval, François. *Chen Zhen: La digestion perpétuelle*, Musée Léon Dierx, La Réunion, France.

1997

"Chen Zhen," *Cities On The Move*, CAPC musée d'art contemporain de Bordeaux, Chapter 3, edited by Hanru, Hou and Hans-Ulrich Obrist.

Da-Wei, Fei. *In-between the limits*, Sonje Museum of Contemporary Art, Kyungju, South Korea.

Hanru, Hou. "Chen Zen" (interview) *Parisiennes*, p.40–43.

Hanru, Hou. "Hong Kong etc.," *Johannesburg Biennale*, South Africa.

Koshalek, Richard. "Meditations on Hybrid Art," *Kwangju Biennale*, South Korea.

Miki, Akiko. "Chen Zhen," *Immutability and Fashion*, p.18–19, 33.

Nanjo, Fumio. "Immutability and Fashion: Chinese Contemporary Art in the Midst of Changing Surroundings," *Immutability and Fashion*, Tokyo, Osaka, Fukuoka, Japan.

Szeemann, Harald. *L'autre*, 4th Lyon Biennial, France.

Weibel, Peter. *Inklusion : exklusion*.

1998

"Chen Zhen," *Sehnsucht Heimat*, Salzlager Hall, Kunsthalle Tirol, p.21.

"Chen Zhen," *Concession perpétuelle IV*, Musée Léon Dierx, La Reunion, France.

"Chen Zhen," *Chronologie: artistes français en Israël 1988–1998*, Chapter 98.

"Chen Zhen," *The Edge of Awareness*, Geneva, New York, Sao Paulo, New Delhi, p.216–217.

Gosselin, Claude. "Chen Zhen, Reflexions ou culture," *Chen Zhen*, Centre International d'Art Contemporain, Montreal, Canada, p.39–41.

Hanru, Hou. "Transexperiences of a 'Spiritual Runaway,'" *Chen Zhen*, Centre International d'Art Contemporain, Montreal, Canada, p.42–43.

Lunghi, Enrico. "Chen Zhen," (interview) *Gare de l'est*, Paris, France, p.33–37.

Nanjo, Fumio. "Chen Zhen", *Taipei Biennial*, Taipei, China, p.54–57.

Pujo, Aline. *Silent Paces*, edited by Aline Pujo.

Stefanidis, Manos. *Global vision II*, New York.

Zhu, Xian and Chen Zhen. "Transexperiences," *Transexperiences/Chen Zhen*, CCA- Center for Contempory Art, Kitakyushu, Japan.

1999

"Chen Zhen," in *Carnegie International 1999/2000*, Pittsburgh, Pennsylvania, p.94–95.

"Chen Zhen," *Cities On The Move 4*, Louisiana, p.85.

"Chen Zhen," in *Naturally art*, Germany, Kunsthaus Bregenz, Germany, p.128–130.

"Chen Zhen," in *Album ZOO*, Issue n.3, October, p.202–203.

Bonami, Francesco and Hans-Ulrich Obrist. "Chen Zhen," *Dreams*, Roma, Italy, ed. Castelvecchi, p.125.

Dematte, Monica. "Chen Zhen," *La Biennale di Venezia, 48th Esposione Internazionale d'Arte*, Italy, p.98–99.

Grynsztejn, Madeleine. *Carnegie International 1999–2000*, Pennsylvania, vol.1, p.120, 200.

Hanru, Hou. "Chen Zhen," *Beyond the Future, The Third Asia-Pacific Triennial of Contemporary Art*, Queensland Art Gallery, Australia, p.198–199.

Hanru, Hou and Obrist, Hans-Ulrich. *Cities on the Move*, Hayward Gallery, London, United Kingdom, p.10–15.

Sans, Jérôme. *Chen Zhen* (interview), ADDC-Espace Culturel François Mitterrand, Périgueux, France.

Smallenberg, Sandra. "Chen Zhen," *Panorama 2000*, Centraal Museum, Utrecht, The Netherlands, p.40–41.

Yilmaz, Yilmaz. "Chen Zhen," *Kunst-welten im dialog*, Museum Ludwig, Cologne, Germany, p.394–395.

2000

Buren, Daniel. "A Conversation between Daniel Buren and Chen Zhen," (interview) *Chen Zhen – In Praise of Black Magic*, GAM Galleria Civica d'Art Moderna e Centemporanea, Turin, Italy, p.97–109.

Koscevic, Zelimir and Jackie-Ruth Meyer, Jérôme Sans, Nada Beros. "Le Silence Sonore/Zvonka tisina/Sonorous Silence," *Chen Zhen*, Cimaise et Portique, Centre départemental d'art contemporain, Albi, France, Muzej suvremene umjetnosti, Zagreb, Croatia.

Morin, France. "The Quiet in the land: Resistance and Healing through Art," *The Quiet in the Land Everyday Life, Contemporary Art and Projeto Axé*, Museum of Modern Art of Bahia, Salvador, Brazil, p.28–41.

Morin, France. "Chen Zhen – Beyond the Vulnerability," *The Quiet in the Land – Everyday Life, Contemporary Art and Projeto Axé*, Museum of Modern Art of Bahia, Salvador, Brazil, p.106–107.

Pace, Alessandra and Giovanni Maria Pace. "A conversation about the praise of Black Magic," (interview) *Chen Zhen – In Praise of Black Magic*, GAM Galleria Civica d'Arte Moderna e Contemporanea, Turin, Italy, p.45–51.

Pujo, Aline. "La métaphore du 'Jardin de la clarté parfaite,'" *Art Grandeur Nature*, Département de la Seine-Saint-Denis, France, p.10–11.

2001

Sans, Jérôme. "A Field of Energy," *Chen Zhen*, Serpentine Gallery, London, United Kingdom, p.6–7.

Hanru, Hou. "Transexperience in the Art of Chen Zhen," *Chen Zhen*, Serpentine Gallery, London, United Kingdom, p.15–28.

Vettese, Angela. "Field of Synergy," *Chen Zhen Field of Synergy*, Galleria Continua, San Gimignano, Italy, p.31–48.

The programs at P.S.1 Contemporary Art Center are made possible in part by the New York City Department of Cultural Affairs, the Office of the Borough President of Queens, and the Council of the City of New York.

P.S.1 would like to thank Chris Apple; agnès b; Eric Angels; Janine Antoni; Sylvie Blocher; Chen Bo; the Cultural Services of the French Embassy; Domenico De Clario; Mario Cristiani; Jeffrey Deitch; Nora Donnelly; Alice Fontanelli; Galleria Continua, San Gimignano (Italy); Giulio di Gropello; Cai Guo-Qiang; Hou Hanru; Eleanor Heartney; Pierre Hubert; Institute of Contemporary Art, Boston; Xu Min; France Morin; Yan Pei-Ming; Hans-Ulrich Obrist; Anthony T. Podestà; Michel Rein; Maurizio Rigillo; David Rosenberg; Sam Samore; Jérôme Sans; Gilbert Vicario; Antoine Vigne; Nari Ward; Annie Wong; Annie Wong Art Foundation; Richard Yiu.

Special thanks to Rosa and Gilberto Sandretto and Lorenzo Fiaschi.

194

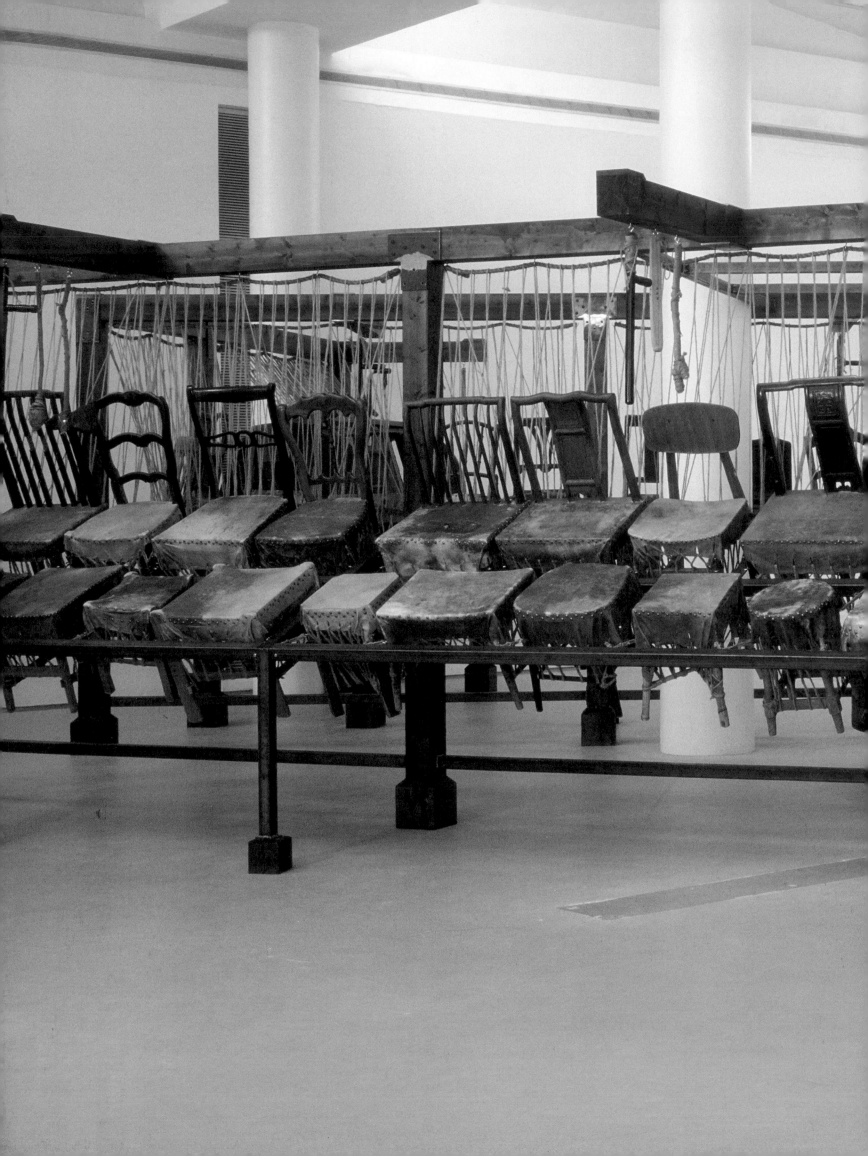

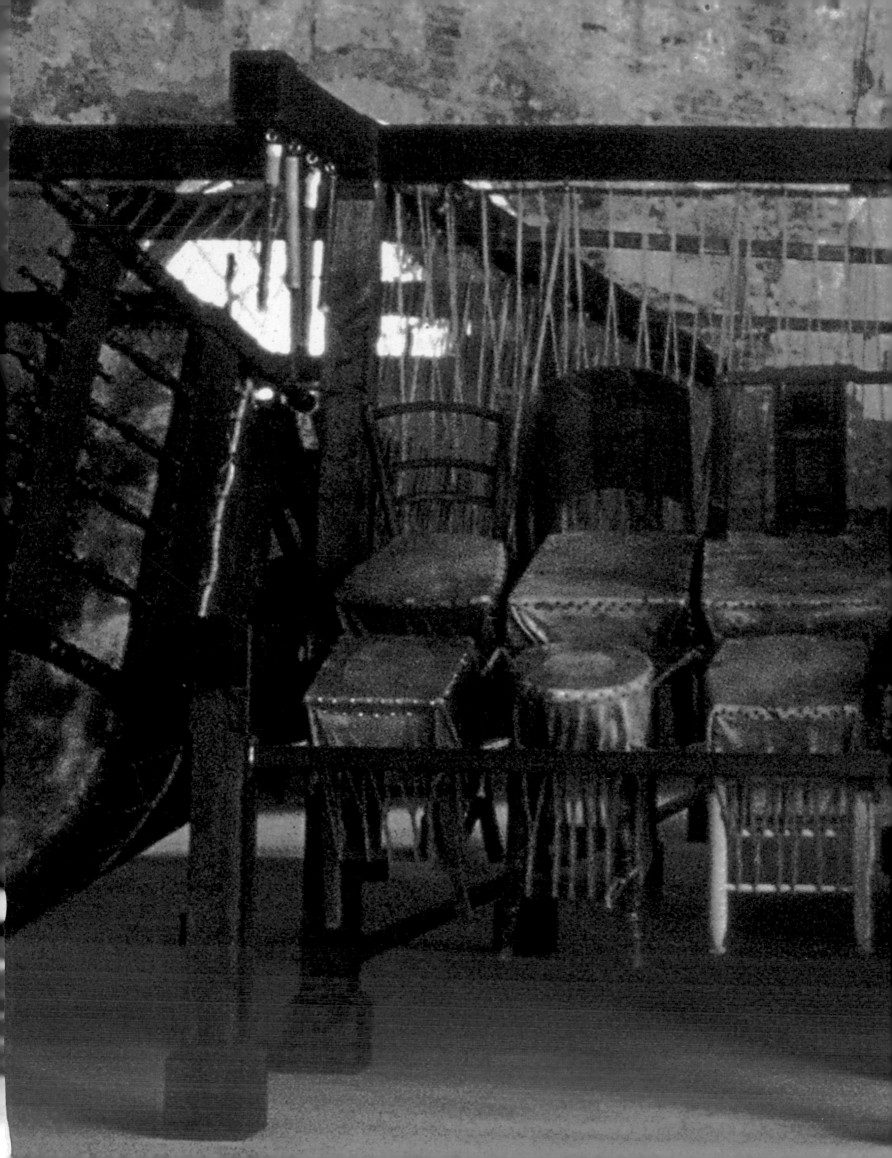